Stone Sculptures

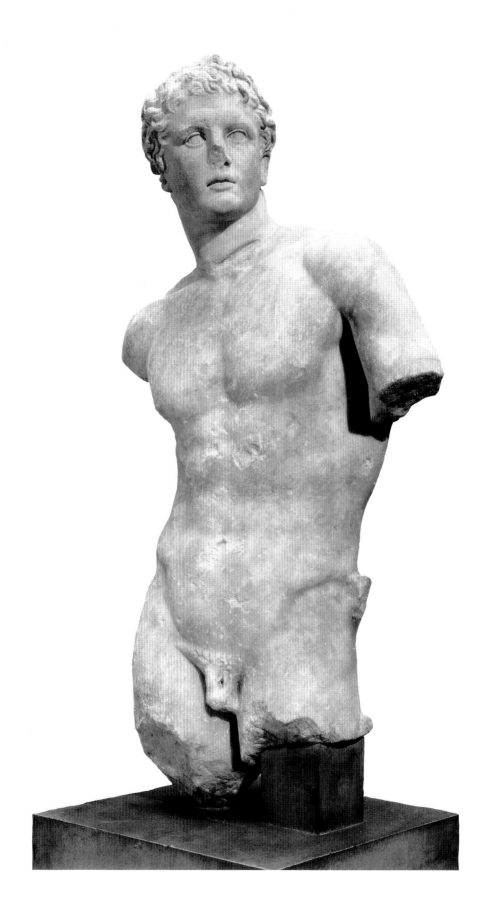

Stone Sculptures

The Greek, Roman, and Etruscan Collections

of the

Harvard University Art Museums

Cornelius C. Vermeule

and

Amy Brauer

Harvard University Art Museums

Cambridge, 1990

Cover illustration: cat. no. 10
Frontispiece: cat. no. 30

Produced by the Publications Department, Harvard University Art Museums.

Peter L. Walsh, director of publications
Michele Millon, project editor

Production of this publication was supported, in part, by a grant from the
National Endowment for the Arts, a federal agency.

Photographs by The Photographic Services Department, Harvard University,
except for 1927.203 and 1932.56.118, by David Stansbury

Library of Congress Cataloguing in Publication Data:
Harvard University. Art Museums.
 Stone sculptures: the Greek, Roman, and Etruscan collections of the
Harvard University Art Museums/Cornelius C. Vermeule and Amy Brauer.
 p. cm.
 Bibliography: p.
 1. Sculpture, Classical—Catalogs. 2. Sculpture—Massachusetts—
Cambridge—Catalogs. 3. Harvard University. Art Museum—Catalogs.
I. Vermeule, Cornelius Clarkson, 1925– . II. Brauer, Amy.
III. Title.
NB87.H37 1989
733'.074'7444—dc20 89-15409
 CIP

ISBN 0-916724-70-0

Contents

Director's Foreword

When Edward Waldo Forbes became director of the Fogg Art Museum early in this century, he had an idea about how to teach young people about art which remains a remarkable one today. He believed that students learn best not only from original works of art, but from original works of art of the highest quality.

No collection in Harvard's art museums is a better illustration of this theory in practice than the classical stone sculpture. Far from being a conventional "teaching collection"—that is, a group of lesser works acquired on the assumption that such things are "good enough" for students—it ranks with the finest small collections of classical sculpture in this country. Its riches range from the magnificent Roman copy of Skopas' Meleager, one of the first original sculptures to enter the collections and still one of the most important art works at Harvard, to the beautiful Hellenistic Aphrodite, given to the museums just this past year.

As it exists today, the collection is the cumulative result of the generosity of generations of devoted alumni and friends, as well as teachers and curators, especially the late George M. A. Hanfmann. The vast majority of works of stone sculpture and other objects came to the museums through gifts and bequests, and without the dedication and support of our donors and patrons, this catalogue would be much shorter and not nearly as significant for scholarship.

We are deeply grateful to an informal adjunct curator, Cornelius Vermeule, who, although his official duties are at the Museum of Fine Arts, Boston, has been a constant presence at Harvard's art museums since the days when he, himself, was a Harvard student. Cornelius spent many years of his own free time on this important project, with the continuous support and aid of our own curator of ancient art, David Mitten. Amy Brauer, assistant curator, has devoted many hours over the past several years to her role as Cornelius' collaborator and co-author on the Harvard side of the Charles.

This catalogue is part of a long-term priority of mine systematically to catalogue the permanent collections in a way that will make them accessible to both scholars and students. We are also indebted to the National Endowment for the Arts and the Andrew W. Mellon Foundation for their continued support of this goal.

Edgar Peters Bowron
Elizabeth and John Moors Cabot Director

Preface and Acknowledgments

A long-standing objective of the staff of the Ancient Art Department, Harvard University Art Museums, has been the publication of a comprehensive scholarly catalogue of the Greek, Roman, and Etruscan stone sculptures in its collection. Although some of the larger sculptures have received extensive, repeated treatment in articles and monographs, most of the collection has remained virtually unknown to scholars and the general public.

We are enormously fortunate in the willingness of Dr. Cornelius C. Vermeule, who generously and enthusiastically offered to initiate such a catalogue several years ago, and who has placed his enormous learning and keenly practiced eye at the service of this project. His intimate knowledge of the collection began in his student days, early in the 1950's when he collaborated with the late Professor George M. A. Hanfmann in publications and exhibitions involving the collections. His close and fruitful working relationship with the collection has continued ever since, through the decades of his curatorship of Greek and Roman art at the Museum of Fine Arts in Boston.

I am also grateful to my colleague, Amy Brauer, for her willingness to collaborate with Cornelius Vermeule in every stage of the research and writing of this catalogue. Their collaboration has been exemplary and inspiring.

During the research, writing, and preparation of this catalogue, the staff of the Ancient Art Department has incurred many debts, some of them reaching back a number of decades. First, it is a pleasure to thank Cornelius Vermeule's colleagues in the Department of Classical Art at the Museum of Fine Arts—Mary Comstock, keeper of coins and associate curator; John J. Herrmann, Jr., associate curator (who has contributed especially helpful discussion on questions of dating, attribution, and identifying of marble sources); Florence Wolsky, department fellow; Michael Padgett; and Carolyn Townsend. Emily T. Vermeule has contributed many helpful clarifications and details throughout the text of the manuscript.

At Harvard, the members of the Object Laboratory of the Center for Technical and Conservation Studies have rendered invaluable service in the cleaning, reassembling, and remounting of many sculptures for study, photography, and ultimate installation in the galleries on the top floor of the Arthur M. Sackler Museum, which were opened to the public in October, 1985. We want in particular

to thank Arthur Beale, then head of the Center, and more recently Marjorie Cohn, his successor, for their unstinting help and support; Henry Lie, now head of the Object Lab; along with Csilla Felker and interns in the Object Lab, Daphne Barbour, Jane Carpenter, Andrzej Dajnowski, Pamela Hatchfield, Eva Sander, and Valentine Talland, who carried out innumerable tasks of conservation that materially added to the appearance of these works and our understanding of them. We are especially grateful, too, to Dr. Eugene Farrell, head of the Analytic Laboratory for analytic work, tests and advice, as well as to his colleague, Richard Newman, now at the Museum of Fine Arts Research Laboratory.

For many courtesies extended beyond the call of duty, we thank the photographers of the Harvard University Art Museums' Photographic Services Department—Michael Nedzweski and Richard Stafford, as well as Martha Heintz and Elizabeth Gombosi, past and present administrators of the department. For overcoming great odds and providing photographs of the two Etruscan urns on extended loan to Mount Holyoke College, we are indebted to Wendy Watson, curator at the Mount Holyoke College Art Museum.

For much help in proper reading of Greek and Latin inscriptions and patience in answering epigraphical and historical questions, we owe a lasting debt of gratitude to Professors Herbert Bloch, John Bodell, Sterling Dow, and Mason Hammond. We also give great thanks to our colleague, Professor Caroline Houser for her astute observations and especially for her suggestion that the newly constructed Sackler galleries include, in addition to the skylights, a side window, specifically designed to provide the magnificent statue of Meleager with the natural light that is so important for appreciating and understanding Greek sculpture in the round.

In any museum's operation, the registrar's staff serves a crucial role in locating objects and facilitating their movement inside and outside the confines of the museum. For constant help in these and in many other ways, we are grateful to Jane Montgomery, Maureen Donovan, Andrea Notman, Rachel Vargas, and Betsy Weyburn for almost daily cooperation.

Displaying and moving sculpture has enlisted the help of the Exhibitions Department, in particular Kate Eilertsen and her successor Danielle Hanrahan, as well as Joao De Melo, Peter Reichel and Lubosch Cech, whose strong arms and keen minds have moved our sculpture large and small with unfailing safety and care.

In the early states of research and writing of the catalogue the help of Sharron Kenney, Anne Phippen and Beryl Bowen stand out. Without their dedicated involvement and critical eyes the manuscript would be much poorer. We are also deeply indebted to our colleague Aaron Paul of the Ancient Art Department, who for years

has done whatever has needed to be done to advance its writing and production, and to Michael Bennett, who prepared the concordance.

In the production of the manuscript, many have played important roles. Leonie Gordon, formerly executive assistant to the director and Porter Mansfield spent countless hours transforming the initial draft into an advanced working computer print-out that has formed the basis for all subsequent editing and revisions. We are immeasurably indebted to Peter Walsh, director of publications of the Harvard University Art Museums, for his unswerving support and critical guidance in bringing this manuscript to publishable form.

The catalogue was made possible through a grant from the National Endowment for the Arts. We are grateful in this connection to Russell Sana and Sally Zinno, past and present assistant directors of finance and administration at the Harvard University Art Museums for their support and expert financial management, and to their assistants, Anna Coyle, Jeffrey Russian, Martha Lovejoy, and to Landon Hall, grants officer for the Harvard University Art Museums in 1985, who helped us in the grant writing process.

The catalogue could never have been written and produced without the unwavering and constant institutional support provided by past and present directors of the Harvard University Art Museums, Professor John Rosenfield (through October 1985) and Dr. Edgar Peters Bowron (1985 to the present). Their commitment and encouragement has heartened and strengthened all of us throughout the research, writing, and production of the catalogue.

Finally, our lasting debt remains to the late George M. A. Hanfmann, curator of the Ancient Art Department from 1949–1976, who continued his association with the collection until his death. His high scholarly and aesthetic standards and vision of why classical sculpture is indispensable to the training of students of the humanities at Harvard University has left its mark on every part of this catalogue.

David Gordon Mitten
James Loeb Professor of Classical Art and Archaeology
and curator of ancient art

History of the Collections

In 1909, President Eliot invited Edward W. Forbes to become director of the Fogg Art Museum at Harvard University. Addressing the Cambridge Historical Society some three decades later, Forbes found himself reminiscing about his return to Harvard and the Fogg after traveling and teaching abroad. His description of conditions in the old Fogg Museum, until 1927 located in Harvard Yard, included a reference to what he always considered the most important example of ancient sculpture in Harvard's collections:

> The finest among the very few original objects, which had come to the Museum in 1899, was placed in a conspicuous position near the foot of the stairs among the plaster casts. This was the noble Greek statue of Meleager, lent to the Museum and later bequeathed to it by Edith Forbes Webster.[1]

1. Edward W. Forbes, "The Beginnings of the Art Department and of the Fogg Museum of Art at Harvard," *Cambridge Historical Society* 27 (1941): 11.

He would undoubtedly delight in seeing Meleager installed prominently in the Arthur M. Sackler Museum, the hero's elegant features bathed in the natural light that so favors marble sculpture.

Like so many other titans of his generation, Edward Forbes learned the history of art at Harvard from Charles Eliot Norton. Such was the influence of his venerable teacher:

> I took his classical course in 1892–1893 and was deeply interested. The only visual impression that I remember having received (since Professor Norton used practically no illustrations) was from a visit to the Museum of Fine Arts in Boston, where I went one day obeying his instructions. All that sticks in my mind is a long dismal row of plaster casts of Greek and Roman heads. But at the end of the year I went over with a younger brother to join the rest of my family in England. On the first afternoon in London one of my older brothers invited his three younger brothers to go to Paul Boynton's World Wide Water Show. I said, "No, thank you. I cannot wait a minute longer," and took a hansom cab to the British Museum to see the Parthenon marbles.[2]

2. Ibid., 5.

Following his graduation from Harvard in the class of 1895, Forbes continued to study art first hand in England and on the Continent, and he also began collecting Greek sculpture and early Italian paintings, chiefly with the help of Richard Norton, then a professor at the American Academy in Rome. Many of these objects he acquired with the intention of giving or lending to Harvard. The 1895 opening of the original Fogg Museum in Hunt Hall, a small, neo-Roman building designed by Richard Hunt, lent a focus for such gifts; it inspired him as well to solicit family donations and subscriptions from fellow Harvardians.

Edward Forbes's first two gifts to the Fogg Museum in 1899 were remarkable in that they typify what a university's classical collection should comprise. The sections of an Antonine Amazon sarcophagus from Smyrna (no. 121) offer one of the finest examples of Attic art in the age after Hadrian; and while the smallish female head from Greece (no. 60) was seen at that time as an ideal Graeco-Roman creation in the Hellenistic tradition, if today it is considered a hermaphrodite, it is no less appreciated.

In 1900, he discovered through Richard Norton that the Barone Barracco in Rome was willing to sell "a statue of Aphrodite, or a divine female such as a nymph" (no. 34). A major subscription drive to acquire the statue was directed at every member of Forbes's Harvard class in 1895. The final list of donors was impressive, and the statue quickly became a standard item for display in the classical galleries and corridors of the Fogg. Its Praxitelean beauty was such that it hardly mattered that the statue turned out to be a Graeco-Roman copy after an early Hellenistic original.

While continuing to rely on the advice of Richard Norton by letter or on his trips to Europe, Forbes had a circle of eminent acquaintances, later colleagues, in Cambridge whom he could consult about collecting. Edward Robinson succeeded Charles Eliot Norton as Professor of Ancient Art until 1902 when he turned to a museum career in Boston and New York. George H. Chase began his forty-four-year career as teacher of Classical Art at Harvard. After 1927 when the present Fogg Museum of Art building opened, both teaching and curating took place in vastly improved surroundings. George M. A. Hanfmann filled the position of teacher, as well as that of curator of the growing ancient collection, during the last two decades of Edward Forbes's busy life. Chandler R. Post lectured on Renaissance art and Greek literature, and wrote on sculpture through the ages (in collaboration with Professor Chase) during the earlier decades, and Frederick R. Grace taught at the Fogg in the 1930s, until World War II and his death on active duty.

The "Ponsonby Head," exhibited and published in Victorian London, was given by Mr. Forbes in 1905, together with another Roman head in the high classical tradition (nos. 93, 94). The former is renowned for exemplifying the way in which the Romans, at the height of the empire, viewed their subjugated provinces. The second head can well stand reappreciation as a Roman cult-image based on models going back through Hellenistic art to the world of Pheidias.

In 1903, Forbes was elected a trustee of the Museum of Fine Arts, Boston, which was then at the peak of collecting Greek and Roman art under the inspiration of Edward Perry Warren and John Marshall. Forbes made important gifts of sculpture to the Museum of Fine Arts as well, among them the famous Augustus, still known

as the Forbes Head, and the Graeco-Roman head of a goddess, from Alexandria (BMFA 06.1873, 07.487).

Some of the works Mr. Forbes admired most for their expression of the Grecian spirit have remained monuments in the Fogg's collection: the Polykleitan "Narcissus" or boy victor (no. 19) and, of course, the Meleager (no. 30). Other marbles, considered noteworthy during his era, have proven less important by research over time: the marble lekythos from an Attic cemetery, acquired from old Italian collections and given by Mrs. Edward M. Cary, Edward Forbes's aunt (no. 23); the Attic grave stele with its old nurse on the left recut to make a man (no. 25); and the large red-stone head of a goddess from a vineyard at Porta Salaria, Rome, an impressive sculpture that must have been created for sale to foreign connoisseurs (no. 156).

Other marbles received scant attention when they were acquired but have gained in significance in recent times. Such is the case with the early Hellenistic votive relief from Athens (no. 42), showing the Macedonian prince or king Demetrios Poliorketes on horseback. The Palmyrene sepulchral relief of a lady flanked by two children (no. 149), which was given in 1908 by Forbes, Richard Norton, and a friend and fellow painter Alden Sampson, has proven to be one of the most important Syrian imperial portrait-reliefs in America. In addition, the fragmentary Palmyrene head (no. 154), seemingly of a man, which Mr. Forbes presented to the Fogg near the end of his life, stands as a symbol of his longtime interest in the arts lying between Greece and Egypt.

Professor Paul J. Sachs, who came to the Fogg Museum as assistant director in 1915 and guided the Department of Fine Arts for many years as chairman, also donated important Graeco-Roman sculptures, although his greatest fame lies with his collection of master drawings. The head of a young divinity, hero, or athlete, given in 1922, seems to be a Julio-Claudian copy of a prototype created in the first half of the fourth century B.C. (no. 20). The Roman copy of the lost Greek original of about 425 B.C. known as the Ares Borghese, a gift of Professor and Mrs. Paul Sachs in 1956, is one of the most powerful statuary fragments in America (no. 17). In 1926, he purchased a pilaster capital from a dealer in Rome; at the time, this gift was said to have derived from the Ara Pacis Augustae (no. 111).

Individuals famous for other endeavors found works of Greek and Roman sculpture for the Fogg Museum. In 1913, Edward Perry Warren gave a magnificent fragment of a likeness of an Asiatic warrior, a barbarian, or a giant, a Roman copy of a work in the best Hellenistic baroque traditions of Pergamon (no. 46). The great Harvard historian and teacher, Albert Bushnell Hart, donated a fragment of a Byzantine stele or tombstone found on the slope of the

Acropolis in Athens (no. 80), and two small marble heads of goddesses or personifications in the fifth and fourth century styles were presented by President Lowell in 1933 (nos. 39, 54).

Amid other gifts, bequests, and purchases, there were instances when the Fogg Museum received large groups of sculptures in stone. In 1920 and 1924, the Misses Norton, daughters of Charles Eliot Norton and sisters of Richard, gave the museum numerous small sculptures that their father and brother had collected over the years. Some are of minor importance, while others warrant considerable study; all fall into the category of marbles most useful for teaching and study in a department of ancient art. The 1932 gift of Dr. Harris Kennedy was significant for its group of interesting Roman sculptures, including some parts of late Etruscan urns.

Prof. George M. A. Hanfmann as curator, in concert with Prof. John P. Coolidge as director, used the relatively limited resources of the Alpheus Hyatt Fund to buy a large group of Roman, Late Antique, and medieval sculptures and architectural fragments at the Joseph Brummer Sale in 1949. The same team, working in the traditions of Messrs. Forbes and Sachs, arranged the 1960 bequest from Professor Hanfmann's teacher and friend, David M. Robinson. Professor Robinson also left a fund for the acquisition of ancient art. The Sleeping Eros (no. 49) and the relief of Hermes with the Infant Dionysos (no. 95) are random examples of major sculptures acquired from this income. Professor Hanfmann's successor, David Gordon Mitten, the James Loeb Professor of Classical Art and Archaeology, has continued the policy of acquiring Greek, Etruscan, Roman, and Late Antique works in stone, as well as in other materials, courtesy of the David M. Robinson and Marian Phinney Funds.

While many names from the past deserve mention in connection with this collection, George Hanfmann deserves final and special recognition. Acquisitions of Professor Hanfmann's three decades of curatorship have been mentioned. What deserves notice is how much the collection as a whole reflects the attention to details of scholarship with each and every object. Professor Hanfmann encouraged generations of students to write papers and publish articles about individual pieces.

The files for objects are full of his notations and the results of his readings or his discussions with scholars from near and far who visited the galleries and storerooms of the Fogg Museum. In more ways than the public records show, the work contained here is a monument to the fact that George Hanfmann brought ancient art at Harvard to a level equal to that of any museum in the world.

Note to the Catalogue

In his 1929 *Catalogue of the Ancient Marbles at Ince Blundell Hall,* Bernard Ashmole described and included photographs of every one of the hundreds of sculptures around the house, outbuildings, and the park. He omitted only photographs of several Roman theater masks high up on the outside wall of the so-called Pantheon. As he related twenty years later, one of these masks proved to be a key sculpture in T. B. L. Webster's studies of the Greek theater in art and archaeology. Professor Ashmole's message was clear: a catalogue must include text and pictures for every object, regardless of seeming importance at the time.

A number of excellent catalogues have appeared in the United States in recent decades. B. S. Ridgway's 1972 *Classical Sculpture* in the Museum of the Rhode Island School of Design, Providence, offers a very comprehensive treatment of a relatively small number of masterpieces of all types (55, including the sculptures of questionable authenticity), acquired over several generations with taste and selectivity. Ellen Reeder Williams's 1984 *The Archaeological Collection of the Johns Hopkins University,* Baltimore, offers another model catalogue of 137 classical objects of all types, from stone sculptures to a Roman mosaic. The Harvard University Art Museums' *Stone Sculptures* comprises nearly 160 statues, heads, torsos, fragments, reliefs, stelai, sarcophagi, and selected sections of architecture.

Naturally, the entries are uneven in length. The masterpieces, from the *Veiled Head of a Woman* (no. 28, part of a large Attic funerary monument of about 320 B.C.) to the *Cuirassed Statue of the Emperor Trajan* (no. 138, A.D. 117), invited longer texts and often, as expected, have fuller bibliographies. Some enigmatic sculptures, such as the *Head of a Bearded God* (no. 86), of about A.D. 150–175, have suggested documentation in fuller detail, with alternative parallels. Because these sculptures are the basis of a collection designed for instruction as much as exhibition, it is hoped future generations of students will take these entries, long and short, as starting points for papers, articles, and monographs.

Divisions are always somewhat arbitrary. In the fifth, fourth, and Hellenistic centuries, originals and copies seem best placed together because we view Polykleitos in his High Classical frame, although virtually everything that survives is a Graeco-Roman copy or derivation. There is not enough Etruscan sculpture to form a

special section. Thus the *Sphinx from a Tomb* (no. 10, about 540 B.C.), fits in the Archaic section, while the Etruscan and Roman Republic (Italic) urns are treated as the forerunners of Roman cineraria and sarcophagi.

Finally, we should remember that a comprehensive catalogue is like an elephant among the blind sages of China. Each user seeks different information and will probably come away with different conclusions. The best that can be achieved in an undertaking such as this is to present everything in such a way that the resources available can be put to best possible use in the future.

Prehistoric and Archaic

The collections of Cycladic and Archaic sculptures consist mainly of study pieces, the Bronze Age marbles being mostly fragmentary and the figures classed as Archaic containing heads and statues (notably the volcanic stone group) that have been published in at least one monograph as forgeries. The most impressive marble is the Late Archaic Ionian fragment of a figure in high relief, from a monument probably never finished owing to the Persian Wars (no. 11). The grandest statue in volcanic stone (nenfro) is the Etruscan sphinx of about 535 B.C. (no. 10), undoubtedly one of a pair or a set that must have adorned the dromos or lintel of a tomb in the region of Vulci. The late Daedalic head of a woman from Cyprus (no. 9), work of about 545 B.C., is a rare example of the island's pre-Ionian style in monumental limestone. It is in terrible condition, but what remains shows evidence of great beauty and power.

Among the "cliffhangers," the helmeted head of 510–500 B.C. (no. 14) was said to have been found near Aphaia's temple on Aegina, but in reality can at best be Cypriote work of the type found around Idalion. The collection of sculpture at the Museum of Fine Arts, Boston, has the parallel example of the famous Archaic head of a woman (Kore), said to have been found at Sikyon on the northern coast of the Peloponnesus but surely brought from the region of Salamis-Enkomi on the eastern coast of Cyprus.

Head

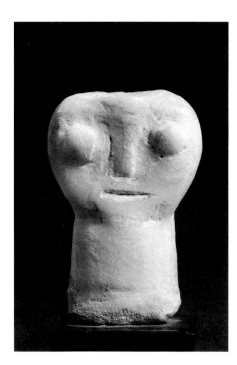

ca. 2400 B.C.
Marble, H. 0.065 m

There are a few brown stains on the back.
The area around the even break across the
base of the neck is chipped. The very top of
the head was once restored in plaster.

The head is almost round and rises
from the elongated, tubular neck.
The entire profile is flat and two-
dimensional. The eyes are large and
bulbous, and the nose is indicated
by both modeling and incision. The
mouth is incised. Two diagonal
indentations between the round part
of the face and the neck are
intended to suggest the chin.

The crudeness of this head
might speak of the transition from
the end of the Stone Age to the early
Bronze Age in Helladic, Cycladic, or
western Anatolian lands. It might
also speak of something later but
rustic in style and origin, rather
than some work of the Christian
Dark Ages or a modern villager's
idea of what Early Cycladic art
should be. Compare this with the
unusual male (?) head published in a
Basel collection and its documented
parallels, although the latter has a
triangular face, ending with a very
pointed chin (Thimme, Getz-Pre-
ziosi, 1977, pp. 234, 440–441, no.
76). The Fogg head conforms more
to the shape of a head of unknown
provenance published in a German
private collection (Thimme, Getz-
Preziosi, 1977, pp. 283, 479, no.
210).

P. Getz-Preziosi indicates that
this head went through a transfor-
mation from torso to head and neck
in Cycladic (Bronze Age) times, but
there remains the possibility, seen in
crude cutting beside the "nose" and
the slightly fresh gash of the
"mouth," that this fragment was
reworked in later times. A brown
stone head found at Corinth in
1901 shows the timeless qualities of
such rustic endeavors (Johnson,
1931, p. 6, no. 3).

Published: Getz-Preziosi, 1987, pp. 82–83,
fig. 45: the Norton head as a reworked EC II
torso of the Spedos variety.

Gift of the Misses Norton, 1920.44.201

Torso of a Statuette

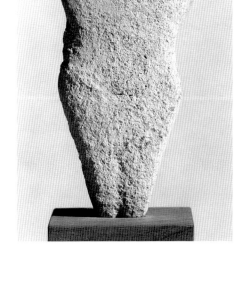

2500–2000 B.C.
Marble, H. 0.10 m

Marble of poor quality. The head and legs (at the feet) are broken away. There is no indication of arms. A groove runs between the legs, visible at the back and front.

Flat and violin-shaped, but not a "violin idol" since it has legs and a head, this torso has been termed Early Cycladic. The arms are roughly indicated by a horizontal groove as being held across the front of the body. It appears to be an idol of what is now termed the Spedos variety (Thimme, Getz-Preziosi, 1977, pp. 270, 469, nos. 169, 170).

In an age where there are so many spectacular, beautifully polished or patinated forgeries of so-called Cycladic idols, the condition of the statuette and its style, as well as publication by the foremost scholar on the subject, all insure its authenticity (and the genuineness of similar survivors).

In modern museum installations the standard Cycladic statuettes are always shown as standing, but their poses, even when complete from head to toe, suggest they were made to be shown stretched out on a flat surface, as if laid out for a "wake." To be sure, the flutists, the seated harpers, and the paired figures supporting a third, smaller image between them are rarer illustrations of standing and seated postures, but the awkward construction of most "idols" is not a sign of primitivism but a product of ritual uses. Since the giant statuettes, almost statues, were broken across the bottoms of the neck and the legs at the knees for placing in small, rectangular tombs, the figures were clearly created for some other purpose and afterward interred with the deceased (Vermeule, C., 1971, pp. 37–38, fig. 46; Vermeule, E., 1964, pp. 56–58). They were not gods, goddesses, or votaries, like statues on Cyprus from the early archaic period when Near Eastern influence was at its height onward, since they are not found in shrines. It seems logical, therefore, that they played a part in ceremonies of passage to another life and were then laid in tombs as they had been laid out ceremonially above ground.[1]

Published: Fogg Museum, 1961, p. 26, no. 199; Getz-Preziosi, 1966, pp. 105–111, pls. 27–32, p. 107, pl. 28, figs. 3–5.

1. All types, standing, seated, and in groups, of Cycladic figures and related artifacts are considered with chronological charts and proportional drawings, etc., by Getz-Preziosi, 1985.

Bequest of David Moore Robinson, 1960.455

3 Cycladic

Figurine of a Woman

2500–2000 B.C.
Translucent Parian marble, H. 0.117 m

There is slight incrustation on the right side of the face and neck, and the back is covered with a thick layer of lime deposit.

The left arm is crossed above the right at a strong angle. A break at the base of the neck has been mended. The breasts and arms are modeled, while the lines from the lower torso to between the legs are separated by incision.

This small figure has been identified as Early Cycladic. High, square shoulders and relatively stubby legs characterize the frontal view. Professor Olaf Hockmann (in a letter dated Oct. 26, 1978) has compared this figurine, a relatively late type, to one once in the Walpole collection "From Attica." (Walpole, R. A., *Memoirs Relating to European and Asiatic Turkey* London: 1817, pp. 541–542, illus.) P. Getz-Preziosi likened the statuette to a slightly cruder statuette in the Museum of Fine Arts, Boston (Comstock, Vermeule, 1976, p. 4, no. 5 [61.1089]; Thimme, Getz-Preziosi, 1977, p. 289, no. 228, p. 484).

Published: Robinson, 1955, p. 19, pl. 11, fig. 1a, b; Fogg Museum, 1961, p. 26, no. 200; Getz-Preziosi, 1966, p. 108, pl. 29, fig. 9; Chapel Arts Center, 1970, p. 33, no. 15, fig. p. 13; Getz-Preziosi, 1987, p. 226, no. 68, fig. 68 a & b.

Bequest of David Moore Robinson, 1960.447

4 Cycladic

Head

2500–2000 B.C.
Parian (?) marble, H. 0.118 m

There is a horizontal break across the face. The end of the nose, part of the left cheek, and part of the back of the head are missing. Otherwise, the surface is in good condition.

This fragment from a statuette or, technically, a small statue, has flat contours and a pyramidal nose in relief. It came from a female figure of developed type. The size of this head made the complete figure more unusual than the other, smaller statuettes in the Robinson-Harvard collections.

Published: Fogg Museum, 1961, p. 26, no. 201; Getz-Preziosi, 1966, pp. 110–111, pl. 32, figs. 23–25.

Bequest of David Moore Robinson, 1960.452.

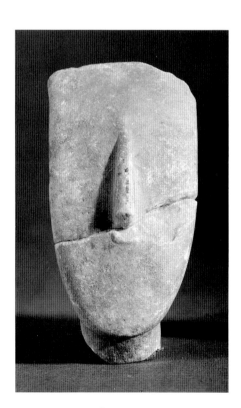

5 Cycladic

Head

(top left)
2500–2000 B.C.
Marble, H. 0.036 m

The nose, small and turning toward the rectangular, is in low relief and is worn.

This fragment from a statuette has flat contours and a pyramidal nose in relief. The head, which is pear-shaped, probably belonged to a female figure of normal, developed type. Traces of the eyes and mouth are visible in raking light.

Published: Fogg Museum, 1961, p. 26, no. 202; Getz-Preziosi, 1966, p. 110, pls. 30–31, figs. 17–19.

Bequest of David Moore Robinson, 1960.454

6 Cycladic

Head

(lower left)
2500–2000 B.C.
Dolomitic marble, H. 0.049 m

The body and part of the neck are missing. The surface is worn and lightly incrusted.

This fragment from a statuette has flat contours and a pyramidal nose in relief. The head is nearly rectangular. The mouth is indicated by a short groove, and the eyes by narrow depressions. The neck is set back from the face, giving the head a shallow chin.

The closest parallels for this head are to be found in two marble idols from Aghios Kosmas, which combine the amorphous and the anthropormorphic Cycladic types. Idols of this general type are known from both the Greek mainland and the Cyclades (Mylonas, 1959, xv, fig. 163).

Published: Fogg Museum, 1961, p. 26, no. 203; Getz-Preziosi, 1966, pp. 107–108, pl. 28, figs. 6–8.

Bequest of David Moore Robinson, 1960.453

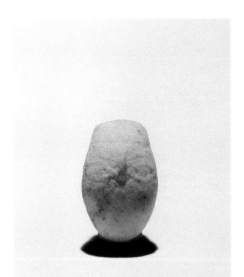

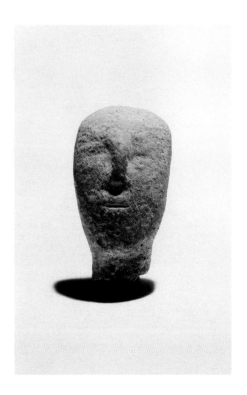

7 Cycladic

Bowl

(lower left)
2500–2000 B.C.
Grayish marble, H. 0.045 m, Diam. 0.137 m

One side of bowl has been cracked in numerous fragments and repaired.

This kind of simple bowl without feet, handles, or lugs is the shape most frequently executed in marble during the Early Cycladic period. In the majority of examples, as here, the rim is slightly rounded and set off on the interior by means of a shallow groove. There are many examples in various sizes and proportions, thirty such bowls being recorded in a private collection in Athens; Museum of Fine Arts, Boston, no. 1962.180, is of similar dimensions. The bowl found on Thera with the two Karlsruhe harpers seems related, if more elegant (Thimme, Getz-Preziosi, 1977, pp. 318, 508, no. 299). For a complete discussion of the chronology of these bowls see Getz-Preziosi, 1987, pp. 67–74.

Published: Fogg Museum, 1961, p. 26, no. 204; Getz-Preziosi, 1966, p. 111, no. 10, pl. 27, fig. 26.

Bequest of David Moore Robinson, 1960.461

8 Cycladic

Bowl

(lower right)
2700–2200 B.C.
Grayish marble, H. 0.053 m, DIAM. 0.129 m

The bowl is complete, with traces of a brown incrustation on the interior and exterior surfaces.

The molding of the rim or lip of this bowl is well rounded, and the overall appearance of the object would seem to place it late in the sequence of Cycladic bowls (Getz-Preziosi, 1987, p. 304, no. 126).

Unpublished.

Bequest of Marian H. Phinney, 1962.70

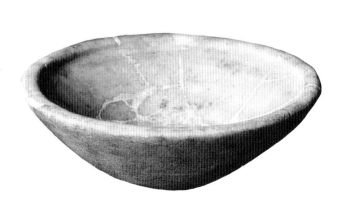

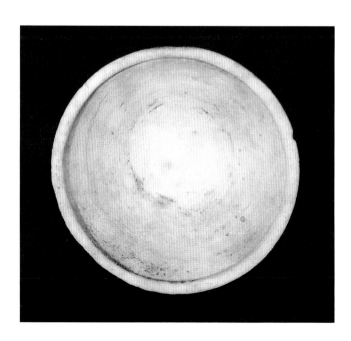

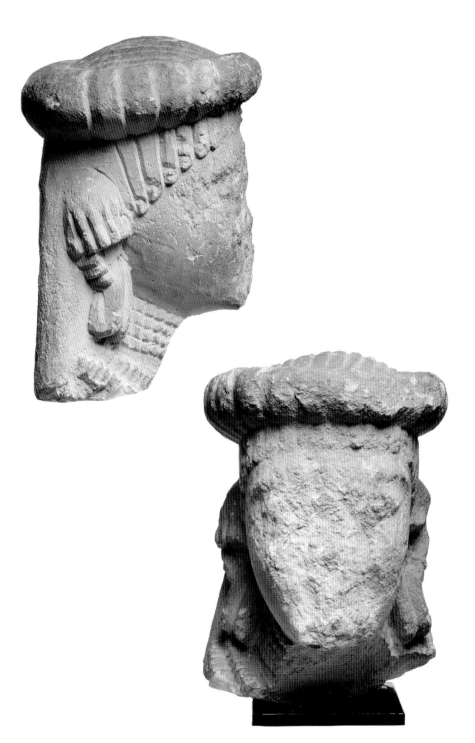

Head of a Woman in the Late Daedalic, Pre-Ionian Style

ca. 550–540 B.C.
Limestone, H. 0.235 m

The face is greatly damaged; likewise but less so, the turbaned headdress and (lower) front of the neck.

The head came from a statue. The stone and the parallels with turbaned terracottas from the temple site at Arsos suggest that the head came from this area (Porphyrios Dikaios, note in object file, January 1953).

 Her cloth turban is drawn tightly over the rolls of hair around the crown of her head, revealing strings of stylized curls around the forehead, and loops of hair and braids under it. The cloth falls vertically and simply, without wrinkles, down the back of the head and over the neck, like a British soldier's or a French legionnaire's dustcloth in the period around 1900. What remains of the face shows that she had the large, bulging eyeballs of the Daedalic heads and the hint of an Archaic smile.

 Although a simpler cloth headdress is worn and the face is thinner, this head, especially in the eyes, relates to the upper part of a limestone statue in the Cyprus Museum, from Arsos (Dikaios, 1961, p. 96, pl. XIX, fig. 1). The rolled-turban headdress merged with the Ionian face is a stylistic combination that occurs around 540–530 B.C. (Pryce, 1931, pp. 102–103, Type 30).

Provenance: From the Estate of Joseph Brummer, New York.

Unpublished.

Purchase from the Alpheus Hyatt Fund, 1949.47.142

Sphinx from a Tomb

ca. 540–530 B.C.
Volcanic stone (nenfro), H. 0.533 m;
L. (including restored section): 0.66 m

The center of the body, from next to the start of the major part of the wing, is restored. The surfaces are chipped and pitted, and there are other damages, such as to the nose, which are visible in photographs. Almost all of the legs, save the start of the forelegs, are missing, as is the base that supported the paws.

This statue represents the elegance of high Ionian sculpture translated into an Etruscan material and Etruscan forms of expression. The sphinx's head is turned at right angles to her body. Her hair is parted in the center, and four heavy tresses fall onto her neck and right side from behind her ears. Strong, round fillet moldings delineate the divisions of head and neck, body, and the conventional curving East Greek wings. Like all of these monumental sculptures from Archaic

Etruscan tombs, this sphinx was carved to be viewed from the direction to which the head is turned and to which the body runs at right angles. The other side (left and back of the head) was finished with much less detail, suggesting that such statues were set in pairs along the dromos or over the lintel of a tomb.

While the Etruscan lions and sphinxes with heads facing ahead are free-standing entities, probably set facing each other at the entrances to the tombs, the start of the dromoi, leopards, panthers, hippocamps, and certain other real or mythological creatures share the qualities of paired mirror reversals seen in the sphinxes with heads to right or left. Size determines which surviving sphinx might have been the pendant to the Kelekian-Robinson-Phinney-Fogg statue. One possibility in scale and style is the fragmentary sphinx exhibited on several occasions in the possession of Münzen und Medaillen A. G., Basel, and André Emmerich Gallery, Inc., New York (André Emmerich Gallery, Inc., 1970, no. 35; André Emmerich Gallery, Inc., 1975, no. 37).

Among the comparable Etruscan nenfro sculptures in the Museum of Fine Arts, Boston, the two sphinxes had their faces straight ahead, while the three leopards with head turned right (one) and left (two) were clearly designed to be set on lintels or within the confines of pediments.[1]

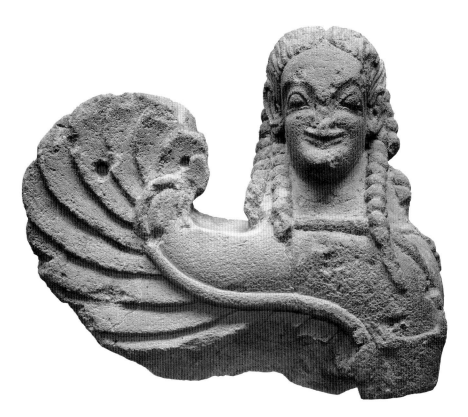

Provenance: From the Kelekian Collection, New York. Presumably from the vicinity of Vulci.

Published: Sotheby Parke Bernet, Sale 5195, New York, June 8, 1984, lot 13, color plate.

1. Comstock, Vermeule, 1976, pp. 251–254, nos. 387–393, with bibliography, in addition to references in the three sales catalogues cited above, on all the Etruscan sculptures in stone published in the late 1950s to the mid 1970s.

Purchase from the David M. Robinson Fund, Marian H. Phinney Fund, and William Hayes Fogg Ancient Art Discretionary Fund, 1984.195

Head of a Kouros in Relief

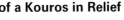

Statue of a Young Man or Boy (Kouros)

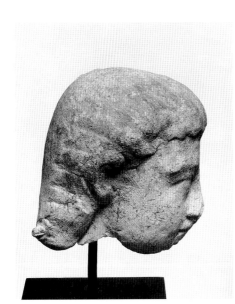

ca. 500 B.C.
Dolomitic marble from Thasos, 0.185 m × 0.158 m

The carving seems to be in unfinished condition. The marble is Dolomitic from Thasos, Saliari area, probably from the Aliki quarries (J. J. Herrmann, Jr.).

This head, in the Ionian style of the Archaic Artemision at Ephesos, comes from a semicircular monument, the drum of a column, or a votive base. Another fragment of the same monument, an East Greek *Kouros* of the Samian style, is in the Museum of Fine Arts, Boston. It is also unfinished (Vermeule, C., January 1971, p. 38, figs. 44–45; Comstock, Vermeule, 1976, p. 15, no. 22, 69.982).

 The presumption is that the monument or group of sculptures to which these heads belonged was left unfinished on account of disturbances connected with the Ionian revolt and the Persian wars.

 On the analogy of the Archaic column drums from the Artemision at Ephesos, around 540 B.C., this head can be seen as coming from a thin, long-garmented figure walking from left to right on the semicircular surface (Boardman, 1978, p. 62, fig. 57; Homann-Wedeking, 1968, pp. 120–121, fig. 25). The head in Boston, however, comes from a plumper figure, akin to the men from the Geneleos base at the Heraion on Samos, dated about 560 B.C. (Homann-Wedeking, 1968, pp. 93–94, fig. 17).

Provenance: Said to have come from Philadelphia in Lydia.

Published: Fogg Museum, 1971, p. 131; Hoffmann, 1971, p. 10, fig. 10; Vermeule, C., 1981, p. 35, no. 10.

Gift of Norbert Schimmel, 1969.175

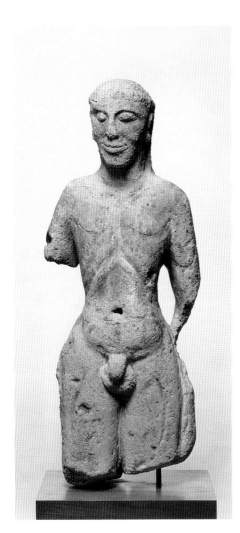

ca. 525 B.C.
Volcanic tuff, H. 0.706 m

The right arm from the middle of the upper arm, the left forearm, and the legs from just above the knees are missing. A break through the waist has been mended.

This small statue has been called "Sikel" sculpture as a way of explaining the awkward style and carving. The face has a strong Archaic smile with a thick lower lip. Something of this regional identification may have been conditioned by the alleged attribution of this and the following statue to inland Sicily. Material and style might better associate them with the art of the Etruscans around 500 B.C., a precise date being difficult to determine because of delayed uses of current late Archaic Greek models by the sculptors of Vulci and surrounding areas.

 Generally speaking, were this statue to have been fashioned in Southern Italy or Sicily, as in the majority of surviving examples, it would have been carved in imported Greek marble or fashioned in terracotta. The kouros from Megara Hyblaea in Geneva was worked from marble quarried on the island of Chios (Schefold, Cahn, 1960, pp. 213–214, no. 234b, dated around 490 B.C.). The earlier, more famous torso from the same region, in the Museo Nazionale, Syracuse, was carved from Parian marble and has a strong resemblance to the statue discussed in the following entry (Schefold, Cahn, 1960, pp. 146, 173, no. 111a).

Published: Fogg Museum, 1961, p. 27, no. 206; Turr, 1984, p. 98, no. E 3.

Bequest of David Moore Robinson, 1960.451

Torso of the Type Identified with Archaic Kouroi

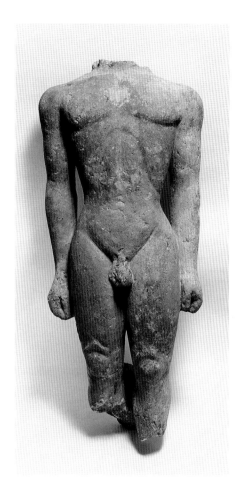

ca. 525 B.C.
Volcanic tuff, H. 1.01 m

This statue bears traces of purple paint on white underpaint. The head and lower legs are missing. There are patches on the chest repaired in plaster.

The forms of the area from the waist to the knees are suggestive of the section of a kouros found in the tumulus of Pietrera at Vetulonia and now in the Archaeological Museum, Florence. It was made of *pietra fetida*, a stone of local nature (Hus, 1961, pp. 30, 127–133, pl. I).

The face of the Robinson kouros with head preserved can be paralleled in the head of a sphinx in the Musée du Louvre, from Vulci, no. 2054 (Hus, 1961, p. 42, no. 11, pl. XXIV), and a double-herm in Florence, no. 73.138, from Orvieto (Hus, 1961, p. 84, no. 1, pl. XXXVII). The first statue is made of nenfro, and the second sculpture is carved in trachyte.

In summation, the increased understanding of local, Archaic sculptures in Etruria suggest that the two Robinson statues, as well as other heretofore unclassified, "rustic" works of Archaic art in rough stones, belong in the "twilight" world (made so by illicit excavation) of Etruria, rather than in any obscure, undocumented Sicilian antiquarian "red herring" of an alleged provenance. In truth, these statues could have been set up in the same way as all the more common Etruscan animals, real and fantastic (leopards, lions, sphinxes, hippocamps, and a centaur), along the dromoi or atop the entrances of Etruscan tombs at Vulci and nearby areas.

Provenance: Said to have been found at Selinunte.

Published: Fogg Museum, 1961, p. 27, no. 205; Turr, 1984, pp. 97–98, no. E 2.

Bequest of David Moore Robinson, 1960.460

Helmeted Head of a Young God, Goddess (Athena?), or Warrior

perhaps ca. 510–500 B.C.
Limestone, H. 0.241 m

The piece is limestone, rather than poor Parian marble as first published. It is corroded, damaged, and weathered, and the nose is partly missing. A portion of the lower part of the chin has been broken and reattached. Some evidence suggests that the head was artificially corroded in a fire. The piece is evidently unfinished.

Material and parallels would suggest that this head came from a monument on the island of Cyprus. There is ample precedent for "upgrading" Cypriote sculpture by supplying provenances in the Peloponnesus or the Aegean islands.

However, if technical evidence is confirmed, this head is a forgery made in the early part of the present century after the sculptures found in the German excavations around the Temple of Aphaia on Aegina.

A group of figures of the young, beardless Herakles, with the lion's skin on the head instead of the helmet, come from the Idalion region of Cyprus and have the same style of hair, face, and eyes, as well as the same Ionian cast to the mouth (Pryce, 1931, pp. 85–87, figs. 139–140). An especially close example, with finely carved eyelids and with a better preserved face emerging from the hero's lion skin cap, was long in the de Clercq collection in Paris and lately in that of Mr. Gilbert Denman, Jr., San Antonio. Its superlative Ionian style dates this head of Herakles about 510 B.C. (Hoffmann, 1970, pp. 8–11, under no. 3).

Provenance: Said by the dealer to have been found near the Temple of Aphaia on the island of Aegina about 1901.

Published: Robinson, 1955, pp. 19–20, pl. 11, figs. 2, 3; Fogg Museum, 1961, p. 27, no. 208; Turr, 1984, pp. 85–88, no. A 26.

Bequest of David Moore Robinson, 1960.448

Greek Fifth and Fourth Centuries:
Originals and Copies

These sculptures represent the best of Greek art, or at least the centuries when the canonical statues by the greatest masters were produced. The free-standing statues (and fragments) are mostly very good copies. The Meleager (no.30) will probably always be the focus of the Greek collection. It is instructive to see that Harvard has two other Meleagers, a head in mirror reversal (no. 31) and a torso (no. 29). Going backward in time, the Polykleitan statue of a youth in repose, traditionally "Narcissus" but more likely Adonis, has been felt to embody all the ethos of the later fifth century (no. 19). It is a perfect statue for a university dedicated to the lofty ideals of American youth.

The reliefs are funerary, with original, Attic stelai and lekythoi occupying center stage. The little girl Melisto with her doll, bird, and furry dog (no. 24) is as charming as the veiled head of a woman (no. 28) of about 320 B.C. is monumental. The bearded head of a young to middle-aged man (no. 22), highly idealized, recalls the frieze of the Parthenon but belongs to the world of Athens when Kephisodotos was creating his statue of "Peace with the Child Wealth" in the conservative, retrospective style of about 380 B.C. An interesting footnote to Athenian sculpture in its passage through Morosini's Venice to Edward Forbes's vision of Harvard is embodied in the multi-figured grave stele (no. 25), about 325 B.C., where a famous scene of a woman's death has a powerful impact despite the recuttings of long ago. Indeed, despite the fortunes and fates of the past, which turned the old nurse or grandmother into a bearded patriarch, the vision of death is so strongly presented in the ideal terms of Athens in the age of Alexander the Great that the stele was the focal point of the exhibition "To Bid Farewell" at the Museum of Art of the Rhode Island School of Design in the spring of 1987.

Edward Forbes also secured the grave lekythos (no. 23), set up in an Attic cemetery about 340 B.C., from the Ferroni family and, ultimately, the Museo Nani in Venice. The scene in relief on the marble vase is a standard one, a family handling their grief in the ideal, poetic fashion of Athenian funerary art before the advent of Alexander the Great and the early Hellenistic age. Finally, original Greek sculpture in the decades of transition from the later High Classical period to the early Hellenistic world is represented by the head of a young girl (no. 27) of the type identified both with the cults of Artemis and with funerary statues in Attica or as far afield as Delphi.

Head of a Young God or Hero

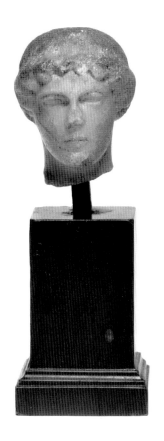

ca. 480 B.C.
Marble, H. 0.039 m

The nose is chipped, and the top of the head is discolored. There are two drill holes above the ears. The hair is arranged in eleven curls around the forehead.

A number of heads of young gods or mortals—including the Apollo of the West Pediment at Olympia, a head in the Volos (Thessaly) Museum, and a head in the Cyrene Museum—are related, although no other has the exact arrangement of the curls around the forehead (Ridgway, 1970, pp. 57–58, figs. 73, 76–77, 80–83). A nearly life-sized head, with a neck probably worked for insertion in a herm, from the Ludwig Pollak and Jacob Hirsch collections, shows how such heads appeared as early Roman imperial copies in marble on a full-sized scale (*Ars Antiqua*, A.G. no. 1, May 2, 1959, pp. 12–13, no. 30, pls. 13, 14).

A life-sized head (albeit damaged, with most of the area above the forehead missing) once seen in the Basel and Zurich art markets would suggest that the tiny head at Harvard probably came from Sicily (André Emmerich Gallery, Inc., 1975). The tiny scale of this head, together with the fact that it is an original rather than a copy, suggests that this statue was carved in Sicily or Southern Italy between the Late Archaic and Transitional periods, a time when good marbles were relatively expensive in Western Greece.

Published: Fogg Museum, 1982, p. 172.

Purchase of David M. Robinson Fund through the Estate of Therese K. Straus, 1979.402

The Hermes Propylaios
of Alkamenes

ca. 27 B.C. to A.D. 14
Marble, H. (of original part) 0.24 m, greatest
depth or thickness 0.185 m

Roman copy of an original (ca. 430 B.C.) cre-
ated for the Acropolis of Athens; fine-grained,
mainland Greek marble. The side-locks were
made separately and attached with dowels.
There is some damage, especially in the hair.
The lower part of the beard and the nose are
restored. A section of the beard below the
mouth is rejoined.

This Hermes has been identified by
inscriptions as a variation on two
groups of sculptures (the Pergamon-
Berlin series and the Ephesos-
Munich-Leningrad series) with the
work of Alkamenes, evidently set up
on the north side of the west façade
of the Propylaia (Richter, 1970, p.
182). This creation has been dated

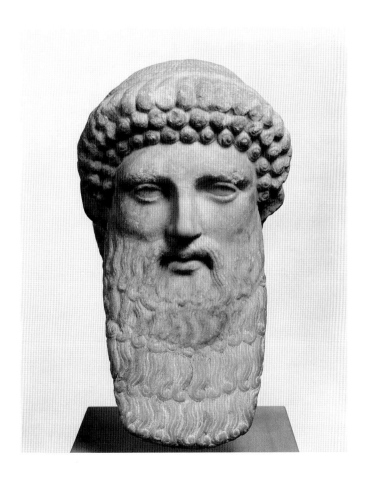

in the time of the Roman emperor
Augustus (27 B.C. to A.D. 14) and
shows the good, lively quality of
such imperial workmanship from
ateliers around Athens itself. A simi-
lar herm formerly in the art market
in Lucerne suggests that here the
beard has been restored with an
extra lower row of curls (*Ars Anti-
qua*, A.G., 1962, p. 13, no. 49, pl.
XVII); another of the Pergamene
type, and with a similar, full beard,
was long in the Villa Mattei in
Rome (Paribeni, E., 1981, pp. 82–
84, no. 2). A herm of the type or
types created by Alkamenes with
such a long, "triple-decker" beard
as restored here would probably
have been confused or conflated
with the bearded, draped Dionysos
"Sardanapallus" identified with a
work of Praxiteles in the fourth cen-
tury B.C. (Johnson, 1931, pp. 33–
34, no. 27).

Such terminal figures or herms,
including busts rather than complete
shafts, were among the *ornamenta*
or furnishings for courtyards and
gardens that Romans of wealth, like
Cicero, imported from Attica and
elsewhere for their town houses and
country villas or estates.[1]

Provenance: Seemingly from the art market
in Athens.

Published: Robinson, 1955, p. 22, pl. 13, fig.
10; Fogg Museum, 1961, pp. 27–28, no. 215;
McCredie, 1962, pp. 187–188, pl. 56, figs. 1,
2; Vermeule, Cahn, Hadley, 1977, p. 32,
under no. 41.

1. These ideas are stated more fully in con-
nection with a herm head of generally
Alkamenean type (part of a double herm?) in
Baltimore: Williams, 1984, pp. 25–26, under
no. 13.

Bequest of David Moore Robinson, 1960.463

Head of Ares

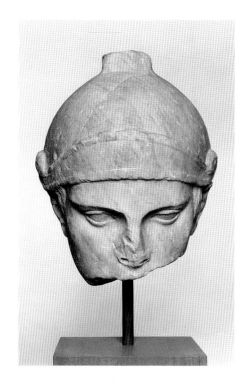

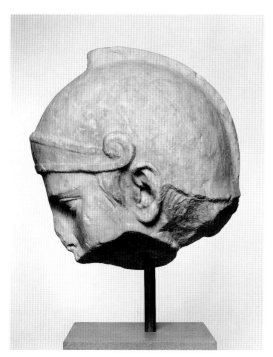

ca. A.D. 110
Hymettan marble, H. 0.32 m

The end of the nose and all of the head on a diagonal line through the upper lip are broken away. The back of the head and helmet are missing from behind the right ear.

This head is a Roman copy of an original of ca. 430–420 B.C., known as the Ares Borghese. The head is wearing an Attic helmet with visor and rudimentary crest. The roughened yet cold surfaces and the drill points at the inner corners of the pupils of the eyes date this copy in the Trajanic period, ca. A.D. 110.

Replicas of the Ares Borghese, associated with Alkamenes about 420 B.C., are discussed in connection with the statue found in Building M at Side in 1950 (Inan, 1975, pp. 47–50, no. 10, pl. XXII; Inan, 1975a, pp. 69–71, no. 1). The fact that the statue has been found in decorative and official contexts at a wide variety of locations around the Graeco-Roman world, from Italy to Asia Minor and North Africa, shows that the original was famous, certainly attributable to one of the major masters working in Athens a decade or so after the Parthenon was finished (Picard, 1939, II, 1, p. 250, II, 2, pp. 578–580, fig. 237 Louvre).

The complete statue, showing the god or a young hero in divine guise, may have been made for the cults of Ares expanded in Attica as a result of the Peloponnesian Wars. The slender, athletic figure stands with weight on the left leg, left hip thrown out, right arm and hand lowered to the side, and left arm flexed with hand grasping the spear. The figure takes its name from the marble copy in the Louvre, Paris, which came from the Borghese collection in Rome (Fuchs, 1969, pp. 94–96, fig. 86).

Jenifer Neils has recently suggested that the Ares Borghese may be a statue of Theseus on the basis of three characteristics: hairstyle, ankleband and stance (Neils, 1988, pp. 155–158).

Published: Fogg Museum, December 1921, pp. 3–6; Deane, 1922, p. 204, fig. 1; Chase, 1924, p. 71, fig. 81; Philippart, 1928, p. 41; Fraser, 1925, pp. 314–320, figs. 1, 2; Hanfmann, 1950a, p. 14, no. 36 with bibliography; Hanfmann, 1950, no. 180; Fogg Museum, 1965, p. 199, list; Dohrn, 1975, pp. 67–69, pl. 1c; Hanfmann, Mitten, May 1978, p. 364, note 9; Beck, 1984, p. 110, note 399, p. 131, note 484.

Gift of Meta and Paul J. Sachs Collection, 1956.9

Head of a Female Figure

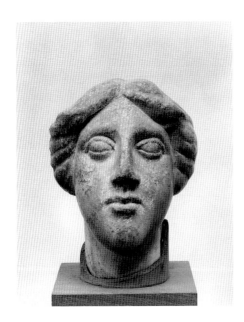

first century or first half of second
century A.D.
Marble, H. 0.15 m

The nose is rubbed, and there are surface
scratches around the mouth, eyes, and
forehead.

The head is of a woman with her
hair drawn up in back, forming a
chignon; she is wearing a fillet. The
head may have been part of a votive
or funerary statue of small dimen-
sions, or its frontality could make it
part of an architectural ensemble,
such as a balustrade.

The facial type points to a pro-
vincial style of the fifth century B.C.
Small, provincial heads of divinities
and others from Egypt or Cyprus
(Comstock, Vermeule, 1976, p.
121, no. 185), from mainland
Greece or the Aegean islands (Com-
stock, Vermeule, 1976, p. 122, no.
188), and from Asia Minor by way
of Istanbul, of the divinities Mên or
Attis (Comstock, Vermeule, 1976,
p. 143, no. 229) show the same
large eyes outlined by simple, heavy
lids, summary hair in a retrospective
style, compressed lips, and direct,
unemotional frontality.

Whatever its antecedents, this
head appears to have been carved in
the Roman Imperial period, proba-
bly in Asia Minor some time during
the first century or first half of the
second. Simple though they may be,
and of indifferent quality in terms
of Greek sculpture of the fifth cen-
tury B.C. through the Hellenistic
age, heads such as this provide a
bridge to the Late Antique, proto-
Byzantine statues and reliefs in the
Greek Imperial world.

Published: Fogg Museum, 1961, p. 27,
no. 209.

Bequest of David Moore Robinson, 1960.456

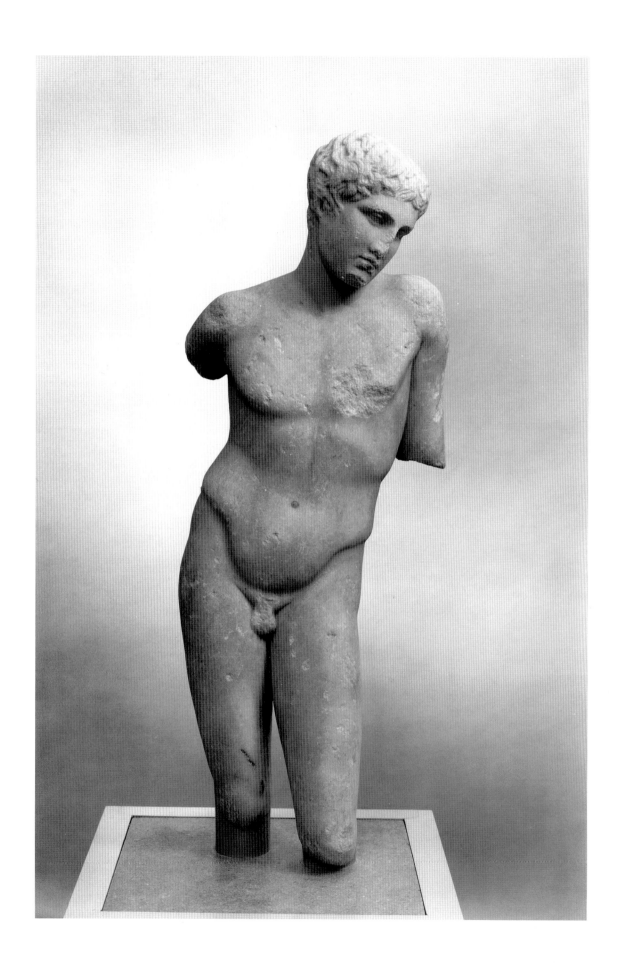

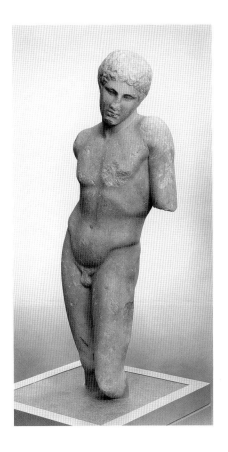

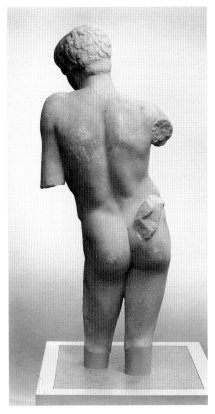

Statue of a Young Athlete in Repose

Roman copy of a Greek original,
ca. 430 B.C.
Parian marble, H. 0.838 m

The nose, arms from below the shoulders, and legs from below the knees are missing. There are small surface chips all over but especially on the chin, shoulders, and chest. There are remains of the right hand as it joined the right hip at the back. There are brown stains on the back. The neck was first restored, early in 1903, by Bela Lyon Pratt. It was cleaned and reset at the Fogg Museum's Center for Conservation and Technical Studies in 1966–1967.

This statue is a copy of the type thought to have been a funerary monument of a boy victor, in the tradition of Polykleitos. These figures have been known from Neo-Classic times onward as Narcissus, from the pose that appears on Graeco-Roman gems and pastes. Dorothea Arnold has dated this particular excellent and very Greek copy in the Hadrianic period (Arnold, 1969, p. 255, no. 16). The original statue, doubtless in bronze, could have been a very late work of Polykleitos, in the 430s B.C., or a creation by a follower, or a statue by a sculptor of the first century B.C. who revived the master's style.

There are also those who point to the fact that one of the copies has wings in the hair, indicating identification as Hermes or Hypnos. Because an idol of Aphrodite is occasionally part of the support and because copies, as well as representations on gems, show the attributes of a hunter, including the boar's head, Adonis has been suggested as the subject (Blanco, 1957, p. 84, under no. 124-E, pl. LXXIV).

A Graeco-Roman marble copy with an ancient and belonging boar's head as part of the tree-trunk support (on top, below the youth's elbow) has long stood in the Italian Renaissance gardens of Isabella Stewart Gardner's country estate at Green Hill in Brookline, Massachusetts. In November 1986, the current owner of this portion of the gardens, Mr. William Binnie, presented this statue and other former Gardner marbles from around the property to the Isabella Stewart Gardner Museum at Fenway Court in Boston. This statue certainly came from Italy in the nineteenth century and was probably restored by Bartolommeo Cavaceppi in the eighteenth century. It confirms that other copies of the Polykleitan boy victor ("Narcissus") where the antiquity of the boar's head has been questioned, as the copy at Holkham Hall in Norfolk, England (Arnold, 1969, p. 258, no. 35; Waywell, 1978, p. 8, no. 20; Vermeule, C., von Bothmer, D., 1959, pp. 153–154), were clearly based on ancient sculptural models, as well as on Graeco-Roman gems. Many have called these versions of the youth Meleager, but (aside from the connections with Aphrodite mentioned above) the slender figure seems better suited to Adonis, especially when the statue is compared with the copies of the Meleager of Skopas.

Provenance: From the S. Pozzi collection, Paris. Brought to Scotland from Megara. From the collection of Ludwig Pollak in Rome. Acquired through Richard Norton.

Published: Philippart, 1928, p. 41; Reinach, 1897–1930, IV, p. 56, no. 2; Strong, 1903, p. 14, no. 13, pl. 13; Furtwängler, 1905, p. 280; Chase, 1924, pp. 63f., fig. 68; Hanfmann, 1950, no. 182; Arnold, 1969, pp. 54–60, 82, 83–84, 255, no. 16 in list; Vermeule, C., 1969, no. 15; Fogg Museum, 1971a, The Checklist, p. 150; Hanfmann, Mitten, May 1978, p. 364, note 10; Vermeule, C., 1981, p. 59, no. 32; J. Chai, "The Fogg Narcissus," paper in D. G. Mitten's Classical Archaeology 241r, March 7, 1980, 19 pp. and illus.; Merkel Guldan, 1988, pp. 130–131, n. 43, p. 186, nn. 273–274, fig. 15.

Gift of Edward W. Forbes, 1902.10

Head of a Young Divinity, Hero, or Athlete

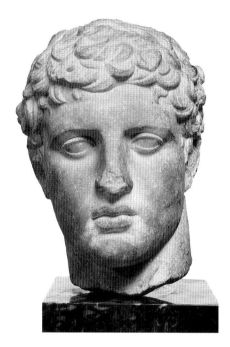

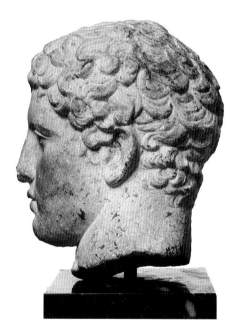

ca. A.D. 50
Thasian marble, H. 0.285 m

The head is turned very slightly to its left. The tip of the nose is broken away, and there is a chip above the break at the front of the neck. The hair, treated in heavy, "bear's-tooth" locks, has been cleaned of root marks, traces of which survive on all surfaces.

The prototype belongs to the period about 400 to 350 B.C. This copy would seem to date in the Julio-Claudian period, perhaps about A.D. 50. Most critics have treated this head as if it were a Greek original, part of an athletic or divine statue leading to the world of the Hermes of Praxiteles. Scholars who have questioned the head's authenticity have generally looked to the cleaned qualities of the surfaces and the shiny, heavily crystalline qualities of the marble from the island of Thasos. The head is most likely an early Imperial copy or adaptation of a statue, probably in bronze, of which few other versions have surfaced.

A. W. Lawrence wrote that this splendid head "has a forcefulness unknown in the fifth century, the result of minor innovations in the treatment of details; the lower part of the forehead bulges rather more, the inner corners of the eyes are more deeply set and the eyes themselves are narrower. It is, however, an unpleasant expression that results from the attempt to gain intensity of gaze by these means" (Lawrence, 1972, p. 182).

A head exhibited at the Royal Academy, Burlington House, when in the collection of Colonel F. Beddington, was published as a carving of about 150 B.C. in the school or wider circle of Lysippos. This athlete, with the swollen ear of a boxer, must be a Julio-Claudian copy of some statue set up late in the fourth century B.C. The head is not a replica of, only a parallel to, the Sachs athlete at Harvard, but it shows how and from what traditions such variations on Greek athletic art of the fourth century B.C. could survive (Chittenden, Seltman, 1947, p. 37, no. 165, pl. 53).

Provenance: The head was bought in Paris (Alphonse Kann).

Published: Fogg Museum, December 1921, pp. 6ff., figs. 4, 5; Deane, 1922, pp. 204f., fig. 2; Chase, 1924, p. 97, fig. 113; Fraser, 1925, pp. 70–75, fig. 1, pl. 2; Lawrence, 1929, pp. 241–242, pl. 78b; Fogg Museum, 1936, p. 11, illus.; Robinson, 1939, pp. 261–262; Hanfmann, 1950a, p. 14, no. 37; Fogg Museum, 1965, no. 83, illus.; Lawrence, 1972, p. 182, pl. 46a; Turr, 1984, pp. 151–152, no. K 25.

Gift of Paul J. Sachs, 1922.171

Head of a Woman

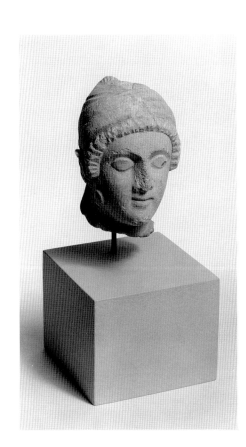

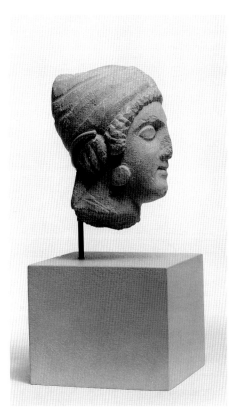

ca. 400 B.C. (or up to a century later)
Limestone, H. 0.09 m

The fragment is broken off from a small
statue, across the neck on a diagonal line
which leaves most of the neck at the start of
the left shoulder visible. The tip of the nose,
the chin, and a section over the middle of the
forehead have been damaged. There are traces
of red paint.

The figure wears a tight turban or
cloth, earrings, a necklace, and a
tunic or cloak. There is a late
Archaic or Transitional fringe of
curls over the forehead and a face
that echoes the Ionian styles of the
time of the Persian Wars. Hair and
face are softened by the fleshy neck
and humanized by a turban that
belongs to the period after the Par-
thenon frieze. These peculiarities,
especially the fringe of archaizing
curls, continue in Cypriote votive
sculpture down into the Hellenistic
period. As was characteristic of
Cypriote sculpture in the fourth
century B.C. and of Hellenistic
periods, the pupils of the eyes were
flat for finishing in plaster and
paint.

Small heads from the first L. P.
di Cesnola Collection in the
Museum of Fine Arts, Boston, docu-
ment the development of this style
of hair and rendering of eyes, from
about 470 B.C. well into or even
through the Hellenistic period
(Comstock, Vermeule, 1976, pp.
273, 276, 277, nos. 437, 442, 445,
446). Since styles on Cyprus were
derivative of several sources and
slow to change, heads such as this
are often dated up to fifty years ear-
lier than their probable dates of
carving. The points of departure are
the so-called "female votaries" of
the Persian period, 525–332 B.C.
Those with cloth headdresses (Brit-
ish Museum, Type 33) are generally
dated in the period 470–400, but
variations continue later, as seems
to be the case here (Pryce, 1931, pp.
104–112, especially pp. 107–108,
C298, C299, both earlier examples).

The male counterpart of this
head, albeit clearly a carving of
about 450–430 B.C. in the Ionian
Archaic style, is the figure in a long
tunic and red cloak from a sanctu-
ary near the village of Mandres in
the Famagusta district and later in
the Pierides collection, Larnaca,
Cyprus (Karageorghis, 1973, pp.
86, 145–146, no. 92). The large
ears and the neck are unadorned,
but the facial expression is similar,
in a timeless fashion. The Cypriote
sources for the Harvard head can be
found in various early Classical
sculptures from the Peloponnesus,
Sicily, Southern Italy, and, of
course, the Greek islands leading to
Western Asia Minor (Fuchs, 1969,
pp. 254–257, figs. 279–283).

Published: Fogg Museum, 1968, p. 79, illus.,
p. 159; Fogg Museum *Engagement Calendar*,
September 1973, illus.; Vermeule, C., 1976,
pp. 25–26, 40, 43, pl. I–14a.

Gift of Stuart Cary Welch, Jr., 1966.134.

22

Bearded Head

380 B.C. or later
Pentelic marble, H. 0.203 m, W. 0.15 m

The bridge of the nose is chipped away, and there is damage elsewhere, especially at the beard on the subject's lower right cheek.

This head from an Attic grave relief is turned to its left, and the youngish man may have been gazing slightly downward, at a seated figure. This Athenian head has traditional elements in common with the heroes and priests or magistrates from the East Frieze of the Parthenon, but the complete work would have shown an Attic stele in the conservative or revivalist style of the fourth century B.C.

On a stele in the Piraeus Museum (no. 386), Hippomachos stands at the left, extending his right hand to old Kallias who is seated to the left on an elegant chair. This monument has been placed in a group dated around 380 B.C., or very slightly later (Diepolder, 1931, p. 39, pl. 23). The man on the left (Hippomachos) leans slightly forward and angles his head somewhat downward toward his seated companion, presumably his old father. Hair, rough beard, and face made to appear flat and round with large-lidded eyes and thick, parted lips of Hippomachos are all details that are exactly like those of the Watkins-Harvard head. Indeed, it would seem this head came from a similar stele, probably carved by the same sculptor. Jiří Frel has named him "Le sculpteur de Chairedemos," after the famous (two) walking-warrior relief of Chairedemos and Lykeas, also in the Piraeus Museum (no. 385) (Frel, 1969, pp. 23, 59, pl. VIII).[1] This stele was carved at the end of the fifth century B.C., thus forming the transition between the Athenian worlds before her final defeat by Sparta and the new vistas opened by the Macedonian attacks on the declining Persian Empire.

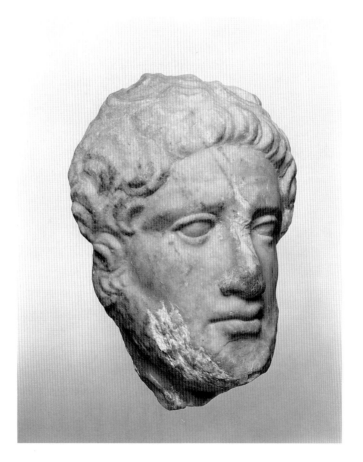

Provenance: From Charles L. Morley, Switzerland and New York.

Published: Becatti, 1951, pp. 13–15, pl. 2, figs. 2, 3; Fogg Museum, 1954, p. 27, no. 147, pl. 37; Fogg Museum, 1973, p. 76, no. 31; Fogg Museum, 1975, p. 84; Ridgway, 1979, under no. 1143.

1. See also Diepolder, 1931. p. 21, pl. 16, for the earlier, two-hero stele in the Piraeus Museum.

Bequest of Frederick M. Watkins, 1972.50

Grave Lekythos

ca. 340 B.C.
Pentelic marble, H. 0.578 m

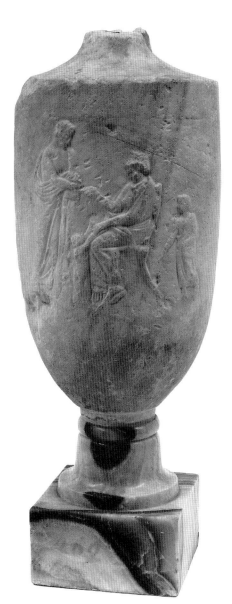

The foot and the neck from above the shoulder are missing, as is the corresponding part of the handle.

Shown is a scene of a seated woman, a man standing in front of her, leaning on a staff and extending his hand, and two children behind or around her chair. The smaller child, in front of the woman, is reaching up toward her, to grasp her left hand. All wear the conventional Attic formal dress of the fourth century B.C. There are many variants of this scene, the woman seated, the man standing, vice versa, both standing, and the children on either side or on one side.[1] A large lekythos in the Metropolitan Museum of Art, New York, has a family and retainers to the number of seven represented on the curved surface.[2] An example from the Ernst Brummer Collection is similar to this in size and style, with the five members of the family all standing (Galerie Koller A. G., 1979, pp. 188–189, no. 604).

A number of Attic marble funerary lekythoi like the Harvard example show similar compositions in mirror reversal, suggesting that the sculptors who carved these standard, low-relief scenes could work from "pattern-books," templates, or even rubbings. A lekythos with reversed scene, dated 375–350 B.C. is in the collection of Mr. Gilbert Denman, Jr., in San Antonio (Hoffmann, 1970, pp. 24–25, no. 7).

Another such lekythos, of a date closer to 330 or 320 B.C., also shows the reversed scene—the child at the right behind the standing young man and a young woman, head bent on upraised left hand, facing to the right in the center rear of the composition (Sotheby Sale, London, 10 December, 1984, Lot no. 288). Clearly the possible combinations were limitless and were simply reduced, low-relief versions of the compositions on the larger, rectangular stelai found in the same Attic cemeteries.

Provenance: From the collection of Giavacchino Ferroni. From the Museo Nani in Venice.

Published: Ferroni Sale, Rome, 19–22 April, 1909, no. 772, pl. LIV; Schmaltz, 1970, pp. 29, 62, 69, 111, 125, no. A 77.

1. Conze, 1900, pls. CXCVI, CXCVII, CCXXI, no. 1124, with a horseman, a standing woman, and two children.

2. Richter, 1954, pp. 59–60, no. 88, pls. LXX–LXXII, with detailed discussion of parallels.

Gift of Mrs. Edward M. Cary, 1909.20

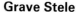

Grave Stele

ca. 340 B.C.
Pentelic marble, H. 0.955 m, W. 0.492 m

An inscription written on a narrow architrave below the pediment reads:

ΜΕΛΙΣΤΏ ΚΤΗΣΙΚΡΆΤΟΥΣ ΠΟΤΑΜΊΟΥ

Melisto, daughter of Ktesikrates, from the Demos of Potamios.

The stele is good-to-average Pentelic marble. The basic condition is also good, but "all the surfaces have been more or less recut" (J. Frel, letter of 15 June, 1973). There are faint traces of painted egg and dart motif above the inscription.

Melisto, daughter of Ktesikrates, holds a doll in her left hand and a bird in the right, and looks down toward the furry little dog springing up at her from the right. She wears a simple girt chiton, like a nightgown.

The deme of Potamios, whence Melisto came, was on the Attic coast, north of Sounion, south of Brauron, where statues of girls similar to this representation in relief were found in the sanctuary of Artemis. The head of a statue in this style and tradition is represented by no. 27 in this catalog. Melisto's somewhat frizzy hair and her smile are paralleled best by the head of a little girl ("bear") in a Swiss private collection (Chamay, 1975, no. 275).

Published: *Ars Antiqua,* Auktion III, Lucern, 29 April, 1961, p. 13, no. 22, pl. 9, with a detailed publication; Fogg Museum, 1963 plate, p. 121; Pedley, 1965, pp. 259–267; Pedley, Gazda, 1981, no. 1; Mitten, Brauer, 1982, no. 42; Rühfel, 1984, pp. 176–177, fig. 73.

Purchase from the Alpheus Hyatt and Gifts for Special Uses Funds in Memory of Katherine Brewster Taylor, as a tribute to her many years at the Fogg Museum, 1961.86

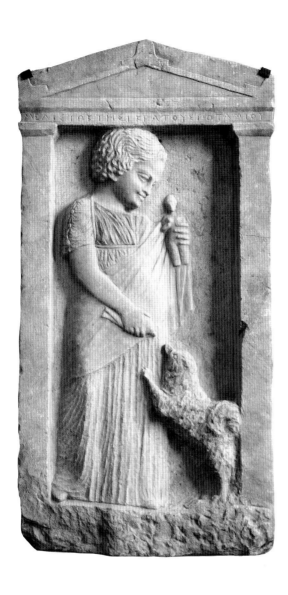

Multi-Figured Grave Stele

ca. 325 B.C.
Pentelic marble, H. 0.838 m, W. 0.559 m

The inscription from the architrave probably contained ca. 23 letters according to Sterling Dow. It has been partially reconstructed:

[woman's name in nominative] [father's nomen in genitive] [father's demotic in genitive] [ΘΥ] ΓΑΤΗΡ

The stele has been considerably recut (J. Frel, note in object file, [13 February 1970). The man is a recut "old nurse," her woman's garb still showing; the back legs of the chair and the dying woman's arms (both?) are also recut.

There are four figures: two are standing—a "bearded man" (originally the "old nurse" and later recut) near the center, and a woman behind him. A dying woman is being supported by a servant at the right. The dying woman, labeled "Daughter" on the architrave above, wears a thin chiton fallen off the left shoulder, and a himation around her lower limbs. The original version of this scene of a woman expiring on a chair or short couch, mourned by one woman, aided by an old nurse in the center, and supported by a servant occurs in other Attic sepulchral monuments, notably a stele in the National Museum, Athens, from Oropos (Reinach, 1909–1912, II, p. 402, no. 3). An abbreviated version, omitting the person on the extreme left, appears on an Attic marble, fluted lekythos in the Louvre (Reinach, 1909–1912, II, p. 292, no. 6).

Provenance: From Giavacchino Ferroni, Rome, 1905. Nani Collection.

Published: Fogg Museum, 1936, p. 14; Chase, 1924, p. 103, fig. 126; Philippart, 1928, p. 41; Fogg Museum, 1971a, The Checklist, p. 150.

Gift of Edward W. Forbes, 1905.8

Fragment of an Attic Grave Relief

ca. 350–340 B.C.
Pentelic marble, H. 0.47 m

The irregular break at the right looks more modern than the older break below. The surface is worn and discolored with some incrustation.

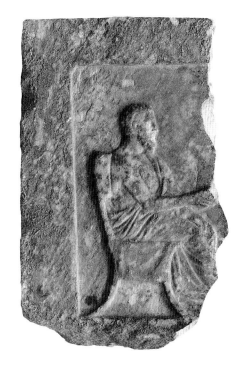

The relief shows a bearded man, seated and turned to the right, with right arm extended. He wears a himation around his lower limbs and over his left shoulder. He sits on a *klismos*, a graceful Athenian chair. He was grasping the hand of a person, probably a woman, who was standing in front of him. There is a broad, architectural border at the left, and a similar flat, fillet border at the top. On the more complete stele of Potamon the Aulete in the National Museum, Athens, the figure standing at the right is a young man (Reinach, 1909–1912, II, p. 396, no. 4). A relief on the art market in New York shows a somewhat more Pheidian man being bidden farewell by a standing woman, while a servant girl holds the lady's jewel box as she too stands, at the right. This relief is complete and is dated 375–350 B.C. (*Sotheby Sale,* London, 15 July, 1980, p. 22, no. 27; Schefold, Cahn, 1960, pp. 81–82, 248, 263, illus.).

Published: Hanfmann, 1950, no. 184; Newark Museum, 1980, no. 40.

Gift of the Society of the Friends of the Fogg Museum, 1927.38

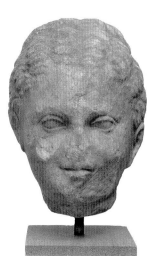

Head of a Young Girl

fourth century B.C., perhaps later
Pentelic marble, H. 0.184 m

The nose and the lower left cheek are broken and rubbed away. The surfaces are very weathered. The hair behind the ears and at the back of the head is finished roughly, the hair above and in front of the ears less so but still rough.

The young girl has her plaited hair arranged in a low knot around the crown of her head. The symmetrical waves above the forehead are divided in the center and are pulled back tightly above the ears. This head brings to mind the statues of young girls of the fourth century B.C. found in the sanctuary of Artemis at Brauron in Attica (Orlandos, 1958, pp. 36–37, figs. 38, 39; Rühfel, 1984, pp. 221–222, pl. 91). Similar statues have been found at Delphi and elsewhere in Greece (Collignon, 1911, pp. 192–196, especially fig. 122, Delphi). A head of a young girl from a funerary monument has the hair arranged in similar fashion and has been dated after 350 B.C. and before the curtailment of monumental grave monuments in Attica, 317–316 B.C. The hair is worked slightly more decisively and the face is slightly more pronounced. The head was bought in Athens by Ludwig Curtius in 1906 and is now in the Royal Ontario Museum (The Royal Ontario Museum, 1983, p. 22, no. S-28).

Published: The Newark Museum, 1980, no. 102: "Head of Arctos."

Gift of L. Melano Rossi, 1922.72

Veiled Head of a Woman

ca. 320 B.C.
Pentelic marble, H. 0.394 m

The chin is chipped, and the edges of the hair at the left have been damaged. The underside of the neck appears to have been finished fairly smoothly in antiquity. A ribbon or fillet, just in front of the veil, holds her hair in place. The nose and a piece of the lower lip are restored; two pieces in the neck have been patched on again.

The relief dates from near the end of the fourth century series, about 320 B.C.: it has been dated and termed "about 320 by the sculptor of the stele in Budapest" (J. Frel, in a letter of 15 June, 1973). It appears that this head came from a monument so large that head and neck were worked separately and set into the body, as was the custom with veiled statues, like the Demeter of Knidos, in the fourth century B.C. Otherwise, with a provenance in Rome, this head could have been broken or cut from a big Attic stele

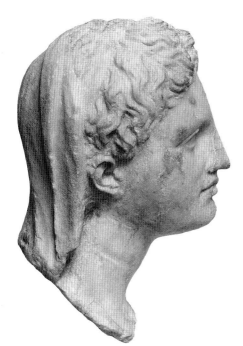

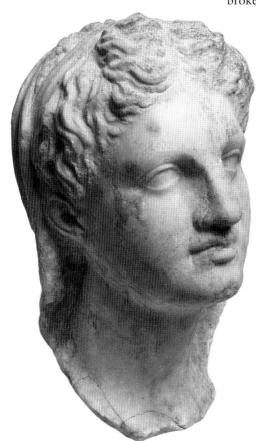

in antiquity, remounted or refinished as a bust or even a herm, and treasured by a Roman Imperial collector. A similar fate appears to have befallen the woman from a big Attic funerary monument, now in the Museum of Fine Arts, Boston (Comstock, Vermeule, 1976, pp. 48–49, no. 70).

A number of big Attic stelai relate to this head in the Harvard University Art Museums. The example in the Budapest Museum of Art shows a woman of matronly aspect (whose head has been broken off) shaking hands with a bearded elder, an aging athlete or an older hero, who is presented in the heroic nude, cloak on his left shoulder and wrapped around his left arm. A boy, a servant with an offering in hand, stands cross-legged between them (Diepolder, 1931, p. 55, pl. 49, no. 2).

Other big stelai, usually with their heads carved in one piece with their bodies, show the type of Athenian matron represented here, standing or seated in very high relief against a flat background or an architectural setting made separately. The stele of Demetria and Pamphile from the Kerameikos in Athens is a perfect example (Diepolder, 1931, pp. 53–54, pl. 51, no. 1). A number of heads of veiled women of about 325 B.C. are related, including those from Chalkis on Euboea and one from the island of Rhodes.[1]

Provenance: From Isaac Newton Phelps Stokes, New York. Seemingly from Rome (Ariel Herrmann).

Published: Comstock, Vermeule, 1976, p. 69, under no. 109.

1. Vermeule, C., 1981, pp. 118–119, nos. 89, 90; Fuchs, 1969, pp. 269–271, figs. 297, 298, the second the Demeter of Knidos. See also Winter, 1898–1902 pls. 314, 315, for various large heads of veiled women from Attic funerary monuments.

Purchase from the Alpheus Hyatt Fund, 1941.2

Torso of an Athlete, Hero (Meleager), or a Young God (Hermes?)

fourth century B.C. in the Polykleitan style
Low grade marble from northwest Asia
Minor or the Propontis with broad streaks of
gray, H. 0.59 m

Both arms from below the shoulders and legs
from diagonally across the upper thighs are
missing, as are much of the genitals. *Puntelli*
remain on both sides near the line of the hips,
also at the left shoulder

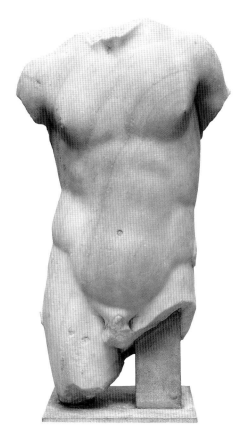

The pose and the positions of the three *puntelli*, as well as the characteristic lines of the shoulder blades and the lower part of the back above the buttocks, all suggest that this small statue was a reduced version of one of the variations on the original Meleager by Skopas. The left arm was lowered and the spear seems to have run beside the shoulder (hence the *puntello* on the upper arm) rather than against the shoulder (as in the Berlin and Copenhagen versions) or under the armpit (as the famous Harvard statue). Positions of the right arm behind the lower back vary, and here the arm may have been attached to the support at the right side, although a rough spot suggests a small strut extending from the middle of the right buttock.

Like the Berlin and Harvard versions, this putative Meleager wore no cloak around the shoulders and left arm. The dog may have been beside the tree trunk on the right side, like the Copenhagen copy, and there is no way of telling whether there was another stump surmounted by the boar's head, as

in the restoration of the Vatican statue, or even whether the stump at the right was plain, and the hound was at the hero's left. The Vatican copy suggests that only the variations with the cloak flying out at the left side would need a second heavy support, although something was often needed to protect and prop up the spear. This would be especially true when the spear was beside rather than against or under the shoulder.

The Romans loved reduced-scale statues of gods and heroes; they could be placed in the gardens of houses or even on tables and in niches within. The Meleager type, whether used for this or another heroic hunter, was popular in palaces, baths, and villas from Italy to Cyprus. Variant versions in marble also featured different attributes and positions. The original bronze statue of the fourth century B.C. did not need the explanatory props found in the marbles—e.g., a routine decorative statue such as this torso or a masterpiece like the Forbes-Webster Meleager.

Published: Hanfmann, 1950, no. 181.

Bequest of E. P. Bliss, Class of 1873, 1917.194

Statue of a Young God or Hero, Usually Identified as Meleager, head and torso

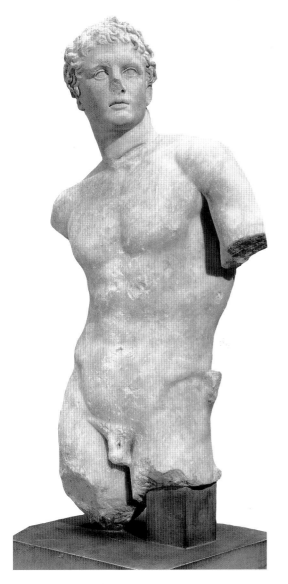

copy of the statue generally attributed to Skopas of Paros, the original having been made ca. 340 B.C.
Parian marble, H. 1.17 to 1.22 m

The arms from above the elbows and the legs at the upper thighs are missing. The head is broken at the base of the neck. Part of the nose, right ear, and right eyebrow and parts of the hair have been broken off. There is some surface chipping. *Puntelli* are visible on the left hip, left thigh, and left buttock. The statue was cleaned and the head rejoined in 1961–1962 by the Department of Conservation and Technical Studies at the Harvard University Art Museums.

A good number of copies of the lost original (which was probably in bronze) show a Greek hero, with a head like those of Skopas and a body influenced by the work of Lysippos, either leaning on a staff or with a spear against the left shoulder. The presence of a boar's head by the left foot and, seemingly, a hound at the subject's right side, plus the relationship to Skopas's sculptures for the temple of Tegea, have given rise to the identification of the subject as Meleager, hunter of the Calydonian boar, and the sculptor as Skopas.

While the original and its numerous, variant copies all show an ideal hero and have nothing to do with Greek portraiture, a head from a statue, now at Houghton Hall in Norfolk, was carved as a likeness of a Hellenistic ruler, surely a Seleucid. The marble was a copy of the Antonine period after an original based on Skopas's statue (Oehler, 1980, p. 73, no. 66, pl. 22).

Along with the head and torso of the statue as rejoined (most recently in 1961–1962) came eighteen fragments that may belong to the base (Hanfmann, Pedley, 1964, p. 62). Three fragments joined to form the hero's lower leg. Another fragment is part of the thigh. Two fragments seem to have been parts of Meleager's dog and boar's head and three fragments joined to form what might have been part of the stick (?) on which Meleager leaned and part of a chlamys falling down the left arm.

The chief difference in the Harvard copy and its mate from Santa Marinella in Berlin, one of the touchstones for the group of copies, is that the javelin held in the left hand has been replaced by a staff lodged under the left arm. The feeling is that both the boar's head and the dog were part of the original composition in bronze, the latter beside the hero's right leg and the former by his left foot.

While the more slender and youthful "boy victor" (Narcissus) after Polykleitos could be identified as Adonis when a boar's head was added to the support on which the lad leaned, there is no question here that the more mature, more formidable figure of Meleager was intended, not the least reason being that a Meleager based on this Skopasian statue appears frequently as the protagonist on sarcophagi.

Provenance: Found, May 1895, in the ruins of a Roman villa on the slopes of the promontory at Santa Marinella near Civitavecchia. First exhibited at the Fogg Museum in 1899.

Published: Borsari, 1895, pp. 195–201, figs. 1, 2; Chase, 1924, pp. 86ff., figs. 97, 101; Chase, Post, 1925, pp. 119f., fig. 63; Buschor, 1928, p. 55, pl. IV; Blümel, 1938, p. 22 (on the findspot of the Harvard and Berlin Meleagers at Santa Marinella); Lippold, 1950, p. 289, note 6; Richter, 1950, p. 276; Hanfmann, 1950a, no. 185; Arias, 1952, p. 128, no. 3, pls. 11, 39; Faison, 1958, p. 112, fig. 1, 1982 ed., pl. 191, fig. 111; Bieber, 1961, pp. 24–25, figs. 54, 56–57; Rowland, 1963, pp. 33–34, fig. 24; Hanfmann, Pedley, 1964, pp. 61–66, pls. 58–72; Hanfmann, 1967, p. 320, fig. 158; Richter, 1970 ed., p. 213; Brinkerhoff, 1971, p. 15; Fogg Museum, 1971a, p. 4; Charbonneaux, 1972, fig. 403; Atalay, Türkoğlu, 1976, cols. 133, 134, note 12, figs. 7, 8, cols. 135–138, in connection with a likeness of Lysimachos, figs. 1, 2; Bieber, 1977, p. 41, fig. 86; Stewart, 1977, pp. 104–107, 110, 122, 144; Vermeule, C., 1977, pp. 15–16, 33; Hanfmann, Mitten, May 1978, pp. 362–363, fig. 1, pl. 44a; Vermeule, C., 1981, p. 81, no. 51; Stewart, 1982, pp. 14–15, fig. 19; Mortimer, 1985, p. 107, no. 119.

Bequest of Mrs. K. G. T. Webster, 1926.48

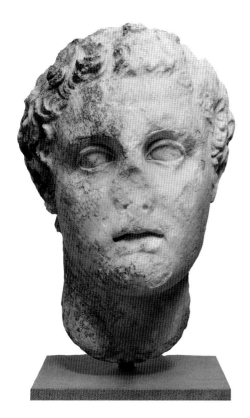

Head from a Reversed Copy of the Skopasian Meleager

Roman copy ca. A.D. 150 after Greek original
ca. 340 B.C.
Marble, H. 0.33 m

The surfaces are rough. Nose, lips, and end of
the lower part of the chin are missing. This
copy must date later than the Forbes-Webster
statue, in the Antonine period.

The head is turned and tilted ever so
slightly to its right. The condition of
the surfaces contribute to the head's
air of wildness when compared with
that of the Forbes-Webster Mele-
ager. The pronounced carving in the
hair, around the eyes, and between
the lips add to this overall appear-
ance.

Since the copy of the Meleager
attributed to Skopas in the Berlin
Museum was found in the same
Roman villa at Santa Marinella as
the Forbes-Webster copy, it is
understandable that an Antonine
decorator or collector would go one
step further and commission a copy
in mirror reversal. This was done
for other popular copies after
famous statues of the fourth century
B.C., notably the *Weary Herakles*
after Lysippos (Vermeule, C., 1980
pp. 328–329). Such pairs of statues
were set around pools in gymnasia,
in the niches of baths (such as the
Roman bath at Perge), or in the
scene buildings of large Roman the-
aters in the tradition of the structure
named for Herodes Atticus in Ath-
ens.

Provenance: From the collection of B. A. G.
Fuller.

Published: Chase, 1917, p. 113, fig. 3; Hanf-
mann, 1950a, no. 54; Vermeule, C., 1967, pp.
175, 177, fig. 2; Vermeule, C., 1968, p. 555;
Hoffmann, 1971, p. 32, fig. 28; Vermeule, C.,
1977, p. 33; Vermeule, C., 1981, p. 83, no.
53; Pedley, Gazda, 1981, Checklist, no. 3.

Purchase from the Van Rensselaer Fund for
the Collection of Classical Antiquities,
1913.28

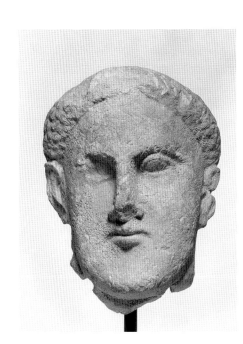

32 Cypriote

Head of a God, Hero, or Votary

late fourth century B.C. *to Hellenistic style*
Limestone, H. 0.15 m

The head is broken off at the neck. The nose
and one ear are partly missing, as well as a
part of the other ear and a piece from the top
of the head. There are small pocks and
scratches over the surface. There are two par-
allel drill channels running, front to back,
under the neck, for attachment to a draped
statue (?).

The face has an empty expression,
enhanced by the recutting and
smoothing between lower lip and
point of the chin. The features are
heavy-set. This head and its stand-
ing statue in a long tunic and cloak
belong close to the Type 36/37
groups that span the period around
380–320 B.C. (Pryce, 1931, pp.
112–118).

Published: Fogg Museum, 1961, p. 27, no.
207.

Bequest of David Moore Robinson, 1960.457

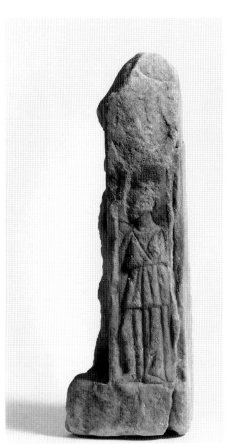

33 Greek

Architectural Fragment with a Standing Female Figure

*right parastade or pillar of a rectangular
votive relief, fourth century* B.C. *to early Hel-
lenistic*
Pentelic marble, H. 0.203 m, W. 0.07 m

The lower right corner and a section of the
right side survive.

The figure in low relief on the front
surface is a woman standing to the
left, a long torch in her right hand.
The image of a woman with a long
torch ought to suggest a dedication
to Artemis, Hekate, or the divinities
of Eleusis. Three types of reliefs
have figures in this position. There
are the dedications to divinities
within a rectangular *naiskos* or
aedicula with pilasters left and right
and a roof above. Such reliefs are
usually crowded with mortals as
well as divinities receiving honors
(Reinach, 1909–1912, II, p. 324 in
Athens). Single divinities in temple-
form niches also can have dedica-
tors in relief on the pilasters, as a
seated Cybele in Athens (Reinach,
1909–1912, II, p. 338, no. 4).
There are also such figures, usually
small athletes or servants, against
the pilasters of reliefs with funerary
banquets as the central theme (Rein-
ach, 1909–1912, II, p. 412, no. 1,
p. 413, nos. 1, 2).

Unpublished.

Gift of the Misses Norton, 1920.44.134

Hellenistic: Originals and Copies

Hellenistic marbles in the Harvard University Art Museums include small originals, mostly fragmentary, and some copies. The relief of Demetrios Poliorketes on horseback (no. 42) is important in the light of concern with the world of Alexander the Great in recent years. The statue of Aphrodite or a nymph (no. 34), a copy early in the history of such creations, is one of the best survivors of a popular figure created on the shadowy line between the world of Lysippos and the established successors of Alexander the Great. Grenville Winthrop's *Sandal-Binding Aphrodite* (no. 36) is a small figure with many parallels, but the sensitive quality of this version of a popular late Hellenistic motif places the headless statuette among the best carvings of the end of the Hellenistic Age.

The most powerful, most forceful example of Hellenistic sculpture is, without doubt, the colossal head of a giant or a barbarian (no. 46), in the traditions of the altar of Zeus Soter at Pergamon or even the original of the *Dying Gaul* in Rome's Museo Capitolino. The sentimental, proto-rococo aspects of Hellenistic sculpture are well represented in the statue of Eros sleeping in the skin of the Nemean lion (no. 49), a splendid version of an allegorical figure (force disarmed by love) popular in the arts of Antiquity and the Italian Renaissance from Michelangelo's early years onward.

The Hellenistic section also includes several miscellaneous architectural pieces and fragments including a section of a Christian monument of the middle Byzantine period (no. 80). This scrap is of interest chiefly because the great Harvard historian of America, Albert Bushnell Hart, picked it up on a slope of the Acropolis in Athens.

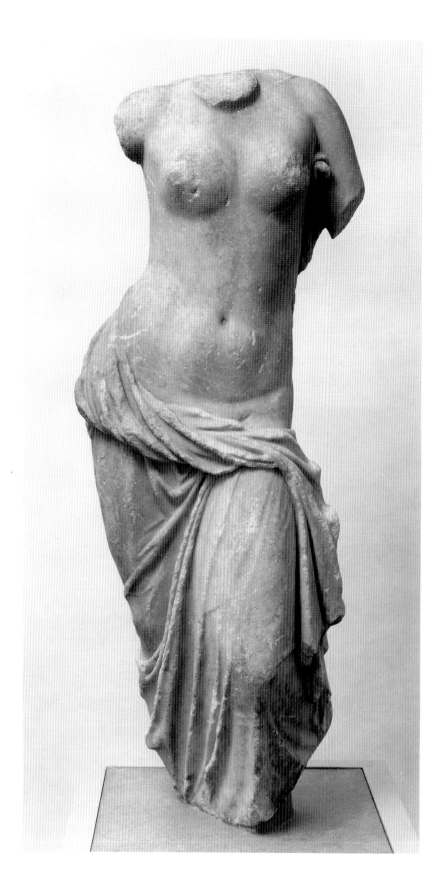

Small Statue of a Divine Female Personage, Aphrodite or a Nymph

late Hellenistic or Graeco-Roman copy of a type created late in the fourth century B.C. Thasian marble, H. 0.98 m

Most of both arms, and her head and feet, are missing. The left breast is damaged, and there are chips on the drapery.

This small statue, existing in about twenty replicas, represented Aphrodite Pontia or Euploia and was used in Graeco-Roman times as a fountain figure, the water some-times emerging from the dolphin serving as support at the left side. The original is thought to go back to the time of Praxiteles, about 350 B.C., and may have stood in a temple by the sea, a smaller version (since the figure is only two-thirds lifesize) of the Aphrodite of Knidos. There are also, however, strong arguments in the diademed, draped head, the elongated body, and the hipshot pose for suggesting the original of these copies was created in the Hellenistic world, perhaps on the island of Rhodes, about 150 B.C. Near mirror reversals of the type were created in late Hellenistic times and also copied.

She appears to have been represented as unveiling herself. She stands with the weight on her right leg, her hip thrown outward to give the body a strong S-curve. Her cloak starts behind the neck, falls down her back, and is bunched in folds on a line around the right hip to the front of the torso, falling

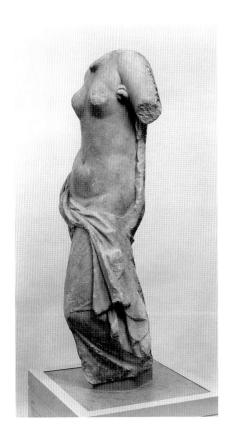

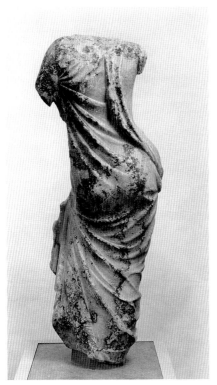

again over the left thigh. The other end is tucked under the left arm, making a diagonal fold across the back. This Aphrodite was wearing a diadem above her hair and, often, the part of her cloak that passed up behind her shoulders as a veil over the back of her head. Her left arm, with a bracelet on the upper part, was lowered and extended, probably once holding a marine attribute such as a stylized wave. Her right arm was bent and appears to have touched and held up the heavy folds of drapery on an extended right hip. The presence of the diadem favors the identification as a goddess born from the sea rather than a nymph of the ocean or water.

The original statue was perhaps a bronze, but, like the Aphrodite of Knidos, it could have been a marble.[1] The copy in the Galleria of the Museo Capitolino, slightly larger than most, has been transformed into a statue of a Roman lady of Domitian's time (A.D. 81–96) wearing her high, exaggerated hairstyle and sandals on the feet. This amusing distortion of the ultimate original may have served as a funerary statue, having been found outside the Porta San Sebastiano in an area where funerary monuments could take on what we would consider surprising pagan forms (Jones, 1912, pp. 127–128, no. 34, pl. 25). A statue in the Museo del Prado, Madrid, in about the same state of preservation as the Harvard statue, of uncertain provenance (perhaps Roman Hispania), demonstrates the widespread export of the type (considering Smyrna as the source of the statue acquired by Edward Forbes for Harvard University) (Blanco, 1957, pp. 71–72, no. 95-E, pl. XXXVIII). A statue similar to the Forbes example was photographed in Zurich in a private collection, in 1962. The draped and diademed head is preserved. The provenance was said to have been the environs of Rome.

Provenance: From the collection of Barone Barracco, Rome. Supposed to have come from Smyrna.

Published: Forbes, 1909, p. 30, pl. 31; Chase, 1924, pp. 119 f., 145, fig. 143; Arndt, Amelung, Lippold, 1893–1950, no. 1542, no. 14 in list of replicas; Reinach, 1897–1930, IV, p. 203, nos. 3, 7; Mansuelli, 1941, p. 156, figs. 10, 11, on p. 159; Hanfmann, 1950, no. 186; Bieber, 1961, p. 133; Hanfmann, Mitten, May 1978, p. 364, note 11.

1. B. Ashmole, *A Catalogue of the Ancient Marbles at Ince Blundell Hall*, Oxford, 1929, pp. 20–21, under no. 36, pl. 15, a more complete replica made as a Graeco-Roman fountain figure.

Gift of the Members of the Class of 1895, 1900.17

Aphrodite

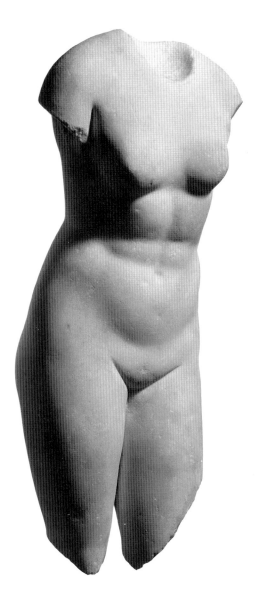

late Hellenistic version of a prototype created ultimately around 340 to 330 B.C. and modified in the decades around 300 B.C. and thereafter.
Low-grade crystalline marble, perhaps from western Asia Minor, H. 0.70 m.

The head and neck were made separately to be inserted in the hollow between the shoulders. The left arm appears to have been attached with a dowel at the shoulder, while the right arm was joined in a similar manner a little farther down the start of the upper arm. The legs are missing above the knees. The dent on the lower part of the left hip, at the break, could be the remains of a strut connecting with an upside-down dolphin or a draped urn, the usual attributes of Aphrodite.

This Aphrodite is a sensitive version of the type best represented by the Aphrodite of the Troad in the Museo Nazionale Romano, from the Palazzo Chigi, a second century

A.D. copy of the Hellenistic prototype.[1] The Aphrodite of the Troad, so inscribed on the Chigi copy (together with the information that Menophantos made the original or, more likely, this copy), is related to the Aphrodite in the Museum at Cyrene.[2] The Cyrene statue, which has a large, inverted dolphin against the lower hip (the end of the tail) and the left leg (the creature's body), goes back through the Aphrodite of the Museo Capitolino in Rome to the original of the Medici Venus in the Tribuna of the Uffizi in Florence.

Along the roads back from the Aphrodite of the Troad and the Aphrodite of Cyrene to the work of Lysippos (the Capitoline Aphrodite) or the creativity of Skopas (the Medici Venus), there were statues in cities from Attica to Asia Minor and beyond which mixed the proportions, details, attributes, and supports of a variety of Aphrodites. By various routes, they all arrived finally at the great source for all such figures of the goddess of love and beauty, portrayed as if stepping from her sponge bath or the sea, namely the Knidia of Praxiteles, made around 350 to 340 B.C.

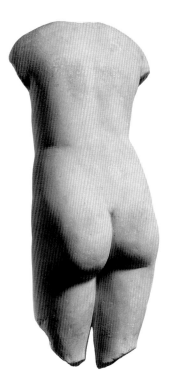

Provenance: Collection of Charles Lipson, Jamaica Plain, Massachusetts.

Unpublished.

1. Felletti Maj, 1951, pp. 54–58, pl. XIII, 1. Compare also the Capitoline Aphrodite torso in The Metropolitan Museum of Art, New York (Richter, 1954, pp. 83–84, no. 147, pl. CVIII, a–c).

2. Felletti Maj, 1951, pp. 58–61, p. XIII, 2.

Gift of Emily and Kenneth Bergen, in memory of Emily's parents, Rev. Dr. and Mrs. Newton C. Fetter, 1988.459

Statuette of Aphrodite Adjusting Her Sandal

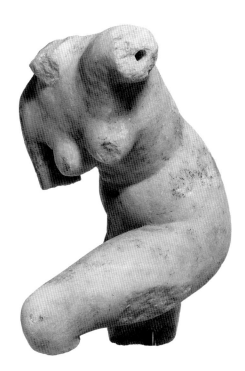

early Roman Imperial replica of a type created in the third century B.C.
Crystalline Greek marble, perhaps from Naxos, H. 0.204 m

The head and top of the neck, right arm from the middle of the upper arm, right leg from the middle of the thigh, left leg from below the knee are broken away. The left arm was made separately and attached with a dowel near the shoulder. There are other minor damages and incrustation.

There are many statuettes in marble, bronze, and terracotta of the popular theme of Aphrodite tying on or adjusting her sandal. The original may have been created in western Asia Minor by one Polycharmos, but Alexandria in Egypt became a center for such productions in late Hellenistic and Roman times (Brinkerhoff, 1978, chapter IV, pp. 70–97). A number of statuettes of Aphrodite adjusting her sandal have marine attributes or have been associated with shrines where sailors made dedications, hence the name Aphrodite Euploia (Huskinson, 1975, pp. 1–2, no. 2, pl. I).[1]

Such decorative statuettes, when complete, could also have erotic overtones, as the example in Berlin from Aigion, where the goddess leans on a terminal figure of the ithyphallic Priapos (Conze, 1891, p. 13, no. 23). These small statues and statuettes also vary in anatomical proportions, the Harvard Aphrodite being plump, while an example just over twice as large

emphasizes the slenderness of the figure (Galerie Koller A. G., 1979, pp. 238–239, no. 632). The statue found at Antioch-on-the-Orontes and now in the Baltimore Museum of Art also follows the slenderer, more elongated system of proportions (Brinkerhoff, 1970, p. 38, fig. 53). Statuettes like the Winthrop-Harvard example and that in Baltimore from Antioch have been found in various states of completion on Delos (Marcadé, 1969, p. 509, pl. XLVII).

Provenance: Purchased from Harold W. Parsons, 7 January, 1930.

Published: Fogg Museum, 1969a, The Checklist, p. 256.

1. The statuette from Cyrene was found in the Temple of Aphrodite there.

Bequest of Grenville L. Winthrop, 1943.1045

Statuette of Aphrodite Standing

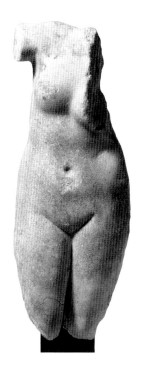

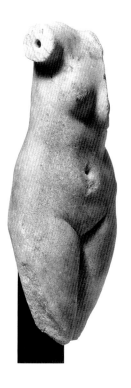

late Hellenistic of a type found in Egypt, 50 B.C.–A.D. 50
Crystalline Parian marble, H. 0.267 m

The head and neck, left shoulder including most of the breast, and legs below the knees are missing. The raised right arm was attached with a dowel at the right shoulder. The surfaces have dents and abrasions, and there is weathering that has brought out the crystalline structure of the marble. Much of the back from waist to upper thighs is cut away. The back is carved in a flat profile to begin with. Supports and/or attributes joined the outer legs along the thighs.

There are many variations of this small figure of Aphrodite who was probably raising her arms to wring out her tresses. Sometimes these figures, which are associated with the art of Alexandria and do turn up in considerable numbers in Egypt, as well as Asia Minor, have drapery around the lower limbs, as if her cloak had slipped down by accident or in connection with a bath. An example in Ny Carlsberg Glyptotek, Copenhagen, demonstrates this (Poulsen, 1951, p. 603, no. 868, pl. XVI). Variations of Aphrodite Anadyomene are collected and discussed by Brinkerhoff (Brinkerhoff, 1978, pp. 170–177), perhaps as a late

Hellenistic, classicizing creation originating in or around the island of Rhodes and soon spreading to the statuette workshops of Alexandria in Egypt. Some have tried to suggest that the half-draped type is a century earlier than the nude Anadyomene, the former going back to the period around 250 B.C., while the latter belongs to the beginning of the late Pergamene period or Hellenistic rococo. Others reverse the sequence and put the unclothed Aphrodite emerging from the sea back in the workshop of Lysippos's disciples such as Eutychides, about 280 B.C. (Brinkerhoff, 1978, pp. 170–177; Budde, Nicholls, 1964, pp. 53–54, under nos. 85, 86, pl. 27, both from Egypt; Comstock, Vermeule, 1976, p. 116, under no. 178 A).

The late Hellenistic and Greek imperial worlds played with and produced numerous variations of the type, not only in attributes and minor details of pose but in such mechanical *tours de force* as mirror reversal. Indeed, a larger counterpart, identical in style but with everything reversed, was found in Sardis (Hanfmann, Ramage, 1978, p. 107, no. 111, fig. 237). A more vertical, more static version of Aphrodite holding her hair in her right hand and an alabastron in the left (therefore with the left shoulder level with the right instead of lowered, as in the Rowland torso) was found in a villa near Narbonne in France and has been dated in the Constantinian age, pushing the subject to the end of pagan antiquity (Brinkerhoff, 1970, p. 36, fig. 47).

Published: Fogg Museum, 1969, pp. 121, illus., 153.

Gift of Mr. and Mrs. Benjamin Rowland, Jr., 1968.106

Man Seated on a Rockwork Throne

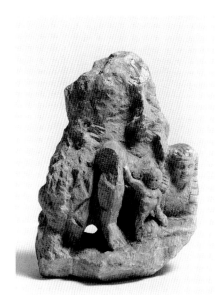

Limestone, of the type found on Cyprus, H. 0.127 m, W. 0.09 m

The figure is badly damaged from the shoulder down on the right side. The left knee, the lower part of Eros, and the attributes and left arm of the seated figure have also suffered. A large round hole runs through, front to back, just above the ground.

The figure is seated with a recumbent sphinx at his left side, and an Eros riding a dolphin at his left leg. The figure is portly and wears a cloak covering the back and the left shoulder. The other end of the cloak seems to cover the subject's right leg and hang down beside the right foot. He may also be wearing a Hellenistic cuirass with skirts, although the condition of the front makes detail hard to see. The Eros touches the figure's left knee with the right hand and the Sphinx's right paw with the left hand.

D. G. Mitten has suggested this man may be one of the early Ptolemies (either Ptolemy II or III), who claimed not only Egypt (hence the sphinx) but also Cyprus, the island of Aphrodite's birth (hence her son Eros, riding on a dolphin).

Unpublished.

Gift of the Misses Norton, 1920.44.145

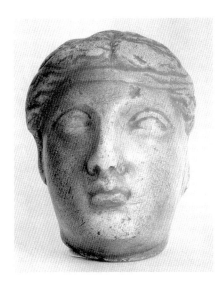

Head of a Woman

Graeco-Roman or provincial, imperial (Asia Minor?) type, based on an original of the fourth century B.C.
Marble, H. 0.133 m

The back of the head is flat, as if possibly split off from a relief. The surfaces are smooth and worn and the marble is discolored.

The woman's hair is parted in the center and drawn back over the ears. The fillet runs across the brow, under the hair.

A head in the National Museum at Athens, identified as Ariadne and seemingly of the time of the young Alexander the Great, gives a good idea of the general prototype for this head. The Ariadne in Athens was discovered on the south slope of the Acropolis in Athens (Lawrence, 1927, p. 13, pl. 10 c).

A head in Berlin, from the Riccardi collection in Florence, has been related to another copy in the Palazzo Ducale, Venice, and then to the head in Athens. It is suggested that there was a monument to Dionysos and Ariadne in the Street of the Tripods at Athens, from which all these heads derived, the Acropolis head being the original or very close to it (Blümel, 1938, pp. 32–33, no. K251, pls. 71, 72).

Unpublished.

Gift of Dr. A. Lawrence Lowell, 1933.158

Head of Sophocles

Roman copy of a Hellenistic prototype of the second century B.C.[1]
Luna marble, H. 0.33 m

The tip of the nose was broken and cut away and once restored with an iron pin. The back or crown of the head was broken off, cut down, and restored; half the restoration remains. The base of the neck is cut to fit ito a terminal shaft. The surfaces are chipped, worn, or weathered, and have been cleaned. Some scholars according to notes in the object file have questioned the antiquity of this head.

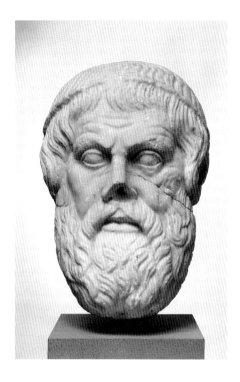

Sophocles lived from about 496 to 406 B.C., reaching the height of his political and intellectual career in Athens around 436 B.C. Seven complete plays and fragments of others survive from his lifetime production of over 120 plays. The Athenians honored him as a hero after his death.

This head is of the so-called "Farnese" type of Sophocles and takes its name from a herm in the Farnese Collection of the Museo Nazionale, Naples. The Farnese portrait was found in Rome, in the Via Ostiense (Richter, 1965, I, p. 127, no. 17). The ideal likeness was intended to show Sophocles at about sixty years of age, in 436 B.C. when Pheidias and Perikles were finishing the Parthenon. The many copies vary widely in quality, from those with the softness of an elder on an Attic grave stele (no. 22, Copenhagen) to those with the metallic harshness and stringiness of the David M. Robinson head (no. 11, Villa Albani). This example wears a fillet or diadem.

Nothing is known of the complete statue from which this head derives, for most of the copies of the head that survive are based on garden herms. However, in support of the antiquity of the Robinson head is the suggestion that it came from a very late and provincial garden herm, like some of those found in the ruins of country villas and parks in Roman Gaul. This head might even have been carved as late as the fourth century of the Roman Empire, in the time of Constantine the Great or Constantius II (A.D. 306 to 337 to 361), when ancient learning was as much admired as it had been in the earlier centuries of the Hellenistic and Roman world. A head of the "Farnese" Sophocles in the collection of Mr. Gilbert Denman, Jr., in San Antonio, Texas, has been recognized as a copy of the Greek original made in the third century A.D.; the original dates from the outset of Hellenistic art in the fourth century B.C., about the time when the young Macedonian Alexander the Great was being educated in the great Greek literature of the time (Hoffmann, 1970, pp. 75–77, under no. 23). The Denman head has the same rigidity as the D. M. Robinson Sophocles, although the former, sawed from a double herm (with Euripides) has the same drillwork found in Roman sarcophagi from Severus Alexander through Gallienus (A.D. 222 to 268).

Published: Fogg Museum, 1961, p. 27, no. 212; Fogg Museum, 1963, plate.

1. For this class of likenesses of the playwright, see generally (and the comparative lists): Richter, 1965, I, pp. 125–128; Richter, 1984, pp. 205–209.

Bequest of David Moore Robinson, 1960.459

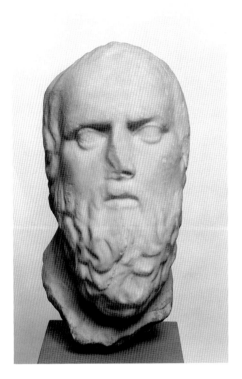

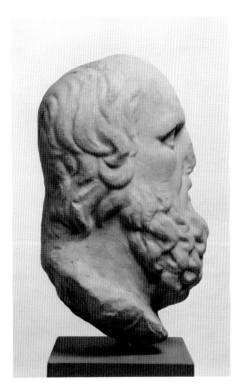

Head of a Long-Faced Philosopher

Roman copy or version of a creation of the period ca. 320 B.C.
Marble from western Asia Minor, H. 0.39 m

The surfaces are very water-worn. A section of the left rear of the head was damaged and restored in antiquity. The restoration is now missing, but the dowel remains.

This head could be a portrait of a late Antonine or Severan man of intellect in the traditions of Attic art in the fourth century B.C. The head has been compared with a supposed likeness of Aristippos, a sophist from Cyrene who lived about 435 to 360 B.C., was a predecessor of Epikouros, and a pupil of Socrates in Athens. Aristippos, identified by Karl Schefold, appears on a small double herm in Berlin; the other half of the herm shows his daughter Arete, who studied with him (Richter, 1965, II, pp. 175–176, figs. 1015, also 1016, 1017).

The face of the old man in the Berlin double herm is that of a typical elder on a large Attic grave relief, such as the mourner contemplating the heroized hunter-athlete on the famous stele from the Ilissos River, in the National Museum, Athens (Diepolder, 1931, pp. 51, 59, pl. 48). The Robinson head might still be the same distinguished intellectual of the fourth century B.C. world, Aristippos, or someone else, but, despite its worn surfaces, the face has more individuality and character than the man in the Berlin double herm.

Provenance: Said to have come from near Naples.

Published: Robinson, 1955, p. 28, pl. 21, fig, 48; Fogg Museum, 1961, p. 27, no. 211.

Bequest of David Moore Robinson, 1960.449

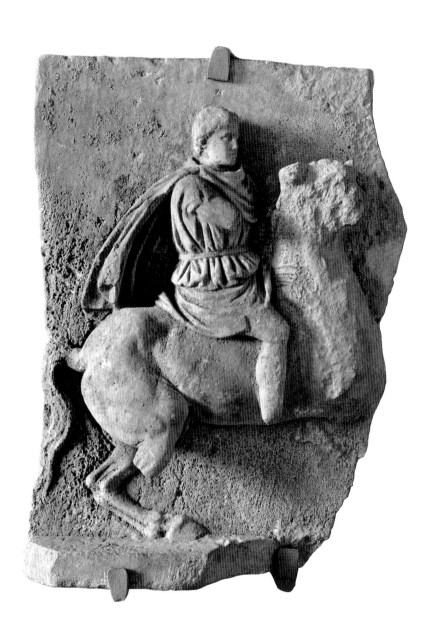

Votive to a Hellenistic Ruler on Horseback: Demetrios Poliorketes

later fourth or third century B.C.
Marble, H. 0.47 m, W. 0.343 m

There is an irregular break at the right. The left edge seems slightly irregular also. The horse's head is abraded, and the forelegs are missing, as is the lower part of the right hind leg and the rider's right arm. Overall pitting, indicating extensive water damage. Area behind the rider is worn through.

He wears a tunic belted at the waist, an undergarment to the thighs above the knees, and a cloak pinned at the right shoulder, flying out behind. The fillet in his hair was perhaps once painted (?) and might suggest a ruler (?). There is a fillet molding below. The horse prances to the right, rearing back slightly on the hind legs and with tail flowing out and down toward the ground-line of the molding below.

Comparison with the equestrian figures on the so-called Alexander sarcophagus, as well as details of the head of the Harvard relief, strengthen the suggestion that this is a commemorative representation of a Hellenistic ruler, one of the successors to Alexander the Great. Coins indicate he is Demetrios Poliorketes of Macedonia, Greece, and western Asia Minor (306 to 286/2 B.C.). The head can also be brought into comparison with the full-sized, free-standing head of a draped portrayal, seemingly of

Demetrios I Poliorketes, in the Smith College Museum of Art, an ideal portrait perhaps copied from the equestrian statue discussed below (Hadzi, 1964, pp. 38–39, no. 15). Many coins confirm the identification, showing that, as the young Macedonian king grew older, his nose became sharper and his jaw heavier. Some votive marbles traditionally do not have the details of physiognomy found on coins. The nose of the rider in the Forbes relief has lost its tip, as is so often the case with figures in Attic funerary and votive marbles, but the strong one to three o'clock angle of the nose remains in the sculpture, just as it appears on the coins. Compare, *inter alia*, the silver tetradrachm struck at the Pella mint from about 289 to the autumn of 288 B.C., where the diadem is visible as well as the bull's horns, which are not present in the reliefs but can be seen in the Forbes marble.[1]

"Demetrios the Besieger" had a bronze equestrian statue in Athens, dated 303–302 B.C., and, despite the differences (the bronze statue may have shown Demetrios wearing his helmet), the monument set up in the Athenian Agora was, like the prototypes of the Alexander sarcophagus and (translated into three dimensions) the Alexander mosaic, undoubtedly an influence on this votive relief (Houser, 1982, pp. 229–238). The bronze statue in Athens has been restored wearing a crested helmet with a Pegasus support under the crest on top. Since no other early equestrian representation of this type shows the ruler, Alexander the Great or a successor, wearing such a helmet, it is tempting to think the helmet was part of a trophy on the plinth or was set on the plinth, perhaps under the horse's hoof.[2]

Provenance: "From Athens" (Richard Norton, letter to Edward W. Forbes of 7 June 1901, and another, 12 December 12 1901).

Published: Reinach, 1909–1912, II, p. 203, no. 1.

1. Newell, 1978, no. 89, pl. VIII; *Numismatic Fine Arts, Inc.,* Auction XII, Ancient Coins, Beverly Hills, California, 23–24 March, 1983, no. 45. The bull's horns are visible on the head of the possible Demetrios Poliorketes in the Museo Nazionale, Naples. See Richter, 1984, p. 228.

2. See the ensemble in marble in Liverpool: Ashmole, 1929, p. 120, no. 402, pl. 28.

Gift of Edward W. Forbes, in trust to the University, 1902.5

Diademed, Bearded Head

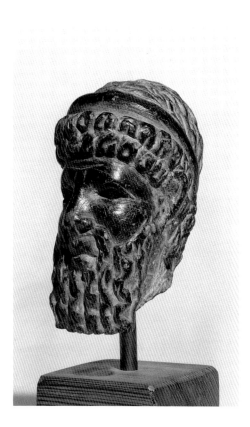

Identified as Parthian and said to represent
King Mithradates I (171–138 B.C.)
Chlorite, H. 0.087 m

The head is broken, irregularly, through the
neck. The eyes were probably inlaid, as they
remain hollow. The top of the head is made
separately, a tight join.

The diadem is similar to that worn
by Alexander the Great in the mar-
ble head from Egypt in Boston. The
hair is in two rows of curls around
the forehead. Hair and beard are cut
in rough curls, round and irregular.
The ears are large and pulled
slightly forward. The face has a
high polish.

Mithridates I is a celebrated
Philhellene known from his coins.
This head from a small statue, a
bust, or even the top of a scepter-
staff, seems to have been carved at
Babylonia where the pertinent coins,
as well as those issued under Mith-
ridates II about 122–121 B.C., were
struck. The stone was used in these
regions in Neo-Sumerian times, ca.
2100 B.C., for heads and statues of
rulers and officials in the time of
Gudea and others (Terrace, 1962,
no. 9). D. M. Robinson suggested
that the eyes were made of ivory,
with asphalt lining, as in the case of
other statuettes from this part of the
world in Parthian times.

While the details of hair, face,
and beard identify this head as that
of a famous, early Parthian king,
and while the material is peculiar to
lower Mesopotamia or Iran, coins
show us that Mithridates I and oth-
ers issued silver tetradrachms and
drachms that placed them firmly in
the traditions of Alexander the
Great and their Seleucid predeces-
sors and contemporaries. A series of
tetradrachms struck at Seleucia on
the Tigris River combines the king's
diademed, draped bust in profile to
the right on the obverse with a typi-
cal standing Hellenistic Herakles
holding cup (skyphos) and club on
the reverse (*The Garrett Collection,*
Part II, Bank Leu AG, Zurich, Octo-
ber 16–18, 1984, p. 68, no. 313, pl.
20; Wroth, 1903, pp. 12–15, pl. III;
Sellwood, 1971, pp. 25, 38, etc.;
Richter, 1984, p. 247). Mithridates
II of Parthia struck tetradrachms,
with a portrait very much like this
small head in profile to the left on
the obverse, also at Seleucia on the
Tigris from 123 to 91 B.C. Here
Herakles on the reverse has been
replaced by what had been intro-
duced earlier and would become the
standard type for the series, a Par-
thian archer seated (on an
omphalos?, later a throne) testing
his bow (Jenkins, 1972, pp. 272,
274, 276, fig. 667; *Garrett Collec-
tion,* loc. cit. no. 314; Wroth, 1903,
p. 24, pl. VI. Mithridates II also puts
on an elaborate, high "helmet").

Published: *Cambridge Ancient History,* Vol-
ume of Plates, IV, no. 24; Robinson, 1927, pp.
338–344, figs. 2–4; Fogg Museum, 1961, p.
27, no. 213; Richter, 1965, III, p. 277.

Bequest of David Moore Robinson, 1960.446

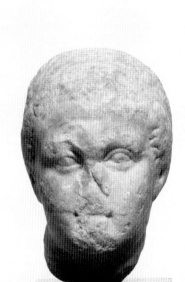

44
Head of a Hellenistic Ruler

(upper left)
ca. 150–50 B.C.
Marble from the Greek islands or western Asia Minor, H. 0.10 m

The head is broken through the back vertically, and the nose, chin, and neck have been further damaged, as well as the area above the left eye.

With a ruler's or perhaps a philosopher's rolled fillet in the hair, this full-faced older man might be identified as one of the Attalids or one of the kings of Bithynia. Another head, with a bit of draped bust fashioned for insertion, has been dated around 250 B.C. and may be an Attalid. It appears to be earlier than the Harvard example, but perhaps the two meet some time around the outset of the second century B.C.; the two are much alike (Bastet, Brunsting, 1982, p. 205, no. 378, pl. 112). The small head in the Department of Classical Studies, Duke University (1966.1), has been published as possibly Ptolemy III Euergetes (246 to 221 B.C.), and is said to come from Egypt. This is not the same man as the Harvard head, but it has similar visual style (Ackland Arts Center, 1973, no. 7 [M. F. Scott]).

Circular arguments are common and dangerous in the identification of Hellenistic rulers, but G. M. A. Richter has suggested as a possible Ptolemy III Euergetes a statue from the Arundel collection (thus from Asia Minor or the Greek islands) in the Ashmolean Museum, Oxford; this almost complete, himation-clad statue could have represented the same ruler as the small head at Harvard, which must have once belonged to a small statue (Richter, 1965, III, p. 263, figs. 1815–1817).

Unpublished.

Gift of the Misses Norton, 1920.44.204

45
Head of a Young Man(?) of Barbarian Origin

(lower left)
Greek(?), Hellenistic in the Pergamene tradition, 100 B.C.
Marble from the Greek islands, H. 0.08 m

The face is battered, and the surfaces are worn.

The masses of hair around the forehead were treated in summary, impressionistic fashion. Traces of a fillet around the ample locks might suggest that this head is the ideal presentation of a prince from one of the nations on the fringes of the Greek world, perhaps in Asia Minor. Despite damage, the head conveys much of the strength and nobility of the subject.

A slightly larger portrait, termed Hellenistic and related to the heroic iconography of Alexander the Great in Egypt, was found in the area of ancient Aquileia in Northern Italy (Scrinari, 1972, p. 57, no. 162).

Unpublished.

Gift of the Misses Norton, 1920.44.136

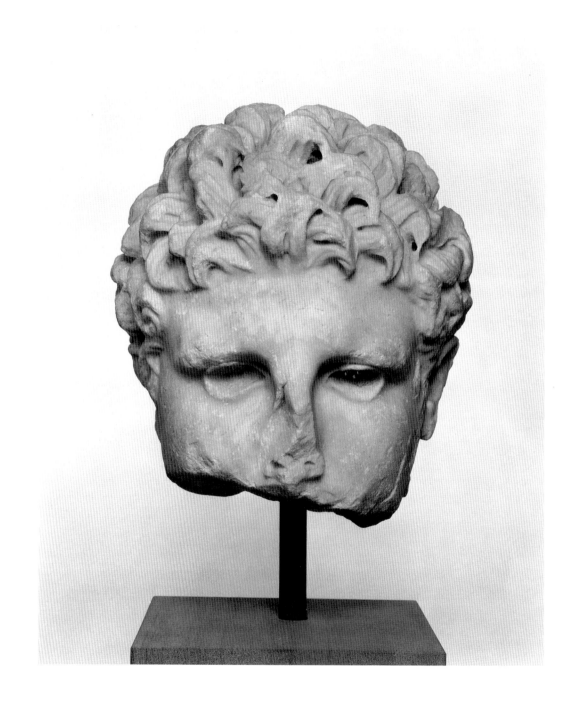

Colossal Head of a Giant or Barbarian

From an overlifesized statue in the Hellenistic tradition, Roman copy of first or second century A.D. of a type of ca. 150 B.C.
Asia Minor marble, H. 0.45 m

Over half of the head from under the nose is broken away on a slight diagonal from upper left to lower right. The nose is broken, curls in the hair are chipped, and drill holes pierce the hair.

The subject of this powerful, fragmentary head could have been a giant related to types seen on the larger frieze of the Altar of Zeus Soter at Pergamon in the 160s B.C. Alternatively, the head may have been part of a figure of a heroic warrior, a mythological subject like the companions of Odysseus at Sperlonga or an idealization from actuality. The last suggestion could include barbarian allies of Alexander the Great or one of the peoples (the Pisidians) who fought against Macedonians and Greeks in Asia Minor. The former suggestion embraces the Trojan Wars, where various races fought.

The head is a splendid copy of the late first or second century A.D., made by sculptors perhaps from Aphrodisias in Caria, after an original probably in bronze, or perhaps in colored marble, since the eyes were made separately. This concept radiates the power of Pergamon and shows how widespread was the varied art generated by that hilltop city in northwest Asia Minor. A partial glimpse of just one figure from what was undoubtedly a dramatic group, the muscular brow below masses of thick, undercut curls, demonstrates just how much Pergamene art took from the athletic sculpture of Skopas in the fourth century B.C., figures like the original of the Harvard Meleager. This fragmentary head also reveals the additions Pergamene and Rhodian or Carian sculptors imparted to the fourth-century ideal, creating a force referred to again and again in the arts until the Middle Ages.

There are a number of statues and heads in various European museums that parallel this splendid fragment, but many lack the impressiveness seen here, being much more mechanical copies.[1]

Published: Hanfmann, 1950a, p. 15, no. 39; Hanfmann, 1950, no. 188; Vermeule, C., 1980a, pp. 81, 82, 131, 252, 253, fig. 104A; *idem*, 1981, p. 211, no. 176.

1. Winter, 1900, pls. 348–350, especially pl. 349, no. 5, a warrior in the British Museum and 350, no. 5, a so-called Gaul in the Louvre.

Gift of Edward Perry Warren, 1913.13

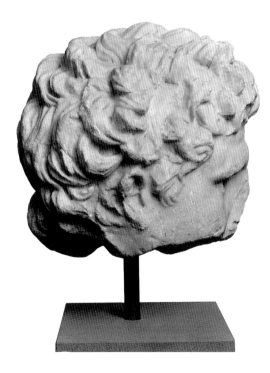
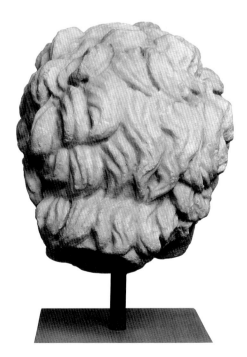

47

Head of a Young Warrior

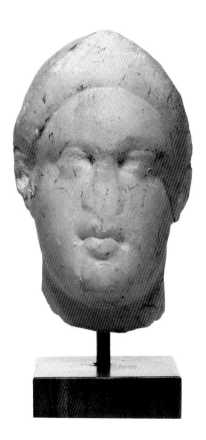

seemingly Hellenistic, perhaps ca. 100 B.C.
Marble, H. 0.076 m

The nose is broken away, and the ears are chipped. Details are rendered in a soft, summary fashion.

The face of this young warrior is fairly long, and the cheeks plump. The stiff, vertical, and somewhat frontal qualities of the head suggest that it was once part of a Hellenistic dedicatory or votive stele. Many of these stelai, and their counterparts for funerary purposes, show the subjects in frontal poses in architectural settings, as an example probably from Asia Minor in the Graf Lanckoronski collection in Vienna of a man of intellectual and athletic rather than military tendencies (Pfuhl, Möbius, 1977, I, p. 108, no. 254, II, p. 48); another, similar and helmetless head of a young man is on a stele in Istanbul from Madytos in the Thracian Chersonnesus (Pfuhl, Möbius, 1977, I, pp. 163–164, no. 538, II, pl. 83). The man ought to have been in the military service of a Hellenistic ruler or city, but Roman military personnel were buried in the Greek islands, Thrace, and Western Asia Minor at a date earlier than the imperial period.[1]

This head is a good carving, in a traditional style found widely. The ultimate influence of Severe Style heads about 460 B.C. from Southern Italy or Sicily can be seen by comparison with a female figure with helmet-like headdress in the Museo Barracco, Rome (Schefold, Cahn, 1960, pp. 218, 220, no. 243, also pp. 58–59).

Published: Fogg Museum, 1982, p. 108.

1. Pfuhl, Möbius, 1977, I, pp. 116–123, especially the examples of frontal figures in military costume: figs. 20, 22–25, from Thrace and Bithynia, although mostly dated in the Empire.

Gift of Nanette B. Rodney, 1978.512

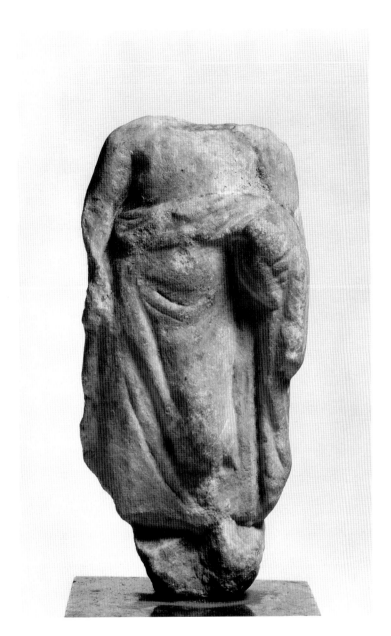

48

Torso of a Standing Man

seemingly late Hellenistic, 50 B.C.
Pentelic marble, H. 0.155 m

The workmanship is crude, the back hardly
modeled. The head and neck are broken
away, as are the right arm from the area
above the elbow and the lower areas of the
drapery, as well as the plinth.

The man wears his cloak over the
left shoulder; the right hand appears
to hold the edge of his cloak as it
falls down along his right side. The
left leg is preserved almost to the
left foot, and it shows the weight
was on the right leg. The object held
in the left hand, in front of the folds
of the cloak, may be a bird, in
which case this could be a small
statue of Asklepios or a person
making an offering to the god of
medicine. Perhaps this is a statue of
Hippocrates.

The bird ought to be a cock or
rooster, since pet birds are generally
held by children in Attic funerary
sculpture (as in the stele of Melisto,
about 340 B.C., no. 24, above), but
the surfaces are too worn to say
with confidence here. When
Asklepios himself is accompanied
by a cock, the bird is usually being
offered to him by an attendant (or a
Gallus, making a sacrifice), as in the
statue set in a recessed niche of the
Juturna precinct near the Temple of
Castor and Pollux in the Roman
Forum (Boni, 1901, pp. 114–117,
fig. 75). These representations are
usually connected with statues in
which Asklepios holds a *rotulus* or
scroll in one hand, which could con-
ceivably be the case here if the god
rather than Hippocrates or a votary
were represented.[1]

Provenance: Probably from Athens.

Unpublished.

1. Compare the statue in the Palazzo Pitti,
Florence: no. 669–205. Arndt, Amelung, Lip-
pold, 1893–1950, nos. 219ff.; Amelung,
1897, p. 135, no. 188

Gift of Mr. and Mrs. William de Forest
Thomson, 1919.507

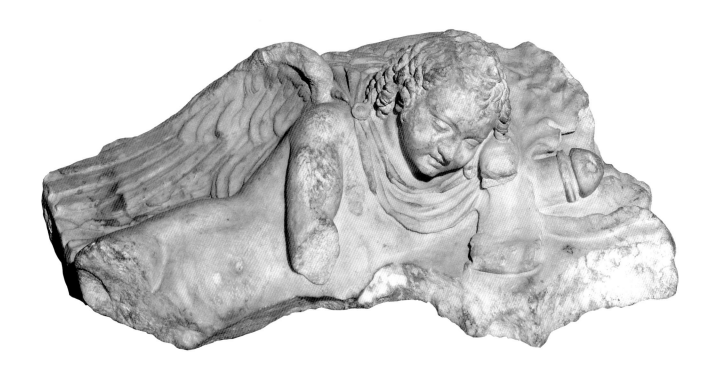

49

Sleeping Eros

ca. A.D. 70–98 copy of second century B.C.
original
Marble, seemingly from western Asia Minor,
L. 0.695 m; W. 0.45 m

The fragment is cut away at the top of the
thighs, including the wing tips. The left side of
Eros, lying on the ground, is missing, as is the
right arm at the elbow and the left hand.
There are some incrustations on the surface,
especially around the head. Drill marks are
visible in the hair and other areas.

His quiver and bow beneath his
cloak, which is fastened with a
brooch on the right shoulder, are all
on a rockwork pillow covered with
the skin of the Nemean lion. This is
a spirited, decorative version in
marble of exceptional quality of one
of the more complex Hellenistic cre-
ations in bronze or terracotta. The
original was probably made in the
second century B.C. This copy has
been dated in the Flavian period
(A.D. 70 to 98) of the Roman
Empire.

Of all the various sleeping
Erotes that have survived from
ancient times, the bronze in the
Metropolitan Museum of Art, from
Rhodes, is closest to the original
version, and Boethus has been sug-
gested as the original creator, in the
third century B.C.[1] Almost every
major site with decorative sculpture
in marble has yielded statues of the
sleeping Eros. All the examples at
Side in Pamphylia were found in the
areas around the city, indicating

they were used as monuments on
tombs, in the same way sleeping
children and little Cupids or "cher-
ubs" were placed on the graves of
babies in New England cemeteries
of the nineteenth century. The sym-
bolism went back to sculpture iden-
tified with Lysippos in the middle of
the fourth century B.C. (Capitoline
Eros, unstringing the bow of Hera-
kles) and represented Love disarm-
ing Force or Strength. Here,
confident Eros sleeps surrounded by
the trophies of Herakles (Inan,
1975, pp. 161–163, nos. 86–88;
also Parke Bernet 4753Y, 9 Decem-
ber, 1981, New York, no. 236.)

Thus, to recapitulate, various
versions of the sleeping Eros in mar-
ble attest to the popularity of one or
more Hellenistic originals, presum-
ably fashioned in bronze, but occa-
sionally in marble. The bronze Eros
in the Metropolitan Museum of Art
has been perceived as an original
creation of around 150 B.C. or ear-
lier, one that may have inspired ver-
sions in marble, although no exact,
mechanical copy has survived. The
sleeping Eros who has captured the
bow or club or lionskin of Herakles
is one concept that developed for
somnolent little love gods from the
Eros holding the bow (attributed to
Lysippos) among the popular stand-
ing, genre statues of the fourth cen-
tury B.C. The Eros asleep with
poppies in hand is the figure that
has a more funerary implication,
again the ancient equivalent of the
sleeping children in classic Ameri-
can cemeteries like Mt. Auburn in
Cambridge-Watertown.

All these small statues were cre-
ated (and copied) in an age when
divine (or human) child-forms were
popular, and when sculptors of the
late Hellenistic period were inter-
ested in new positions, new angles
(as here, lying asleep) for the divine
or human subject. And, finally, a

sleeping Eros must have been a pop-
ular work of art on the table at ban-
quets of the type described by
Petronius in his *Satyricon* or in a
garden of the type commissioned by
Cicero in his letters to his friend
Atticus. It is not without reason and
a sense of history that the young
Michelangelo's *Sleeping Cupid* was
sold to Cardinal Riario as an
ancient sculpture in marble. The
Italian Renaissance, in the traditions
of Donatello's children, admired the
phase of antiquity that produced
these sleeping Erotes (Haskell,
Penny, 1981, p. 54f.).

Provenance: From Mathias Komor, New
York.

Published: Fogg Museum, 1964, p. 114, pl. p.
27; Williams, 1968, no. 59, pl. 15; The New-
ark Museum, 1980, no. 103; Vermeule, C.,
1981, p. 186, no. 153; Mitten, Brauer, 1982,
p. 15, no. 51; Soldner, 1986, pp. 439, note
396, 477, note 732, 511, note 1005, 593, cat-
alogue nos. 111–113, vol. 1, pp. 117, no.
111, 208, 236–237, 317, 373, and 377.

1. Older discussion: M. Collignon, *Les Stat-
ues Funeraires dans l'Art Grec*, pp. 242–245,
figs. 217, 218 (both examples in the British
Museum, the second with attributes of Hera-
kles); recent consideration: Havelock, 1979,
p. 123, no. 88, illus. (the Metropolitan
Museum bronze).

Purchase from the David M. Robinson Fund,
1963.24

Small Head (of Sarapis, Zeus, or possibly Asklepios)

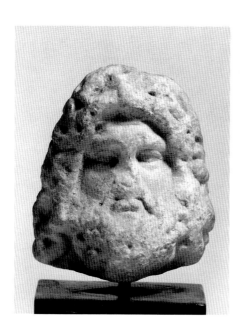

fourth century B.C. or later in type
Greek marble, probably from the Aegean islands, H. 0.07 m

The nose is missing, and the modeling is rough. There are slight touches of a simple drill-point in the hair. The four curls across the forehead that would confirm identification as the Sarapis of Bryaxis have been rubbed away. There are the remains, broken irregularly, of a polos or modius (or crown?) on the top of the head. The hair is worked in summary fashion on the back of the head.

This head would appear to come from a small statue of Sarapis seated, based ultimately on the early Hellenistic statue by Bryaxis the Younger for the Sarapeum at Alexandria. It is characterized by the very rich head of hair and beard indicative of a late Hellenistic variation on the original; the sunken eyes have something of the flavor of the ultimate prototype, despite the figure's small scale and damaged condition. There are many variations in all media in Roman Imperial times, including figures of Sarapis reclining on a couch.[1] A head of Sarapis of this type and only slightly larger in size, said to have been found in Rome and now in the Metropolitan Museum of Art, New York, was even carved in red jasper (Richter, 1954, p. 90, no. 165, pl. CXVIII).

Small statues of Sarapis (or busts based on such images) were often made of various materials—white marble heads and black schist or red porphyry bodies—to reflect the chromatic effects of the original image in the torch-lit recesses of its temple. Priests of the Graeco-Egyptian cults of Alexandria, principally Sarapis and Isis, fanned out all over the Roman Empire carrying such little busts and statues as far afield as the Mithraeum in London. A splendid small bust in alabaster dates to the years A.D. 117–138 and is in the Museum of Fine Arts, Houston (Hoffmann, 1970, pp. 72–74 under no. 22). Small statues, both in white marble (Luna and Parian), in the Liverpool collections give good illustrations of the seated Alexandrian cult image (Ashmole, 1929, pp. 21–22, nos. 38, 39).

A head in Kassel, dated in the second century A.D., has been termed Zeus and shows the same style, on a larger scale, as the head at Harvard (Bieber, 1915, p. 21, no. 25, pl. XXIII). Another head of Sarapis, sold in Lucerne, is identical in style with the Harvard example and is more complete, the ends of the beard, neck, and bust being preserved (*Ars Antiqua* A.G., Auction V, 7 November, 1964, p. 7, no. 9, pl. V). Such heads could also be used for Graeco-Roman statues of river gods, perhaps Father Nile but probably also local streams, as an example in Bologna.[2]

Unpublished.

1. Kater-Sibbes, 1973, especially the complete statuette from Alexandria in the Lewis Collection of Corpus Christi College, Cambridge: p. 3, no. 8, pl. I, for the type of figure that produced this head; also, Grimm, Johannes, 1975, p. 22, nos. 30–32, pls. 62–66.

2. Brizzolara, 1982, p. 151, illus. Compare also the fragmentary head, identified as Asklepios, from Egypt: *Sotheby Sale*, London, 17–18 July, 1985, no. 310. No. 278 is a marble bust of Sarapis with a similar, complete head.

Gift of Mr. and Mrs. William de Forest Thomson, 1919.509

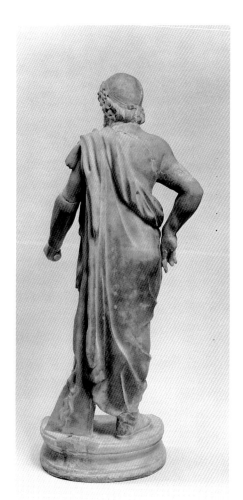

51

Statue of Asklepios Standing, with the Left Hand Extended

Roman copy of Hellenistic original, A.D. 150. Greek mainland marble, H. (as restored) 1.03 m, H. (of ancient torso) 0.70 m

The statue was reassembled from many parts. A drill was used in the hair and beard. Only the torso from the neck to the ankles is ancient.

The statue is a Roman copy of a standard Hellenistic Asklepios, like the cult images from Pergamon. The torso was restored in the seventeenth century to create a thoroughly Italian Baroque image of the god of medicine, replete with a scroll in the lowered, extended left hand. A *puntello* on the drapery above the left thigh suggests this hand originally held the snake-entwined staff.

Unpublished.

Gift of Dr. Rupert Norton, 1906.7

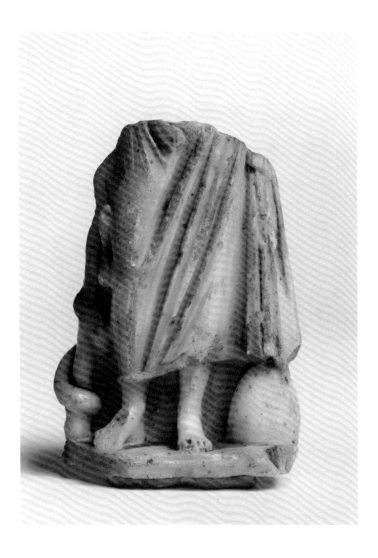

52

Lower Part of a Votive
Statuette of Asklepios

Roman Imperial period, A.D. 150-200
Alabaster-like marble, H. (max. as preserved)
0.125 m

Broken across the waist, with traces of the
right hand remaining at the top of the staff.
The front of the right foot is damaged.

The god stands on a thin plinth
with a tenon for insertion below.
He held the serpent-entwined staff
in his right hand, and the *omphalos*
was set beside his left foot. The
cloak falls to the plinth all along the
back, with a series of stylized zigzag
and diagonal folds that contrast
with the deeper rendering of the fig-
ure at the front. The carving of the
flesh surfaces, including snake, staff,
and *omphalos*, is very smooth, and
the toes of the left foot are rendered
in detail.

This small statue is a summary
but vigorous reflection of a famous
Roman copy in the Museo Nazio-
nale, Naples, the original of which
goes back through the art of Hellen-
istic Pergamon to the fourth century
B.C. (Winter, 1898–1902, pl. 309,
no. 3). The general type has been
named the "Asklepios Amelung"
after the famous German archaeolo-
gist Walther Amelung who sought
an identification with the Attalid
cult statue by Phyromachos at Per-
gamon (Uhlmann, 1982, pp. 33–
34). Variations of the older statue
or statues have survived in replicas,
as here, of all sizes and on Perga-
mene coins from Antoninus Pius
(A.D. 138–161) through Caracalla
(A.D. 211–217) and later.

Provenance: Probably from Asia Minor or
Italy, or Egypt.

Published: Uhlmann, 1982, p. 36, no. 11 in
list of replicas.

Transfer from Department of the Classics,
Harvard University, Haynes Bequest 1912,
1977.216.2507

Torso of a Small Statue of the Triple Hekate

fourth century B.C. or later
Greek marble, probably Attic, H. (max. as preserved) 0.215 m

The head is missing and the lower part is broken away diagonally from the waist of one figure to the feet of the others. The surfaces are battered and abraded, but not unpleasantly so.

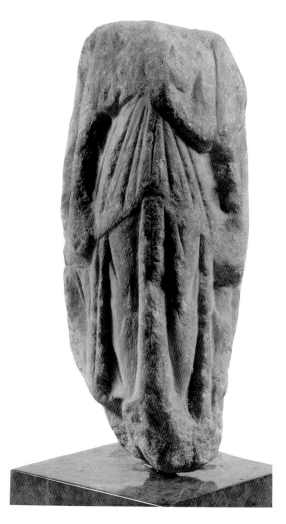

A hound looks upward, right to left, between the two best-preserved figures. The one on the dog's left holds an object in her lowered right hand and places the left on her chest. The one to the dog's right, or rear, is similarly poised, holding a sack, jug, or situla in the lowered right hand. The damaged figure also holds a lumpy object in the lowered right hand, but appears to hold a torch in her left hand. All three "Hekates" wear a high-girt garment with long overfold and ample drapery down to the feet.

A similar, less elegant and slightly smaller statuette is in the Museum of Fine Arts, Boston, a 1918 gift of Mr. and Mrs. William de Forest Thomson, from Greece (Comstock, Vermeule, 1976, p. 65, no. 104). The edges of the high-girt peplos on the Harvard figures are more elegantly curved away from waist to hips, although here too, Archaistic mannerisms are missing. The small marble statues or statuettes of the Triple Hekate from Athens and Ionia (Smyrna) are usually closest to the supposed canons of Alkamenes in the second to third quarters of the fifth century B.C., as Berlin, nos. 171 (from a well at the foot of the Acropolis), 172 (Smyrna), and 173 (Athens) (Conze, 1891, pp. 74–76; Harrison, 1965, pp. 86–107).

A diminutive figure of Pan flanked one of the three figures of the goddess Hekate in a small statue, with somewhat more archaistic peploi, which was brought from Alexandria in Egypt to Trinity College, Cambridge, in the nineteenth century and is now in the Fitzwilliam Museum.[1] The condition of the Norton statuette could allow a similar little figure in the area between two of the bodies of the Triple Hekate.

Unpublished.

1. Nicholls, 1971, p. 80, no. 8, and a full bibliography on such Attic sculptures in marble; see also Nicholls, 1961, p. 47, no. 1, a Roman copy of the High Classical Hekateion, likewise in the Fitzwilliam Museum.

Gift of the Misses Norton, XKA 60

Small Female Head

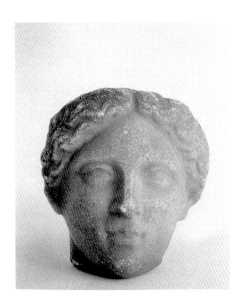

first century A.D.
Marble from Attica, seemingly Pentelic,
H. 0.074 m

The top of the hair, the back of the head, and
the neck are missing. The top to a slightly
diagonal line across the back of the head
appears to have been finished in another
material or covered with plaster or a veil. The
break at the back is flat, slightly irregular, and
the break across the neck is more irregular.

This head is almost certainly a
Roman copy of the first century
A.D. from (or of) a Hellenistic statue
of about 200 B.C. The hair is parted
in the middle and waved. The fea-
tures are rather flatly modeled, the
face being almost diamond-shaped,
the eyes dreamy, the nose pointed,
and the lips generously curved.

One can see the model of a
major Pergamene image in the man-
ner of the fifth century B.C. for this
head. The overlifesized head of
Hera or Demeter given to the
Museum of Fine Arts, Boston, by
the symphony conductor Hans von
Bülow in 1889, shows the Perga-
mene intermediary between the
Lowell head and Pheidian images of
the fifth century B.C. (Comstock,
Vermeule, 1976, p. 58, no. 90). A
mannered version of this type of
head combines both the elements of
the fifth century B.C. and the soften-
ing influences of Praxiteles around
350 B.C., all put together in the late
Hellenistic period and then copied
for decorative purposes under the
Flavians or Trajan, that is, from

about A.D. 70 to 115 of the Roman
Empire. The copy in the Museum of
Art of the Rhode Island School of
Design was found in Rome about
1926 (Ridgway, 1972, pp. 71–72,
189–192, no. 27). A more ani-
mated, more Pergamene head of this
general type, a Roman copy slightly
larger than lifesize and therefore
based on a cult image, seems to
have come from Italy, probably the
area around Rome, and is in the
Wellesley College Museum of Art
(Vermeule, C., Vermeule, E., 1972,
p. 282, illus.).

Small heads of this general type
and in this style of carving have
been found among the late Hellenis-
tic sculptures of Delos. When bodies
have been preserved, they range
from Artemis with her stag to san-
dal-binding Aphrodites (Marcadé,
1969, pls. XLI–XLVII). A companion
from the world of the ultimate pro-
totype(s) exists in a smallish Pentelic
marble head, seemingly from a high
relief and dated 425–400 B.C., from
Cyrene (Paribeni, E., 1959, pp. 32–
33, no. 47, pl. 47).

Unpublished.

Gift of Dr. A. Lawrence Lowell, 1933.157

Torso of a Female Figure in Motion, probably Artemis (Amazon or Virtus)

Late Hellenistic, 100–50 B.C.
Marble, seemingly from mainland Greece,
possibly Pentelic, with slight crystals,
H. 0.132 m

The head, arms (left from above the elbow),
right shoulder, and the lower part of the torso
are missing. There is a big chip in the right
part of the back, where there are remains of
an iron dowel. The right arm and section of
drapery were made separately and fitted to
the sides (and back) with the dowel.

She wears a girt tunic with a V-
neck, a brooch on the left shoulder
and a baldric or belt from the right
shoulder to the left side. The drap-
ery is arranged in swirls, with diag-
onals at the lower back to

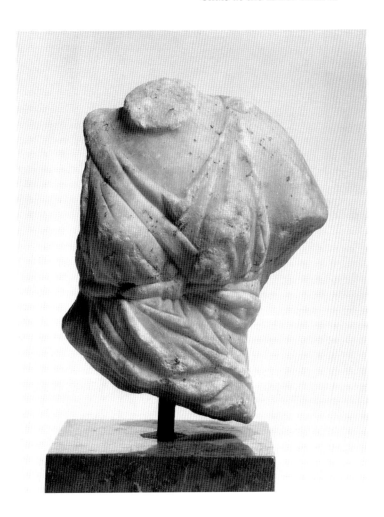

emphasize the pose. It is a work of
considerable liveliness and quality.
The figure appears to have been
running, or possibly bending for-
ward as part of a group like Penthe-
silea in the Pergamene composition
of Achilles and the dying Amazon
queen, or Artemis and Iphigeneia in
the group of the goddess substitut-
ing the stag on the altar. The cos-
tume makes the latter suggestion a
strong possibility: this small group
could show Iphigeneia with both
breasts covered (Bieber, 1961, p. 77,
figs. 268–271) or this figure could
be the Artemis who leans forward
to rescue the girl as she substitutes
the hind (Poulsen, 1951, pp. 81–83,
nos. 83, 83a, pl. VII; Robertson,
1975, pp. 476, 534, pl. 173c). The
Greek sculptural type known as the
Artemis Rospigliosi, leaning for-
ward and in motion, could look like
this small torso (Paribeni, E., 1959,
pp. 71–72, under nos. 163–165,
pls. 94, 95).

The torso of Penthesilea from a
replica of the group in the frigidar-
ium of the Baths of Hadrian at
Aphrodisias, from its condition of
preservation, can be compared with
this smaller fragment. The Aphrodi-
sian statue is a Graeco-Roman rep-
lica and has the characteristic
Hadrianic dryness and precision of
drapery that contrasts with the
looseness and freedom of the cos-
tume visible in the torso illustrated
here. The unfinished running
Artemis from a sculptor's atelier at
Aphrodisias is closer to the Harvard
torso in style as well as arrangement
of drapery (Cook, Blackman, 1971,
pp. 50–51, figs. 14, 15).

Unpublished

Gift of Mr. and Mrs. William de Forest
Thomson, 1919.508

Small Female Head

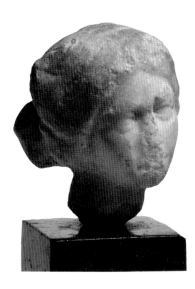

Hellenistic, 50 B.C.
Crystalline Greek marble, probably from the Greek islands, H. 0.054 m

The face is somewhat battered, with most of the nose and lips missing. The area above the eyebrows is also scraped, as is the surface around the subject's own left ear. The head is tilted on its neck toward its own right side.

This small head appears to come from a draped figure of a Hellenistic type based on fourth century B.C. models and used, *inter alia,* for Muses. The hair is tied around the top of the head with two rudimentary fillets, one of which extends to tie up the bun at the back of the head. The face provides a very distant echo of the style of Skopas.

An Aphrodite with a small Eros on her left arm, a late Hellenistic variant of the draped "Venus Gene-trix" type, was found together with an inscribed base "To (the) Syrian Aphrodite," at the shrine of Ptoan Apollo in Boeotia; the head is in a class with this small example (*Sotheby Sale,* New York, 16 May, 1980, lot 264). The so-called "Daughter of Asklepios" of about 270 B.C. from the Asklepieion of Kos, in the Landesmuseum at Stuttgart, is turned in the opposite direction and looks more decidedly upward but gives a frame of reference for what is seen in this small head (Schefold, Cahn, 1960, pp. 470–471, no. VII 363). The Stuttgart head is perfectly preserved, enabling us to visualize the early Hellenistic characteristics surviving, albeit with the wounds of time, in the Norton head.

Unpublished.

Gift of the Misses Norton, 1920.44.148

Headless Statue of a Draped Woman

fourth century B.C.
Marble from northwest (?) Asia Minor,
H. 0.774 m

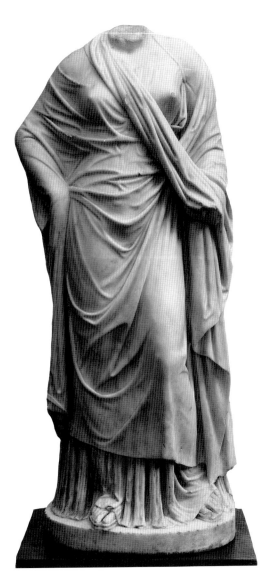

She is missing only the head which may have been made separately and attached, but is more likely a clean break across the lower neck. Also missing, and smoothed off, is the end of the drapery at the left hand. The weight at the end of the drapery above the left foot is broken off. The surfaces, although cleaned, are generally in excellent condition.

She is standing, wearing a long chiton and an ample himation. The garment conceals her right hand in the drapery hanging down her right side and the left hand in the folds that fall from the right shoulder to the left side, and the part of the cloak crossing from the right side to the left shoulder. The polish suggests the early Antonine period of the Roman Empire, but the cleanness of the drillwork could put that date back in the Flavian age.

This small statue has been recognized as a reduced replica of the *Demeter* in VI.5 of the Galleria dei Candelabri of the Vatican (Lippold, 1956, p. 410, no. 5, pls. 174, 175). The Vatican statue, a smaller version in the University Museum, Philadelphia, and a lifesized statue in the Torlonia Collection in Rome all have heads preserved with the figures, and show a young lady with a so-called "melon coiffure." The attributes preserved in part in the lowered left hands of the Vatican and Philadelphia statues included two poppy-buds and sheaves of wheat. The youthful heads, at least one if not all of which must be ancient and pertinent, suggests the subject is Kore rather than the older, more mature Demeter. In a well-reasoned publication of the small statue in the University Museum, Karla K. Albertson has suggested the original should date about 240–230 B.C., when Berenike II of Egypt was being represented in Ptolemaic decorative art. Versions from full-scale to tabletop statuette were carved from late Hellenistic times onward for shrines and houses or gardens from Delos and Crete to Pompeii (Albertson, 1979, pp. 176–179, under no. 86).

As with other, popular draped statues available in Rome from Renaissance times onward, the *Ceres* or *Demeter* of the Galleria dei Candelabri was copied by Neo-Classic sculptors and decorators in various materials. One of these statues, 1.16 m high, is the *Ceres* by François Joseph Bosio, carved about 1800 and given to the Boston Athenaeum in 1845 (this and much other information adduced by Maxwell L. Anderson).

The common characteristic of most of these statues, ancient and modern, is their varying size, most being large statuettes but including a full-scale example. This suggests a variety of uses among the ancient sculptures, some for votive figures in small shrines or funerary portraits. The Grenville Winthrop statue could have been a portrait, with the divine identification of the prototype removed by concealing the left hand in the cloak.

The perception that these statues and reduced versions can be vehicles for imperial portraits is strengthened by the appearance of one of the imperial mothers in this costume on the south frieze of the Ara Pacis Augustae. She may be Julia, daughter of Augustus, following her husband, Agrippa (Bieber, 1977, p. 191, pl. 134, fig. 792).

A somewhat larger, allegedly ancient replica of this statue, specifically the Winthrop marble, was sold at auction in London as work of the first century A.D. Save for damages to the front of the plinth, the preservation is almost identical.[1]

Provenance: Purchased in 1928, through Harold W. Parsons from M. Altounian-Lorbet, Paris.

Published: Fogg Museum, 1969a, The Checklist, p. 256.

1. H. 0.99 m, *Sotheby Sale*, 13 July, 1970, p. 103, no. 178, plate opposite.

Bequest of Grenville L. Winthrop, 1943.1046

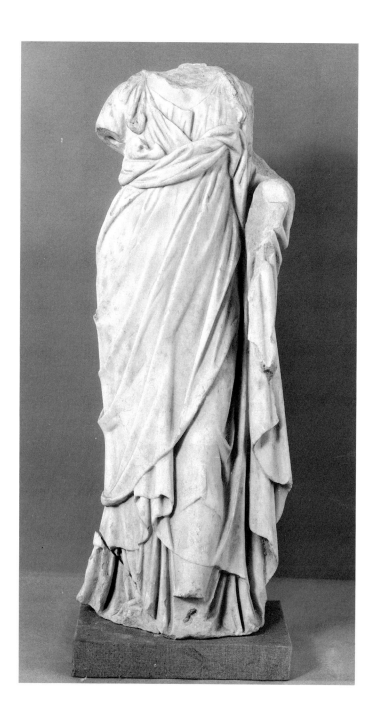

Headless Statue of a Draped Woman, perhaps representing Kore or a Muse

Hellenistic type, 150 B.C.
Marble, H. 0.718 m

Besides the head and neck, missing parts include the right arm which was made separately and doweled on, the left shoulder, the left hand, the left foot, and part of the right. There was a trace of red paint on a strap behind the shoulder. The workmanship at the back is sketchy, as if the statue were carved to be set against a wall. It was found in a cistern.

The more complete figure from the same cistern has been named *The Kore,* while this statue was published as *Demeter,* but the names may be reversed. If the figure with its head is an Antonine work from the so-called School of Aphrodisias, then this statue ought to have been made in the same atelier in the same period (Vermeule, Anderson, January 1981, pp. 16, 19, figs. 35, 36; Flusser, 1975, pp. 13–20, pl. 2; Wenning, 1983, p. 118, section 4f).

The figure wears a chiton and himation, the folds of the latter being gathered around the left arm. There is a long lock of hair on each side of the head and a row of straight tresses behind.

Although precise replicas of this statue are difficult to isolate, the perception that Kore and Demeter are represented is strengthened here by the fact that closely related statues were used as portraits of women as priestesses of Demeter-Ceres (and Kore-Persephone) in the Hadrianic and Antonine periods (Bieber, 1977, pp. 163–167, pls. 124, 125, figs. 730–739); also the famous lady on the Ara Pacis Augustae in Rome, who is leading a little boy by the hand and is looking back to talk to her husband (Antonia and Nero Drusus?) (Bieber, 1977, p. 164, fig. 727).

Published: Crowfoot, Crowfoot, Kenyon, 1957, p. 74, no. 6, pl. VIII, figs. 2, 3.

Gift of the Harvard Expedition to Samaria, 1934.19

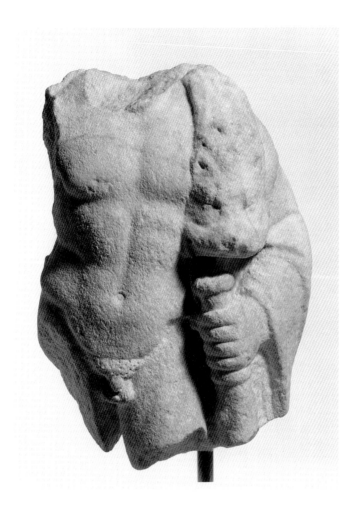

Weary Herakles

Roman copy of Lysippan type of fourth century B.C.
Dolomitic marble, probably from Thasos, H. 0.368 m

The head and lower legs are missing. The head and neck are broken away irregularly, as are all of the right arm, the right leg across the upper thigh, and the left leg across the middle of the thigh.

This is a Roman version of one of the statues associated with Lysippos, a figure grasping a club in the left hand and wearing a lionskin like a cloak over the left shoulder and arm. The right hand (all of the right arm is gone) presumably held the apples of the Hesperides against the right rear buttock.

Among the many copies and variants of Weary Herakles, rustic examples such as this have been found in Gaul, western Germany, North Africa, and Asia Minor.[1] A section of an Attic relief of the Roman Imperial period in Leiden shows a Herakles of this type, grasping his club in similar fashion. The whole figure is in mirror reversal, as happens more than once with Weary Herakles in Roman art, both in decorative statues and reliefs in architectural settings.[2]

Published: Fogg Museum, 1961, p. 27, no. 214

1. Vermeule, C., 1980, pp. 325–326, no. 10, a limestone example from Valkenburg; Inan, 1975, pp. 85–91, under no. 29, pl. XL, an appreciation of the quality of the various versions in all sizes and styles.

2. Bastet, Brunsting, 1982, p. 11, no. 26, pl. 6. Compare also, in the same direction as the David M. Robinson figure and for related rustic qualities, the statuette similarly preserved from the Michel Abemayor estate and, therefore, from Roman Egypt: *Sotheby Parke Bernet*, Sale 3934, New York, 11 December, 1976, p. 29, no. 125.

Bequest of David Moore Robinson, 1960.450

Head of a Nymph or a Hermaphrodite

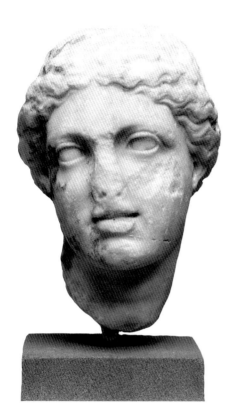

Roman copy of late fourth century, or early third century B.C. original
Greek marble, H. 0.153 m

The nose is broken, and the surfaces have iron stains, especially on the left eye, right cheek, and neck. There is slight chipping on the lips and left cheekbone.

A single figure or a monumental version of a statue related to fore-runners of the well-known group of the satyr wrestling with a hermaphrodite. This head, and its complete figure, seems to have been carved in the second century of the Empire. It features more idealization than do the commonest versions of the groups involving a hermaphrodite in compromising poses, and this head might come from a separate, more ideal and reposeful statue of a nymph or a hermaphrodite. Graeco-Roman copyists offer numerous instances of statues produced independently from groups, with appropriate changes or simplifications, to create a free-standing, decorative figure for an urban courtyard or a rural villa with park or garden.

A small statue, with a restored head, of a hermaphrodite holding Eros found in the ruins of a villa near Rome, shows the type of free-standing, decorative statue from which this head could have come. Such statues were carved in Athens and the Greek islands for export to the country seats of Italy (Jones, 1912, p. 181, no. 109a, pl. 42).

The more vulgar Hellenistic and Graeco-Roman heads, with the thick hair of satyrs and the puffy cheeks of a baby, are also found together with satyrs or Pan grasping them and as free-standing figures. An example in the Museum of Fine Arts, Boston, has a large wreath of vine leaves and grapes in the hair, suggesting a young maenad rather than a hermaphrodite. Like the Harvard head, this example is slightly larger than many of the surviving groups and fragments thereof, which were set in the gardens of Graeco-Roman houses and in the niches of baths and gymnasia (Comstock, Vermeule, 1976, p. 126, under nos. 194, 195). In general, when grouped together the childlike nymphs grasp their satyrs by the hair while the hermaphrodites shove them in the face (Ridgway, 1972, under no. 23, pp. 63, 64, 178–180).

Provenance: The head is from Greece.

Published: Fogg Museum, 1971a, The Checklist, p. 150.

Gift of Edward W. Forbes, 1899.10

Torso of a Statue of a Hermaphrodite

Roman copy of a figure created probably in the second century B.C.
Marble, H. 0.355 m (including base)

The head, arms, and all below the waist are missing. There are drill holes in the right arm and the neck. The sculpture is chipped, especially on the left shoulder, the breasts, and the right side of the body.

The torso was turned a little to its left. The right arm was raised, and the left arm was lowered. What remains shows a body that was well proportioned, almost muscular.

The complete statue showed the figure leaning against a support below the left arm, with the end of the cloak around the lower limbs brought over this wrist and then hanging down in zigzag folds. A lifesize version of this figure was found at Pergamon, and a small statue, like this fragment, was published in the possession of Mr. Piero Tozzi, New York (Bieber, 1961, pp. 124–125, fig. 492). The original concepts may go back through the third century B.C. to the age of Praxiteles in the middle of the fourth century, but these underlife-sized hermaphrodites appear to copy creations made at the outset of the so-called Hellenistic "rococo," around 150 B.C. They would have been carved in Graeco-Roman times for courtyards and the gardens of villas, although the most famous hermaphrodite from Pompeii (Villa Matrone near the seaport) derived from a noble fifth century B.C. model like the Diomedes of Kresilas (Paribeni, R., 1902, p. 576, fig. 4; Reinach, 1897–1930, III, p. 243, no. 6).[1]

In the Harvard torso, it is a step not at all far to the two-figure groups of Pan or a satyr advancing on a seated hermaphrodite with lust in his heart and on his mind. Indeed, in pose and style this torso is very like the corresponding section of the group from the Western Baths at Cherchel, carved in Italy of Luna marble (Gauckler, 1895, pp. 123–124, pl. X). Similar characteristics are seen in the upper body of the hermaphrodite found in the Palaestra at Salamis on Cyprus (Karageorghis, Vermeule, C., 1964, pp. 29–30, no. 21, pl. XXVII).

Unpublished.

1. Museum of Fine Arts, Boston, no. 1981.754. *The Museum Year: 1981–82*, p. 44; Comstock, Vermeule, 1988, pp. 40–41, no. 29.

Gift of Mr. and Mrs. William de Forest Thomson, 1919.510

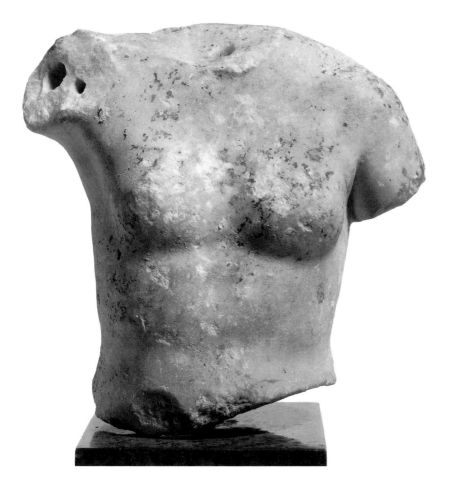

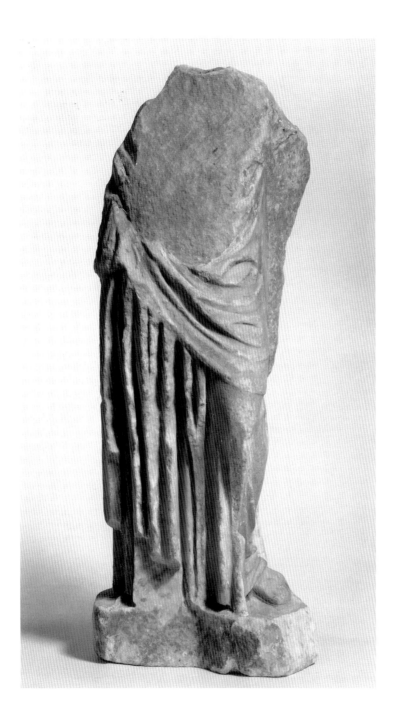

Standing Draped Female Figure

second century A.D.
Marble from western Asia Minor, H. 0.37 m,
H. of plinth 0.035 m

The head and arms are missing. There are damages on the breast and back. The lower front edge of the drapery is missing. The right foot in its slipper or boot and the section of plinth in front are also broken away. There are traces of repair down the left side.

The figure is of a type of the fifth century B.C., solidly reflecting a work of about 350 B.C. It is termed a Roman copy of the second century A.D. She stands with the weight on the right hip, the left knee bent. The drapery is arranged in diagonals across the torso, while the folds beneath, covering the legs, are in sharp, deeply cut verticals. The upper outer garment, a heavy mantle, also covered the upper part of the extended left arm (which may have been made separately) and was represented in heavy folds ending in a curve at the lower back.

The remaining part of the small statue is similar to the bronze Athena from the Piraeus, in the National Museum, Athens (Bieber, 1977, pp. 33–34, fig. 61). This prototype would take the figure back at least to 350 B.C., and the extra wrinkles in the apron-like overgarment are explained as variations of the adaptors and copyists (as in the Athena Mattei in the Louvre, Paris: Waywell, 1971, pp. 373–382, pls. 66–72).

Unpublished.

Gift of the Misses Norton, 1920.44.151

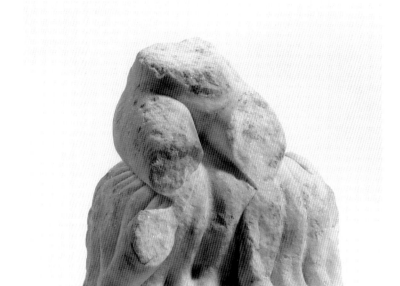

Fragment of a Seated Nude Female Figure

second century A.D.
Marble from mainland Greece, Pentelic (?),
H. 0.186 m, diameter of base 0.152 m

All parts are missing above the waist; the knees and part of the left thigh are also missing. The surfaces are damaged and worn.

The statue appears to have been a Roman copy of a Hellenistic type, probably carved in the second century A.D. The nude figure is seated, with legs a little apart, upon some drapery spread over a pyramidal-shaped rock, set on a rough, circular base. Part of her left hand touching the drapery beside her is visible. The drapery flows down in wide folds and stops just beneath her feet. She is seated slightly to the right of the seat.

The figure is patently fat and unideal. The subject may be Lamia seated in the country; known from Aristophanes and various Greek vases, this very rotund, sometimes sphinx-like creature would be a very suitable subject for the decorative naturalism of Hellenistic sculpture (Vermeule, E., 1977, pp. 296–297).

Unpublished.

Gift of the Misses Norton, 1920.44.135

Fragment of Aphrodite

Greek(?), Late Hellenistic to Graeco-Roman,
50 B.C. to A.D. 50
Marble from western Asia Minor, H. 0.165 m

The nude figure is broken irregularly on a line
below the waist and across the buttocks,
again at the support below the drapery on the
subject's left side, and below the knees. The
surfaces of the flesh have a polish that sug-
gests Greek Imperial work from Aphrodisias
in Caria.

This small, decorative statue of
Aphrodite emerging from the sea
was a type popular in Hellenistic
and Roman times. Here the carving
is skillful and effective, the vigor
seen in the drapery contrasting with
the smoothness of the body, left
hand, and legs.

The most famous statue of this
general type is the Aphrodite in the
Museo Nazionale, Syracuse (Winter,
1898–1902, p. 380, no. 2). Statu-
ettes of this type in marble often
have heavy, molded plinths and
smaller figures of Eros or Priapos as
part of the support at the left side of
the goddess. Such is the case with a
relatively complete marble group in
the London art market a decade ago
(*Sotheby Sale*, 10 July, 1972, Lon-
don, no. 185, pl. XLIX). A fragment
similar to the Harvard example, but
of patently poor workmanship, was
found at Corinth (Johnson, 1931, p.
44, no. 49). A full, fleshy, suavely
finished statue of good quality was
found at Aquileia and is in the
Museo Archeologico there (Scrinari,
1972, p. 13, no. 35). Cyrene has
yielded at least four such figures, of
varying quality (Paribeni, E., 1959,
pp. 101–102, nos. 270–273, pl.
132).

The complete statuette in the
Side Museum, found near Manav-
gat, has the diademed head seen in
so many small statues from the
workshops of Aphrodisias in the
years A.D. 200–300 or later. The
traditional seated sleeping Eros
appears as a support beside the
draped right leg, and the ensemble
is set on a molded plinth. A some-
what larger figure in the Side
Museum has the Eros on the other
side, near the left leg (Inan, 1975,
pp. 152–154, nos. 80, 81, pls.
LXXII, LXXIII).

Unpublished.

Gift of the Misses Norton, 1920.44.146

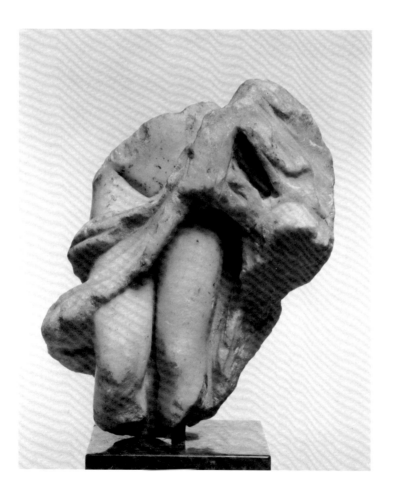

Fragment of the Base and the Area Below the Knees of a Statuette, Aphrodite(?)

ca. 100 B.C.
Marble from the Greek islands, H. 0.115 m,
H. (plinth) 0.032 m

The statuette is cut off at the knees; only the lower legs and feet remain on a circular plinth. The surfaces are chipped and abraded.

From the heaviness of the drapery behind and its elegance in front, this could be a version of the fifth century B.C. standing Aphrodite wrongly called the Venus Genetrix from her appearance and so labeled on Roman coins. The feet are bare, suggesting a goddess, and the folds of drapery falling vertically in front could suggest Isiac dress above. The cloak is not fringed, however, and an Alexandrine Venus Genetrix slightly influenced by Isiac types seems a better identification.

Just such a complete statuette in marble, minus the attribute in the left hand (which, if a jug, could make the figure a fountain nymph), was in the London art market a decade ago (*Sotheby Sale*, 10 July, 1972, London, no. 186, pl. XLIX). Another, slightly more refined but missing the lower limbs, feet, and plinth, was also in London (*Sotheby Sale*, 4 May, 1970, London, p. 60, no. 166, plate opposite). Sometimes the drapery around the lower limbs of these small statues is very transparent, leaving the heavy bunch only where it falls down between the legs and spreads out onto the plinth. Such is the case with the diademed Aphrodite with Eros on the plinth at her left side found near Manavgat and with the sculptures in the museum at Side. It appears to have been carved with portrait features, as late as the year 300 A.D. (Inan, 1975, pp. 41–43, no. 8, pl. XX).[1]

The very elegant drapery of the Aphrodite of the Fréjus type (a copy of about A.D. 100) in the Museum of Art, Rhode Island School of Design, Providence (no. 23.351), shows how the drapery of this fragment was reduced and greatly simplified from the general prototype created in Athens around 420 B.C. and its many late Hellenistic and Roman imperial adaptations (Ridgway, 1972, pp. 40–42, no. 14, illus. pp. 159–160, fig. 3, p. 161).[2]

Unpublished.

1. For the treatment of drapery over the lower limbs, also see: *Sotheby Parke Bernet Sale*, New York, 14 December, 1978, no. 251; and, generally, Bieber, 1977, pp. 46, 47, pls. 23–28, figs. 124–156.

2. The true Roman copies are very different in feeling, much harsher: *Sotheby Sale*, London, 17–18 July, 1985, no. 339.

Gift of the Misses Norton, 1920.44.149

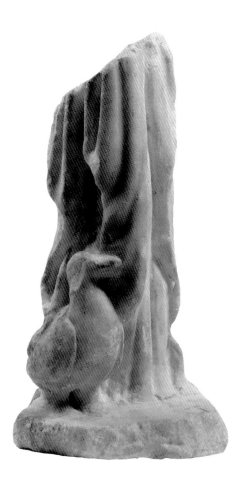

Lower Portion of a Standing Statue, a Duck or Small Goose at the (Right) Side

Late Hellenistic or Graeco-Roman, 50 B.C. to A.D. 50
Marble, H. 0.178 m

The figure is broken below the waist by a flat, diagonal cut. The right side of the duck head is chipped. The plinth is irregularly cut. There are surface incrustations.

The folds of drapery, as preserved, are deep and fall in such a way as partly to cover the back of the bird. The ensemble stands on a plinth about 0.025 m thick or deep. A portion of the fragment is smoothed down one edge, but this contour has been left unmodeled.

The piece may have been part of a draped support or even a draped herm attached to the statue. A small version of the so-called Pothos of Skopas comes to mind. Copies of this statue of "Desire (or Yearning and Longing)" survive in marble, a (winged) youth gazing upward with frowning emotion while leaning against a draped support with a goose on the plinth; the image also appears in the minor arts, on gems. Skopas made the original of this version of the personification of Love's effects for a temple of Aphrodite on the island of Samothrace (Arias, 1952, pp. 89–91, 131–134, pls. XIII, XIV; Richter, 1970, p. 213, note 50).[1]

Unpublished.

1. Stewart, 1977, pp. 144–146, with list of four statuettes and representatives in other media, among all the copies; also pp. 108–110, on the Pothos as a late work of the master.

Gift of Mr. and Mrs. William de Forest Thomson, 1919.511

Head of a Woman, from a Votive Relief

Hellenistic period, or perhaps 330–280 B.C.
Marble from the Greek mainland, H. 0.076 m

The head and part of the neck in relief are broken away from the background. The face and hair are very worn.

This head could be Artemis, Demeter, or a standing votary, torches in hand, in a votive relief of fourth-century B.C. type. Such a figure, albeit veiled and with a crescent above her head, appears on the right side of an Attic votive relief to Apollo or a Deme and Artemis in the Museum of Fine Arts, Boston (Vermeule, C., 1981, p. 92, no. 62). There are a number of such reliefs in the National Museum, Athens, from sites and shrines in Athens and all about Attica (Svoronos, 1908, pl. LXXVII, no. 1461). A splendid example in the Louvre, Paris, shows a similar head on the majestic Demeter at the right end of a long rectangular relief with eight people of Attica and two elders (heroes or Demes) approaching the altar in front of the goddess (Simon, 1954–1955, p. 48, text pl. 25).

Unpublished.

Gift of the Misses Norton, 1920.44.160

Head of a Female Figure

Seemingly Hellenistic, 150–50 B.C.
Marble from the Greek islands(?), H. 0.051 m

All surfaces are very worn.

The hair is drawn back into a bun above the back of the neck. This head could have come from a small figure of a draped woman, the late Hellenistic counterpart in marble of Tanagra figurines.

Small statues and statuettes of Aphrodite in the nude, sandal-binders, figures like the Medici Venus, and related "Rhodian nymphs" also have heads similar to this example (Marcadé, 1969, pls. XLVII–XLIX). Draped statues or statuettes with this form of fourth-century to Hellenistic head are often little more than dressed-up "fountain nymphs" leaning against supports (Marcadé, 1969, pl. XXXI).

Unpublished.

Gift of the Misses Norton, 1920.44.191

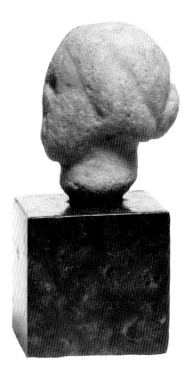

Fragment of a Head of a Female Figure

Greek, seemingly Hellenistic, 150–50 B.C.
Marble from the Greek mainland, H. 0.067 m

The upper left side of the face is broken away.
The nose and chin are damaged.

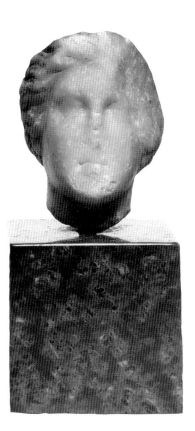

This head is a pale reflection of the major cult images of Pheidian Athens of the Hera or Demeter type surviving in overlifesized copies. It probably came from a small draped statue.

The Demeter of the Vatican offers an indication of the type of colossal Roman copy that suggests the source for a small Hellenistic head of the type at the Harvard University Art Museums (Winter, 1900, pl. 282, no. 8).

Small statues or large statuettes in the best Greek traditions of 440–340 B.C. and representing Demeter or Persephone in the full, heavy garments of major cult images were popular in Attica, and, especially, the Greek islands. The Demeter or Persephone von Matsch, once in Vienna and now in the Indianapolis Museum of Art, represents the latest end of the spectrum (Vermeule, C., 1981, p. 86, no. 56). At the beginning of the fourth century B.C. we have the Demeter in the Museo Archeologico, Venice, which has the mantle drawn up over the head and a heavy peplos below (Fuchs, 1969, pp. 212–213, fig. 228). It seems safe to say that when these small statues in the sartorial taste of Kephisodotos's Eirene with Plutos are veiled, they represent the elder agricultural goddess. When they are unveiled, as here and the small statue from the von Matsch collection, they show Demeter's daughter Persephone.

Unpublished.

Gift of the Misses Norton, 1920.44.141

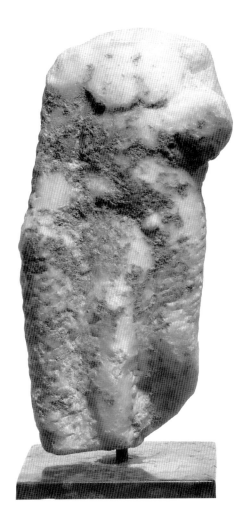

Fragment of a Statuette of a Man

Late Hellenistic period, 50 B.C.
Marble, seemingly from the Greek islands, H. 0.14 m

The head, neck, lower left leg, feet, and plinth are broken away. The surfaces at the front have heavy incrustation. The statuette is unfinished.

The subject was shown in the heroic nude, and may be Herakles with his club in the lowered right hand and the apples of the Hesperides in the raised extended left hand. This arm was probably also wrapped in the skin of the Nemean Lion, but the surviving traces cannot confirm this hypothesis.

If indeed it is Herakles, the type is derived from a statue created around 350 B.C. in the style of Skopas. The lost original statue, in marble, could be that by Skopas himself which appears to have been set up in the gymnasium at Sikyon and which can be visualized from two complete Roman versions, one in the Los Angeles County Museum (sometimes on loan to the J. Paul Getty Museum) and one at Osterley Park House in Middlesex, near London Airport (Lattimore, 1975, pp. 17–23, figs. 1–5; Caputo, Traversari, 1976, pp. 26–27, no. 6—a small statue, headless, with extensive parallels).

The nature of the carving and the type of marble, combined with the size, suggest this unfinished statuette could have come from one of the workshops on Delos before the sackings of 88 and 69 B.C. (Marcadé, 1969, p. 505, pl. IV, especially nos. A 3825, A 6622, "sculptures inachevées"). Comparable for complexity of subject is the small Apollo, of the Cleveland Museum type, with the lower limbs unfinished because the marble split across the tripod support, left foot, and plinth; the small statue was once in the art market in Athens and Copenhagen (Arndt, Amelung, Lippold, 1893–1950, no. 4996).

Unpublished.

Gift of the Misses Norton, 1920.44.193

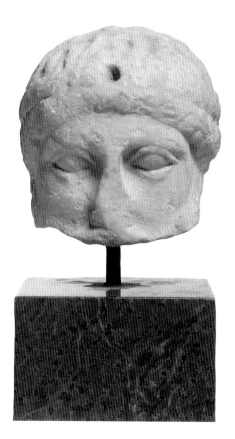

Part of a Head of a Bearded God

Archaistic and Neo-Attic type, probably
Augustan or Julio-Claudian, ca. 31 B.C.–
A.D. 69
Pentelic marble, H. 0.09 m

The break runs irregularly through the
mouth. The nose is broken away. The sculp-
tured surfaces are worn and weathered(?).
The back of the head was finished as a flat
surface and has been smoothed off. There is a
rectangular hole in the middle of the fillet
around the forehead.

A dignified, bearded divinity was
represented, Dionysos or Hermes.
He has ample hair combed forward
from the top of his head to the
broad band or fillet, and somewhat
archaistic, almost corkscrew curls
around the forehead from ear to
ear.

This fragment appears to have
formed the upper part of a small
decorative herm with a flat back to
the head, shoulders, and shaft
below. Such decorative sculptures
were applied to the sides of door-
ways, niches, and elsewhere in Hel-
lenistic and early Roman Imperial
houses. A number of such sculp-
tures, although in a more naturalis-
tic Italic style, have been found in
the houses at Pompeii.

A head of this type, clearly a
Dionysos with a full, corkscrew
beard and the ends of the fillets
hanging like goats' ears from the
sides beyond his real ears, has been
combined with an erotic scene on a

two-sided, decorative relief of the
Roman period from Cyprus (Kara-
georghis, 1984, pp. 214–217, pl.
XXXIX, 2). The fragment in the Har-
vard University Art Museums could
have come from just such a single-
sided relief with a flat background
rather than sculpture on the second
side. When the back side was flat
and finished, evidence from Pompeii
indicates such reliefs, particularly
oscilla or hanging reliefs, could be
painted (Herrmann, 1983, p. 2, no.
1; Dwyer, 1981, p. 247, catalogue
no. 136).

Other subjects were represented
by these low-relief, facing heads on
slabs with flat backgrounds. A frag-
ment at Corinth seems to show the
dying Medusa (Johnson, 1931, p.
136, no. 285).

Unpublished.

Gift of the Misses Norton, 1920.44.208

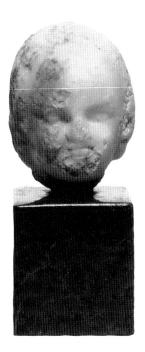

Head of a Child or Eros

Late Hellenistic, 50 B.C.
Greek island marble, H. 0.051 m

The face has been chipped and there is incrustation on the subject's right side and back of the head. The hair is worn, and, in any case, only the ends of the curls were finished in detail.

The dreamy, ideal expression combined with an impish smile suggests this head came from a statuette of Eros of a type popular around the Mediterranean near the end of the Roman Republic.

A smiling child of the Graeco-Roman period, in the British Museum, has a harsher version of the same qualities seen here, with perhaps a greater touch of individuality (Bieber, 1961, p. 138, fig. 546). A child, a very young girl because of the fillet-like diadem in her hair, has the same dreamy, polished aspect and expression; published when in the art market in Basel, it has been dated as early as the third century B.C. and relates to heads from Mount Parnassos (statue in Athens, no. 2772) and Paphos (the head in the British Museum, no. 1954) (*Münzen und Medaillen A.G.*, Auktion 63, Basel, 29 June, 1983, p. 39, no. 94, pl. 37). Such statues dedicated in sanctuaries of Asklepios could represent happy, healthy children (Paribeni, E., 1959, pp. 57, no. 119, pl. 75, and 113, no. 316, pl. 148).

Such small heads of Eros also come from figures that were the supports for larger statues, as the Eros on a dolphin next to the left thigh of a Roman Imperial Aphrodite in Boston (Comstock, Vermeule, 1976, p. 120, no. 183), and the Eros striding forward beside the dolphin in a fragment from a similar statue, where only the lower half of the dolphin and the section of the supporting plinth are preserved (*Christie's Sale*, London, 13–14 December, 1983, p. 56, no. 339, color illus. and color plate on cover).

Unpublished.

Gift of the Misses Norton, 1920.44.138

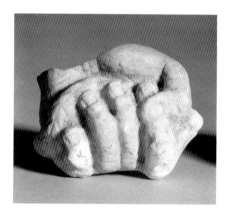

Right Hand

(left)
Greek (?), Hellenistic 150–50 B.C.
Marble from the Greek islands, H. 0.076 m

The hand was joined to the arm by an iron pin, at a point just beyond the wrist. When the hand was detached, this pin split the marble, so that part of the outside of the wrist and arm were broken away. The ends of the thumb and four fingers have been cut away and smoothed, seemingly in antiquity.

This hand is perhaps from a small statue of Aphrodite in the Alexandrian mode. There are several possible explanations for the unusual condition of the thumb and four fingers of this right hand. The hand may have been covering the body in a gesture of modesty, and the sculptor may have cut back the fingers because he miscalculated the position of the right arm. Similarly, the hand may have been holding and partly concealed by a heavy set of tresses. For this reason, also, the fingers and thumb might not have been finished. Finally, it could have been merely that the hand was damaged in antiquity and the fingers later smoothed off.

Unpublished.

Gift of the Misses Norton, 1920.44.32

Left Hand Grasping a Wreath

(below)
Greek, probably Hellenistic, 250–100 B.C.
Low-grade Attic marble, H. 0.07 m

The hand is broken across just behind the thumb and is damaged between thumb and index finger.

This hand seems to be that of a boy, and a votive or funerary statue of the type found on Cyprus might come to mind. Such statues were usually carved in local limestone, but there are examples in imported marbles.

Unpublished.

Gift of the Misses Norton, 1920.44.167

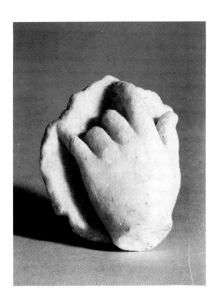

75

Head of a Goddess

Hellenistic or Greek Imperial period, 50 B.C.–
A.D. 100
Marble, H. (as preserved) 0.06 m, W. 0.10 m,
TH. (max) 0.05 m

The fragment is broken off on a slight diagonal across the middle of the neck. There appear to be the remains of two hands, much damaged, on either side of her head. The marble is from western Asia Minor.

The breaks suggest the head came from a rough statuette or relief, perhaps not fully finished, of Aphrodite holding her tresses. Face and eyes are carved and outlined in a sketchy fashion. The hair and the large crown (or extra mass of hair) are carved with equally sketchy parallel lines, designed to suggest strands of hair or the enrichment of the large diadem.

The head has a Syrian cast, placing the figure among late Hellenistic or Greek Imperial images of Aphrodite and Astarte.

Unpublished.

Gift of the Committee for the Excavation of Antioch and its Vicinity, 1940.130

76

Left Hand Resting Against a Tambourine (?)

(below)
100 B.C. or later
Greek island marble, H. 0.053 m

The hand is broken away at the wrist, and the edges of the round object have suffered.

This rather delicate female hand might come from a small statue of Cybele or a Muse or even a personified province such as Phrygia. The colossal figure of Parian marble in the Ince Blundell Hall collection at Liverpool stands with her left hand on a tambourine or tympanum and has been identified as Phrygia, Bithynia, or Cappadocia, one of a series of provinces from Hadrian's Villa at Tivoli (Toynbee, 1984, pp. 67–69, pl. XXIV, 4). This fragment could have come from a small statue of this type.

Unpublished.

Gift of the Misses Norton, 1920.44.180

Front of the Left Foot of a Statue of Eros or a Child (?)

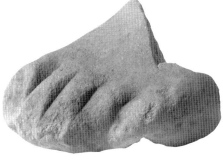

Late Hellenistic or Roman Imperial period, 100 B.C.–A.D. 130
Marble from Naxos, the Roman Imperial quarries, H. 0.089 m, W. 0.07 m

The ends of the toes are scraped or, as in the case of the big toe, broken away. The break across the beginning of the instep is very irregular. The bottom of the foot was worked and finished but was damaged when the fragment lay bottom up in the soil or on an ancient site.

The chubby, childlike nature of the foot suggests identification of the subject. Perhaps this foot was raised, and that is why the underside of what remains appears to have been finished. The date of the carving could be any time from 100 B.C. (before the sack of Delos) to Hadrianic times (around A.D. 130, the period of much of the sculpture from Salamis on Cyprus).

Unpublished.

Gift of the Misses Norton, 1920.44.133

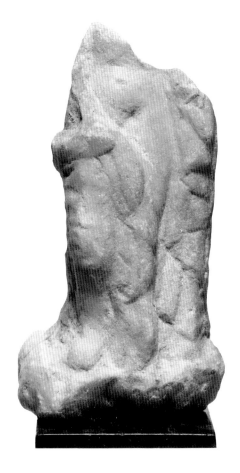

Lower Half of a Statuette of Aphrodite

Late Hellenistic period
Greek island marble, H. 0.125 m, W. (at irregular plinth) 0.067 m

The figure is broken off irregularly on a line through the chest. The hands and plinth are also damaged. The carving is sketchy and slightly cursory but not unfinished.

Aphrodite, or possibly a nymph, is represented standing holding the edge of her cloak with her lowered right hand. The other end of the cloak went up around her left shoulder or arm and fell down in zigzag folds along her left side.

An analogous statuette in Boston, also a gift of the Misses Sara and Elizabeth Gaskell Norton, was found on Cyprus in 1870 and is from the same type of marble (Comstock, Vermeule, 1976, p. 115, no. 176). Another variation on this theme showed Aphrodite with the drapery (himation) grasped in her left hand, a chiton covering her upper body and arms, and a small Eros perched on her left shoulder (*Sotheby Parke Bernet Sale* No. 4869Y, New York, 20 May, 1982, no. 145).

Unpublished.

Gift of the Misses Norton, 1920.44.206

Fragment of a Lion

Greek, ca. 100 B.C. or later
Marble, seemingly Pentelic, H. 0.051 m,
L. 0.105 m

The lion's back end and the area on which the animal crouches are broken irregularly. The mouth is bored through to make the two large front teeth or fangs. Mane and anatomy are summarily treated, including the pinhole-like eyes.

The lion is crouching on a flat surface, which seems to be finished in a slightly curving fillet, probably indicating the edge of a lid. This would place the lion on the right front or left rear corner of a gabled "Greek" sarcophagus or large urn. There is a further section of flat, finished surface at the animal's left side.

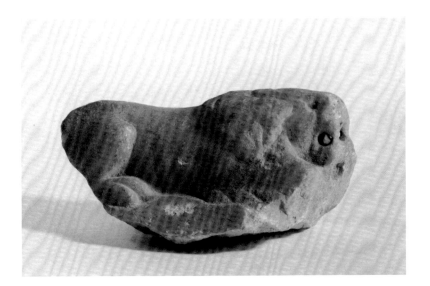

On an early Roman Imperial cinerary urn in Malibu, four small lions (similar to this fragment) crouch facing outward to the long sides at the corners of a very elaborate, temple-form roof with a ridge-pole and imitation covering tiles all in marble. The ends of the body have Hellenistic funerary portals in the tradition of tombs from Asia Minor and Macedonia (Vermeule, C., Neuerburg, 1973, pp. 38–39, no. 86). Other elements are taken from Campanian painting or mosaics (birds drinking from kraters) and Pergamene buildings (capitals and pilasters), all suggesting that the little lions came from a mixture of decorative details remembered as far back as the Alexander sarcophagus from Sidon. Indeed in this vein, back around 400 B.C. four such lions crouch on special little plinths and face outward, again near the corners of the long sides, on the lid of the so-called Lycian sarcophagus from this same Phoenician royal necropolis (Hamdi Bey, Reinach, 1892, pl. 14; Reinach, 1909–1912, I, p. 409, an accessible full view of the side and lid with the two lions). These little corner lions thus became signatures of royal luxury and tradition in the age before Alexander the Great and Alexander's times to the late Hellenistic and Graeco-Roman worlds.

Unpublished.

Gift of the Misses Norton, 1920.44.165

Fragment of a Christian Monument

probably from the middle centuries of the Byzantine Empire, A.D. 800–1200
Pentelic marble, H. 0.15 m, W. 0.11 m, TH. 0.048 m

Top, left side, and bottom are broken irregularly. The right edge is finished with a rough chisel, and the back is even more roughly carved.

The fragment is seemingly the upper right corner of a stele or small shrine with an architectural top. The workmanship is routine and therefore hard to date, but the monument probably belongs to the middle centuries of the Byzantine Empire. The low relief carving on

the front consists of the right corner of a pediment with a stylized akroterion (mostly broken away) above. The fillet molding of the pediment is continued down the right side, and within an inset rectangle are a large rosette enframed upper left and lower left and right by the shaft and arm of a large cross with Maltese ends. There is a section of vertical, fillet molding forming the vertical shaft of the cross at the left and carving of an uncertain nature beyond.

The same rosette appears in the center of the pediment at a commemorative stele from the area of the Agora at Assos. It belongs in the Hellenistic to Graeco-Roman periods (Comstock, Vermeule, 1976, p. 177, no. 283). Here, as a Greek Imperial survivor into the Byzantine period, the rosette exists amid other memories of Classical architectural decoration. The relationship between this cross and foliate acanthus enrichment goes back to the early Byzantine plaque with elaborate scrollwork around the krater, in the Archaeological Museums, Istanbul, from Constantinople (Müfid, 1931, cols. 209–210, fig. 28).

Provenance: The initial description read "probably from a pediment of a shrine, picked up on a slope of the Acropolis."

Unpublished.

Gift of Professor Albert Bushnell Hart, 1928.176

Fragment of Egg and Dart Molding from Epidaurus

A.D. 100–135
Marble from the northern Aegean, probably Thasos, H. 0.107 m, L. 0.133 m

The top is broken or cut away roughly, as if the piece had been reused for building material. The irregular breaks to left and right, forming a rearward "V," are fresher.

This section appears to have formed part of the members of a small cornice, from a building like a small fountain-house or a large niche for a statue or stele. The egg flanked by parts of two darts, a fillet below and behind, a dentil, and cyma reversa molding at the bottom survive, if only in limited surfaces. It was probably carved in the Trajanic or Hadrianic eras.

Unpublished.

Gift of Thomas A. Fox, 1935.6

Doric Capital

Greek, Hellenistic
Marble, seemingly from Asia Minor, H. 0.19 m, W. 0.475 m by 0.475 m

Surfaces chipped and abraded.

The heavy abacus and the flattened but broad echinus, terminating in two rolled fillet moldings, all suggest this capital belonged to a late Hellenistic, early imperial building like those in the agora at Assos (Robertson, 1969, pp. 158–160). The gate of Athena Archegetis, or western propylon of the Roman Agora in Athens, has the Athenian version of this capital, where, however, in the traditions of the fifth century B.C., the start of the fluted column is preserved as part of the capital (Travlos, 1971, pp. 32–33, figs. 40, 41).

Unpublished.

Gift of the Peabody Museum of Archaeology and Ethnology, 1942.211

Roman Imperial: Statuary and Reliefs

The best of the Roman Imperial or Graeco-Roman sculptures are works by Greek artists in Roman decorative taste, or adaptations of Greek creations turned into thoroughly Roman images (the Ponsonby Head, no. 93, for example). The table or basin support in the form of a satyr with a krater (no. 90) and the fragmentary decorative (so-called "Schreiber") reliefs add further aesthetic range and scholarly interest to the collection. The most complete among these reliefs is the panel showing Hermes carrying the infant Dionysos to the nymphs of Nysa (no. 95). It is interesting as one of the largest survivors of this subject in relief and one that was known and admired in Neo-Classic Rome.

The most unusual sculpture, carved in limestone, is the Lycian votive relief of the period sometime around A.D. 200 or later (no. 101). The twelve (local?) gods, the votaries, and the dogs or bears to the left and right, below, give the monument a composition and style unparalleled elsewhere in the Graeco-Roman world. By contrast, the tragic mask in marble from western Asia Minor (no. 92), is as cosmopolitan a work of art as can be found anywhere in the Roman Empire. Examples similar to this have been found in the heart of Athens, around Rome and Ostia, and at Tralles (modern Aydin not far from Aphrodisias in Caria).

Torso and Top of the Legs of a Small Statue of Sylvanus

Roman Imperial period, ca. A.D. 250
Marble from Asia Minor (?), H. 0.541 m

Head, right arm above elbow, right leg from the middle of the thigh, left foot and ankle (at shoe of the boot), and lower part of the support at the left leg are missing.

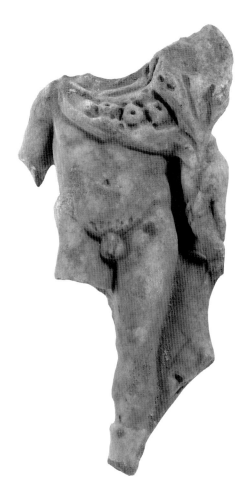

This is a decorative work of the Roman Imperial period of the type perhaps to be found in a garden around Pompeii or Herculaneum. The figure was holding a large branch in his (damaged) left hand. Its top (partly missing) blossomed out into a bunch of leaves and, presumably, fruits. More fruits and flowers are visible in the ample cloak, which is pinned with a brooch on the right shoulder and hangs down the left side and back.

The figure seems too mature to be an Eros or a seasonal Genius. The drillwork in the fruits and cloak and in the pubic hair suggests a date in the third century A.D., around 250.

The prototypes for small, rustic statues of Sylvanus were based on figures of Zeus or even Poseidon or Saturn with appropriate alteration of attributes. In addition to his role as a patron of woodlands and parks or gardens, Sylvanus was much admired in the Antonine period of the Roman Empire as a patron of the countryside of Italy and, eventually, under Commodus (A.D. 180–192) as a deity of the slaves (Poulsen, 1951, p. 251–252, nos. 492, 493, pl. XXXVII).

A pair of statues in Berlin demonstrate that Sylvanus can come in an unclothed version (wearing only the cloak of forest products) or clothed (a workman's tunic), depending on whether his divine or his rustic nature is stressed (Conze, 1891, p. 120, nos. 282, 283). The bodily prototypes for statues of Sylvanus varied in the Antonine period, the probable date of the Harvard figure. Hadrian had borrowed from various figures of the fifth and fourth centuries for his representations, statues and reliefs, of his favorite youth Antinous. Variations in the position of the cloak and mirror reversals in the stance are common. Compare the clean, cold torso based on Polykleitan models that was in the Ernst Brummer Collection (*Galerie Koller A.G.* 1979, pp. 250–251, no. 638) or the almost Severe Style torso with large cloak or goatskin of fruits suspended from the shoulders, in the Isabella Stewart Gardner Museum, Boston (Vermeule, C., Cahn, Hadley, 1977, p. 23, no. 29). One of the finest complete statues of the type from which the small figure at Harvard comes was found between Merida and Santiponce *(Italica)* in Spain and is now in the Museo Arqueologico, Madrid. The noble, wreathed, bearded head bears enough resemblance to the Emperor Antoninus Pius (A.D. 138–161) to suggest a date (Garcia y Bellido, 1949, pp. 107–108, no. 106, pl. 84).

A similar small statue, varying only in the mirror reversal of the hips, and in almost identical condition, shows by its drillwork or lack of same to have been carved in the Trajanic or Hadrianic periods (A.D. 100–135), if not earlier (*Sotheby Sale*, London, 13 December, 1982, p. 86, no. 263).[1]

Unpublished.

1. Compare also the headless Sylvanus from Rokeby Hall: *Sotheby Sale*, London, 10 July, 1979, pp. 168–169, no. 348. And the headless statue, an earlier, better replica of the Kennedy Sylvanus: *Christie's (East) Sale*, New York, 19 June, 1985, no. 209.

Gift of Dr. Harris Kennedy, Class of 1894, 1932.56.125

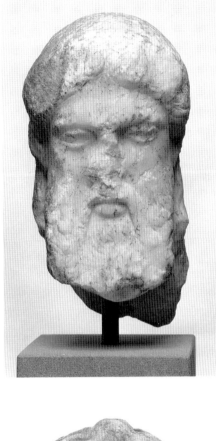

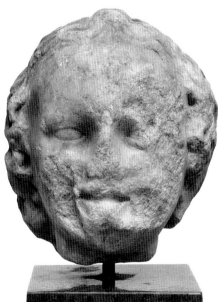

Small Head of a Bearded God

(top left)
first to second centuries A.D.
Greek marble, H. 0.175 m

The nose is mostly broken away and rubbed down. The hair and beard are worn. There is considerable incrustation.

Evidently once part of a Roman household herm, the head is of Greek Imperial workmanship, perhaps to be dated in the first to second centuries A.D. The style has something reminiscent of the head of Zeus by Pheidias at Olympia, as transmitted through derivatives of the fourth century B.C. The quality of carving suggests this herm came from Attica or the Greek islands, for it has a sensitivity and lack of mechanical production not found in the decorative sculptures from Pompeii and Herculaneum.

A filleted head of Zeus or Dionysos of an Asiatic cult type, seemingly from Cyprus, is a slightly smaller variant of this head, perhaps from the same workshop along the western coast of Asia Minor or in the Greek islands. It came to Boston in 1871 or 1872 with the first Cesnola collection (Comstock, Vermeule, 1976, p. 135, no. 212).

Published: McCredie, 1962, pp. 188–189, pl. 56, figs. 3, 4.

Gift of Dr. Harris Kennedy, Class of 1894, 1932.56.115

Head of a Young Girl or Boy

(lower left)
Roman (?)
Marble, H. 0.17 m

The back of the head is flat, and evenly separated from the torso. The surface of the face is badly damaged, including the nose, lips, left eyebrow, cheeks, and chin, also left brow. There are marks of the drill.

The head is frontal; the waved hair starts far back on the wide, high forehead. The type seems to be ideal rather than specific, and it recalls both the draped girls of Attica around 340 B.C. and Eros with the bow, identified with Lysippos about the same time or as late as 330 B.C. The Roman version of the Lysippic Eros in the Walters Art Gallery, Baltimore, shows that the young god's face is thinner and the features sharper (Bieber, 1961, p. 38, fig. 88).

The same ambivalence as to sex, girl or boy, seems to exist in connection with a *Head of a Boy*, dated in the fourth century B.C., at Johns Hopkins University. The parallels for this Baltimore head are also with the "little bears" (*Arctoi*) from the sanctuary of Artemis at Brauron, but the famous Eros with the bow by Lysippos has been shown to have represented the next stage of development in representations of children in the fourth century B.C. (Williams, 1984, pp. 20–21, no. 6). Since the Lysippic Eros is known only from Graeco-Roman marble copies and since the Harvard head seems to be related but individual as a head of a girl or boy, it seems safest to class this sculpture as work of the Roman Imperial period. The sculptor of this child was certainly influenced by the art of the fourth century B.C., and a divine child (like the baby Dionysos) may have been intended.[1]

1. The true child Eros is chubbier with a "Cupid's bow" mouth. See *Sotheby Sale*, London, 20 May, 1985, no. 375, pl. XXXVII.

Unpublished.

Gift of the Misses Norton, 1920.44.144

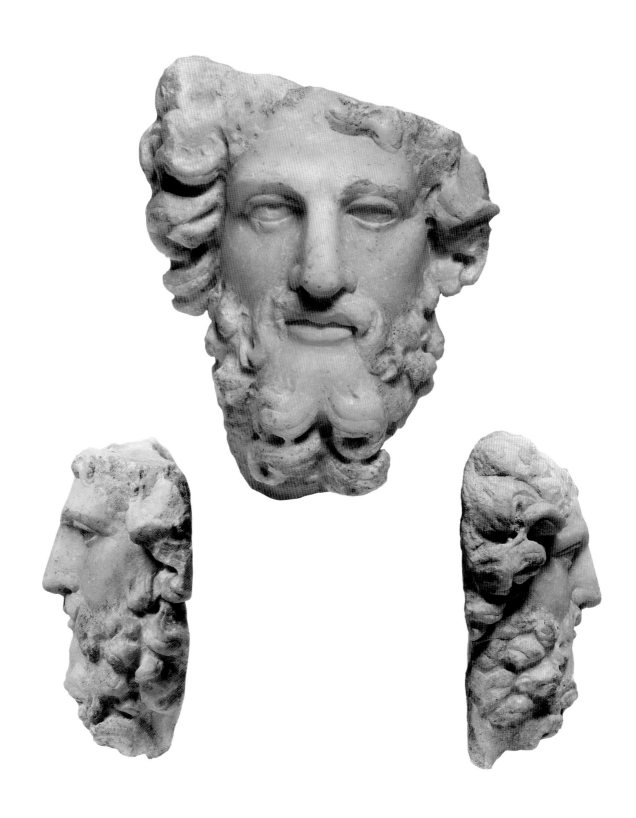

Head of a Bearded God

ca. A.D. 150–175
Marble seemingly from western Asia Minor,
H. (max.) 0.21 m, W. (max.) 0.17 m. D. (max.,
as preserved) 0.055 m

The top of the head is missing on a diagonal
line from the right to left, just above the ear.
The use of the drill is evident in the beard,
hair, mouth, and eyes. The marble has consid-
erable crystalline structure.

The head is seemingly from a high
relief. The style places it with sculp-
tures from western Asia Minor, and
the date ought to be ca. A.D. 150–
175. The subject could be Zeus,
including Ammon, Asklepios, or
perhaps Poseidon. There is a sugges-
tion of the horns of Ammon in the
way the hair curls out on either side
of the eyes with their incised pupils.
A late Hellenistic, more classical
model for this head, with subdued
hair, was evidently found on Crete
and may have had the outer parts of
hair and head finished in plaster or
even wood (Schefold, Cahn, 1960,
pp. 280, 283, no. 391).

Maxwell L. Anderson has
pointed out, after detailed study of
this head, that it could come from a
free-standing statue of the thin type
popular at the outset of the late
Antique period in Graeco-Roman
art. He cites Vatican, Museo Grego-
riano Profano inv. 10265, "which is
almost identically flat on the back,
but is clearly from a free-standing
statue of Asklepios." He also
adduces the example of Kassel SK
86, a Roman Imperial version of an
Asklepios of the fourth century B.C.
He suggests the complete statue
would have been some 1.75 m in
height.

This head, with its curls seem-
ing to flatten out sidewise, may have
once formed one half of a double
herm, similar to the Ammon and
Dionysos in Berlin (Conze, 1891, p.
10, no. 11). Otherwise, the Harvard
head has a decorative frontality that
brings to mind the heads of older,
bearded divinities in the centers of
architectural *tondi* or the coffering
of florid ensembles of carving of the
type found in the theaters of Asia
Minor in the Antonine period, Side
in Pamphylia offering a good exam-
ple. An indicator of the stylistic
source for and the date of this frag-
ment can be found in comparison
with the portrait of a young lady,
veiled, from a large Asiatic sarco-
phagus, a fragment from the bed of
the Pactolus River at Sardis, Turkey
(Hanfmann, Ramage, 1978, pp.
134–135, no. 180, fig. 328).

The imaginative curls of the
hair contrasted with the flattened
beard make this head a later, Asiatic
parallel to the head of the bearded
god (perhaps Oceanus, based on a
Zeus or Poseidon of ultimately Phei-
dian type) in the decorative shield
reconstructed from fragments of the
flanking colonnade of the Forum of
Augustus in Rome, dated 10–2 B.C.
(Boëthius, Ward-Perkins, 1970, p.
191, pl. 108). In the Antonine
period, there is the *imago clipeata*
of the oak-wreathed Zeus in Copen-
hagen, from Venice (Poulsen, 1951,
p. 363, no. 520a, pl. IX). A less
sophisticated, carefully worked
imago clipeata bust of Zeus, from
Rome, is in Berlin (Conze, 1891, p.
381, no. 938). A console with "Cae-
lus," also in Copenhagen, can be
adduced; it comes from Rome
(Poulsen, 1951, p. 214, no. 289a,
supplement, pl. v).

The architectural enrichment of
the great Hadrianic to early Anto-
nine theater at Side is actually very
sober and classicizing when com-
pared with the carving of the mid-
dle-Antonine (Marcus Aurelius and
Lucius Verus, ca. 163) theater at
Aspendus. Architectural carvings
related to, but earlier than the Har-
vard Museums' fragment include
the busts of Artemis and Demeter in
the ceilings of the decorative *aedicu-
lae* of the theater's *scaenae frons*
(Müfid, 1963, pp. 136–137, figs.
112, 113).

Yet another possible origin for
this fragment, or at least, a related
but presumably earlier sculpture is
the figure of Atlas found near Seville
in Spain and in the Museo Arqueo-
logico there. The small statue of the
giant with his head, shoulders, and
hands supporting his globe was ded-
icated to the Emperor Claudius in
the year 49 A.D. (Garcia y Bellido,
1949, pp. 108–109, no. 107,
pl. 85).

Unpublished.

Gift of Dr. Harris Kennedy, Class of 1894,
1932.56.115A

Head of a City-Goddess or Geographical Personification

probably third century A.D.
Marble, H. 0.255 m

The nose is missing, and the face is badly damaged with the lips chipped away. There is also chipping on the eyebrows, forehead, chin, and right cheek. A drill has been used in the hair, corners of the mouth, and eyes.

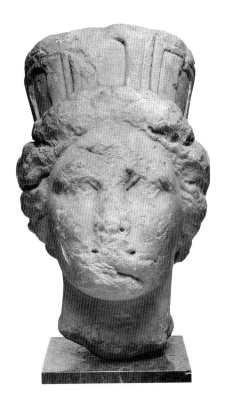

This is probably a Greek Imperial work of the third century A.D. The heavy hair is drawn over the ears to form a knot at the back of the neck. She wears a fairly high crown with a flat top, decorated in relief with a running design (a wide rectangle with a semi-round, arched niche in the center). The modeling is broad in the contours of the face.

The crown is a stylized view of the gate and external arcades of a city wall, of the type seen in the reconstructions of the Palace of Diocletian at Split. Such urban and regional personifications have a long history in Graeco-Roman art, going back to the Tyche of Antioch in the early Hellenistic period. Roman reliefs (Louvre), statues (Liverpool), and Late Antique silver statuettes (British Museum) show the various figures that could have heads such as this (Toynbee, 1934, pp. 7–23, pls. XXI, XXIV, XXVII–XXX; Ashmole, 1929, pp. 23–24, no. 42, pl. 27, as Phrygia).

The lack of angle to the head in relation to the neck shows that this head came from a standing or seated figure in frontal pose, not a figure based on the many later versions of the Tyche of Antioch. Such

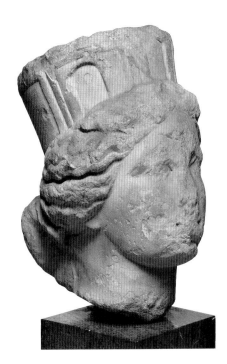

statues existed in every city of the Greek Imperial world, as coins confirm, and they were often gilded for admiration and transport on ceremonial occasions.[1] A head, identified as Cybele or Tyche, must have belonged to a temple statue in the agora area of Corinth; it is, although fragmentary, a more academic version of the same head as that in the Harvard Art Museums, both based generally on the art of the fifth century B.C. It is impossible to tell whether the head is from a standing or seated image (Johnson, 1931, pp. 46–47, no. 54).[2] Cyrene has yielded a number of such geographical heads, one especially like the Harvard example (Paribeni, E., 1959, p. 147, no. 429, pl. 185, and nos. 425–428, pls. 184, 185).

Unpublished.

1. See the Tyche of Antiochene type, part of a head from Sardis: Hanfmann, Ramage, 1978, p. 112, no. 128, figs. 259, 260.

2. Compare also *Sotheby Sale*, London, 13 July, 1976, p. 182, no. 453: with a fillet around her wavy hair and a polos on top.

Gift of the Misses Norton, 1920.44.221

Torso, Fragmentary, of a Woman, perhaps an Amazon or Artemis Bendis

Roman, ca. A.D. 200
Marble, seemingly from mainland Greece,
H. 0.305 m

The surfaces are weathered, and the marble is discolored to a darkish brown.

The date of this figure is undoubtedly in the late second or probably the third century of the Empire. The figure wears a girt tunic, of rough workmanship, with flat modeling. The belt also wraps what appears to be a heavy short cloak covering the shoulders and suggesting the beginning of a hood (a Thracian cap?) for the now missing head. The head and the arms from the edges of the tunic were made separately and joined with dowels or pins.

This lady in Thracian garb could be a late version of an Amazon, but single statues in this costume usually represent Artemis Bendis who, from the fourth century B.C. onward, at least, was worshiped in the greater Athens area, chiefly on the way to the Piraeus where Thracians were settled.[1]

Unpublished.

1. See the comment and bibliography under Poulsen, 1951, pp. 168–170, under no. 231, a votive relief found in the Piraeus.

Gift of Miss Elizabeth Norton, 1924.33

Fragment of a Decorative Relief

ca. 80 B.C.–A.D. 138
Pentelic marble, W. (max.) 0.273 m, H. (max.) 0.162 m, TH. (max.) 0.06 m

Fragment is irregularly cut along edges. There are some surface chips. The back or bottom is flat.

This fragment is either architectural or from a large ensemble of furniture. Linked floral motifs, palmette and honeysuckle, are carved in low relief around the curved outer or upper surface. A suggestion of carving in relief appears to begin on the raised, flat, circular inner surface. The bottom or back is flattened off with a claw chisel.

Worked in a competent archaistic style, the floral designs, including a stylized date palm, suggest a date from Sulla (80 B.C.) to Hadrian (A.D. 117–138). Traces of a rasp around the leaves of the palmettes might indicate carving of the Imperial period, as late as the second century A.D.

Unpublished.

Gift of Mr. and Mrs. William de Forest Thomson, 1919.512

Support of a Table or Basin

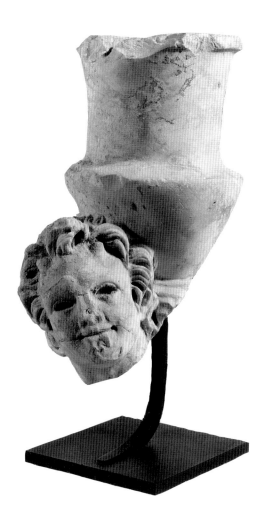

Roman, first half of second century A.D.
Giallo Antico marble from North Africa,
H. 0.275 m

Most of the satyr's nose is missing. Half of
the krater's base is broken off, and the rim is
chipped. There is a rectangular dowel hole in
the center of the krater, and a pin hole for a
repair to the edge above the satyr's head.
There are drill marks in the hair and the eyes
are hollowed out.

This support is in the form of a
head of a laughing, smiling satyr
balancing a krater on his shoulders,
with drapery between. The drilling
of the hair and the hollowed-out
eyes support a date in the Flavian or
more likely Antonine to Severan
periods of the Roman Empire.
Satyrs as supports for garden foun-
tains and decorative tables in the
courtyards of Roman villas were
popular in the country estates of
Imperial Rome, especially in the vil-
las along the Alban Hills. An exam-
ple in the Ny Carlsberg Glyptotek,
Copenhagen, has the satyr grasping
his panther skin, which is rolled
around the water basin on his left
shoulder. The satyr himself was
drilled for a water pipe in this mar-
ble ensemble from a Roman villa
(Hadrian's?), below the Villa d'Este
at Tivoli (Poulsen, 1951, p. 345, no.
485, pl. XXXVI). The motif of the
satyr balancing a krater on his
shoulder (all as part of a larger
ensemble, a furniture support)
developed out of the Hellenistic
group of the satyr carrying the
infant Dionysos on his shoulder, a
statue that existed in mirrored pairs
or reversals (Brizzolara, 1982, pp.
178–179, illus.). A variant in Ber-
lin, a lion-footed table leg, shows
the satyr's head tilted back in the
same fashion as here, an animal
(goat?) draped and carried around
his shoulders in the good shepherd
motif (Conze, 1891, pp. 425–426,
no. 1074, seemingly from Italy).

The motif of the satyr carrying
a krater on one shoulder occurs in a
larger, wider context in the scenes
of Antonine and Severan triumph
on Dionysos sarcophagi, where
satyrs old and young are bringing
such vases home from India. Some-
times these kraters or flatter, wider
bowls, have handles in the form of
lions or panthers climbing into
them, all designed to suggest the
exotic metalwork of the ancient
Near East, the vases created by
Greek, Persian, and Parthian crafts-
men in the wake of Alexander the
Great's conquests.[1] A Dionysiac
relief in the Museo Nazionale,
Naples, with the god and his satyr
and maenads in intoxicated revels,
has a satyr on the left end, seen
from the back and hefting a krater
just as the satyr of the *trapezopho-
ros* or *loutrophoros* in the Harvard
Art Museum (Reinach, 1909–1912,
p. 68, no. 4).

The repertory of these supports
extended to the iconography of bar-
barians as well as Dionysiac figures,
including the kneeling Persians or
Scythians carrying large, elaborate
vases on their shoulders. A heavily
restored example in the Galleria dei
Candelabri of the Vatican shows the
remains of a centaur holding a kra-
ter as in the Harvard piece (Lippold,
1956, pp. 180–182, no. 37, pl. 85,
also pp. 332–333, no. 74, pl. 146).

Published: Mitten, Brauer, 1982, p. 15, no.
49, illus. p. 21; Vermeule, C., 1983a, pp. 43–
45, fig. 4.

1. A Dionysiac sarcophagus with old satyr
carrying panther-handled krater: Comstock,
Vermeule, 1976, pp. 152–153, no. 244; Ver-
meule, Cahn, Hadley, 1977, p. 51, no. 73.

Anonymous gift in Honor of Seymour Slive,
Director 1975–1982, 1981.47

Fragment of the Rim of a Large Krater

ca. A.D. 125

Luna marble, DIAM. (max. as preserved at the rim) 0.215 m, H. (max. as preserved) 0.12 m, TH. (max. at top of rim) 0.051 m

The interior surface is smooth. The breaks are clean. The surfaces are fresh. Remains of chiseling on the exterior run horizontally between the outer edge of the lip and the top of the tongues.

The rim is enriched with broad egg-and-dart molding rising from a band of reels along the inner edge. The ends of concave tongue fluting are visible along the body below the outward curve of the lip or outer edge of the rim. One such complete marble krater, "vase of life," dated in the fourth to early fifth century A.D., has survived to document this decorative art in late antique, early Christian times, aside from representations in relief and other media (Weitzmann, 1979, pp. 334–336, no. 314). A seemingly complete example in the Musée du Louvre has a rich rim and acanthus leaves on the lower body. This krater seems to date from the earlier part of the Roman Empire, perhaps Hadrianic times (about A.D. 125) (Reinach, 1897–1930, I, p. 132, top right). The same is probably true of an example at the entrance to the Vatican Museums (Lippold, 1956, p. 18, no. 14, pl. 3).

Garden and cemetery kraters of this shape, based on metalwork, go back to the beginnings of the Roman Empire, as demonstrated by the example found on the Via Appia near the tomb of Caecilia Metella. Here the floral enrichment is related to the lower outside panels of the Ara Pacis Augustae as well as to silver cups from the Boscoreale treasure and from Caesarea in Cappadocia (Jones, 1912, pp. 104–105, Galleria no. 31a, pl. 28). The bowls on the tops of the Barberini candelabra in the Vatican, although flatter, have the same sort of convex fluting on their outsides (Bieber, 1977, p. 213, pl. 146, figs. 851–854).

The same forms of enrichment were used for flat fountain basins as for deep kraters among the marble garden sculptures of the area around Rome. A fragment of unknown provenance in Rome demonstrates these decorative parallels in the shape of a dish like the bird-baths produced in the modern ateliers working with Carrara marble in the suburbs of Rome (Cima, 1982, pp. 138–139, no. VI.2).[1]

Provenance: The fragment was brought from Rome about 1870.

Unpublished.

1. Another complete krater of the type of the Buckingham-Harvard fragment is among the large collection of such marbles and fragments in Sir John Soane's Museum, London: Vermeule, C., 1953, p. 287, no. 260.

Gift of Mary H. Buckingham, 1947.33

Tragic Mask

third century A.D.
Marble from western Asia Minor, H. 0.175 m,
W. 0.27 m

This larger than lifesized mask is broken at
the top just above the eyebrows and, at the
bottom, at the line of the upper lip; also on
the left side, leaving only a slight amount of
hair. The nose is slightly worn. Drill holes
were used for the tear ducts and pupils of the
eyes and in the hair. The hair is very stylized,
arranged in rows with incised lines over the
surfaces.

This type of mask appeared in various forms all over the Roman
Empire, at Tralles in southern Lydia
(Bieber, 1961a, p. 243, fig. 801), in
a mosaic by Heraclitus in the Lateran (Bieber, 1961a, p. 243, fig.
802), and, in the third century A.D.,
in the theater at Ostia, where Herakles and bearded heroes are represented (Bieber, 1961a, p. 244, fig.
805). Wall paintings at Pompeii
even show such masks of tragedy as
stage props (Bieber, 1961a, p. 228,
fig. 762). A relief in the Villa Torlonia-Albani in Rome shows the
intellectual implications of such a
mask, for it appears on a table
between two poets or playwrights
who are contemplating it (Reinach,
1909–1912, III, p. 150, no. 4).

A mask similar to this, from a
relief or possibly a free-standing
monument, is set on what appears
to be a tripod. It comes from the
area of the Acropolis in Athens and
is in the museum there (Walter,
1923, p. 212, no. 420, fig. 7).
Another mask like the Harvard
example is among a set of such decorative sculptures in Copenhagen.
As has been pointed out by Frederik
Poulsen, they come from Roman
temples as well as theaters (Poulsen,
1951, pp. 252–253, under nos.
377–381, pl. 25). Also there is an
example in a set from the Villa
Altieri at Rome, now in Liverpool,
and termed perhaps that of a young
male character (Ashmole, 1929, p.
57, no. 134, pl. 46).[1]

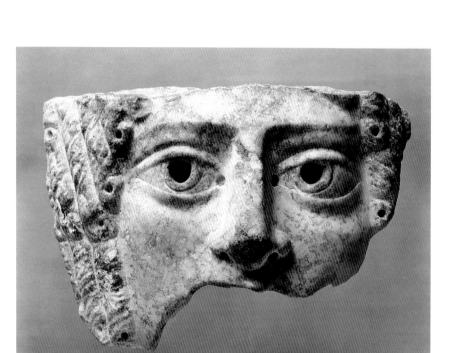

Published: Fogg Museum, 1954, no. 180A;
Webster, 1967, p. 98, 1S14; Mitten, Brauer,
1982, p. 15, no. 54.

1. An excellent discussion of the settings and
uses of such hollowed-out decorative masks
after standard types from the Graeco-Roman
theater is given, in connection with a Pompeiian-era or slightly later (late Flavian) tragic
mask of Herakles, in Baltimore, from Rome
or Naples: Williams, 1984, pp. 28–29, no.
15. While such masks fell out of fashion in
Italy by Hadrian's reign (A.D. 117–138), they
continued to be carved in the Greek Imperial
cities of Asia Minor.

Gift of C. Ruxton Love, Jr., 1956.21

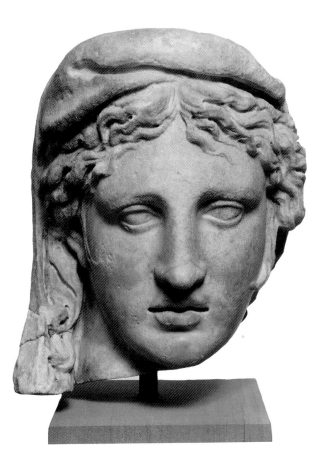

Ideal Head of a Captive Barbarian Queen

ca. A.D. 100–125
Pentelic marble, H. 0.345 m

The end of the nose is restored in island marble. Two sections of drapery on the right side are rejoined.

This head, the so-called "Ponsonby Head," has in the past been identified as Amastris and more recently as Olympias. The noble lady, in oriental costume and with a seemingly sorrowful expression, typifies representations of idealized captive barbarians, as seen on Roman triumphal monuments, on sarcophagi, and in the minor arts. Despite the romantic names attached to this head, it seems doubtful that a direct model can be found in the time of Alexander the Great's immediate successors. The decorative statue, of which this head once formed a part, was probably carved in the Trajanic to early Hadrianic periods of the Roman Empire (about A.D. 100–125). It certainly had an architectural setting.

Provenance: The head is said to have been found at Ostia. It became the possession of a Mr. Jones, then William Francis Spencer Ponsonby, First Lord De Mauley (1787–1855), the Hon. Ashley G. J. Ponsonby, and then his son, Claude Ponsonby.

Published: Waagen, 1854, I, p. 37, II, p. 83; Michaelis, 1882, pp. 472, no. 1, 484, no. 18 (and older references); Strong, 1903, pp. 21–23, no. 29; Six, 1912, pp. 86–93, pl. I, as Queen Amastris of Amastris; Chase, 1924, p. 98, fig. 115; Picard, 1926, pp. 198ff.; Lawrence, 1927, pp. 12, 95, pl. 8; Hanfmann, 1950a, p. 14, no. 38; Calza, 1964, p. 16, no. 5, pl. 3; Fogg Museum, 1971a, The Checklist, p. 150; Museum of Fine Arts, Boston, 1976, p. 7, no. 8; Hanfmann, Mitten, 1978, p. 366; Vermeule, C., 1981, p. 212, no. 177, and colorplate 17.

Gift of Edward W. Forbes (in Trust to the University), 1905.7

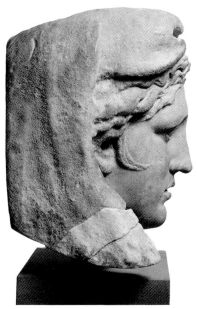

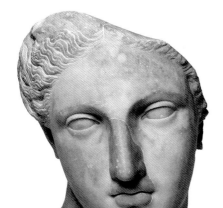

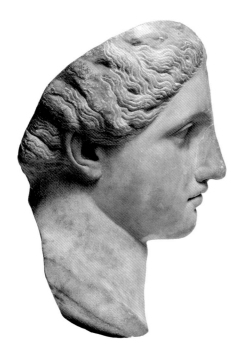

Acrolithic Head from a Roman Cult Statue of a Goddess

Graeco-Roman copy of a fourth century B.C. type, late second century A.D.
Greek island (Naxian?) marble, H. 0.469 m

Ancient drillwork visible. The nose, upper lip, and left ear are restored in Luna marble. The hair at the head's own right side has been reworked. The "brown coating," mentioned by Michaelis (Michaelis, 1882, pp. 484–485, no. 19) has been removed.

The subject may be Hera or Ceres, a draped Aphrodite, or a personified divinity (e.g., Concordia). The remains of ancient drillwork, channels and points, in the hair on the head's right side and around the outer part of the right ear suggest that it was carved in the Antonine or even the Severan periods of the Roman Empire. It is difficult to say whether the statue showed a seated or standing goddess personification with her cloak over the top and back of her head, but the turn of the head on the neck might suggest a statue standing in a pose of some torsion, the way large-scale, draped females in the Pergamene tradition were often represented.

A head, presumably from a standing statue, found in the Temple of Apollo at Cyrene, although turned to the subject's left rather than right, is a good indicator of how this type of cult or votive creation was circulated in the last years of the Roman Republic and the early Empire (Huskinson, 1975, pp. 67–68, no. 126, pl. 49). The much freer, early Hellenistic style of this cult image's forerunner is anticipated in a female head in the Metropolitan Museum of Art, New York (Richter, 1954, p. 91, no. 168, pl. CXX).

A head of a goddess wearing a jeweled diadem and a himation in the form of a veil over the back of her head poses the possibility that some of these heads can represent very idealized empresses, such as Hadrian's wife Sabina (died A.D. 135), although the Harvard head does not seem to have any qualities of imperial portraiture (Vermeule, C., Neuerburg, 1973, pp. 19–20, no. 37).

Provenance: The head was acquired with the "Ponsonby Head" no. 93.

Published: Michaelis, 1882, pp. 484–485, no. 19.

Gift of Edward W. Forbes, 1905.6

Rectangular Decorative Relief Depicting Hermes Carrying the Infant Dionysos

Greek, neo-Attic, last part of the first century B.C.
Marble, H. 0.69 m, W. 0.467 m, TH. 0.07 m

The corners of the slab have been chopped off, and there is ancient and later wear to the surfaces.

The subject is Hermes carrying the infant Dionysos to the nymphs of Nysa; a nymph was seated, receiving the child, in the now lost right side of the panel. Hermes strides to

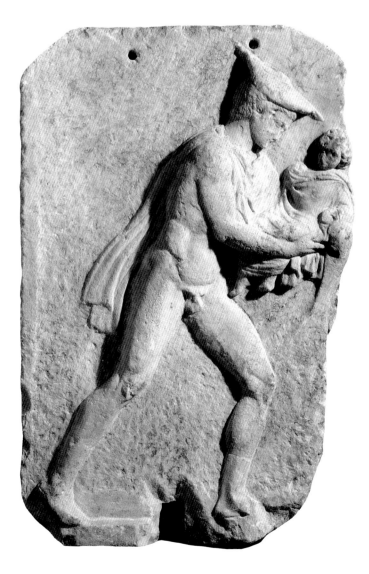

the right, holding the infant Dionysos in front of him. The former wears his petasos and a chlamys pinned on the right shoulder and flowing out behind him. The latter is wrapped in an ample himation. A fillet molding, 0.03 m wide, serves as a groundline, and there are cut-down traces of a similar, thinner molding at the left.

The central group reproduced in this relief (including the personification of Nysa or the chief nymph) was combined with standard Neo-Attic Dionysiac figures on rectangular reliefs, circular bases, vases, and the supports for candelabra in Graeco-Roman times, from the age of Augustus through that of Hadrian (27 B.C. to A.D. 137). A circular puteal or wellhead in the Vatican Museums from a villa at Albano, as well as the famous marble krater signed by Salpion, in Naples, gives a rich repertory of figures surrounding the main group, including an old Silenus, dancing and flute-blowing satyrs, and a maenad beating on a tambourine (Lippold, 1956, pp. 240–244, pl. 112, 113).

A relief such as the Del Drago-Harvard example must have been set on a villa or garden wall between other such reliefs with the same stock neo-Attic figures also appearing together on the marble kraters and wellheads.

Provenance: From the Lanckoronski Collection, Vienna; then from the Palazzo Albani-Del Drago in Rome.

Published: Zoega, 1808, pp. 20–22, pl. III; Matz, von Duhn, 1882, III, p. 134, no. 3733; Vermeule, C., 1964, p. 333, note 89; Fogg Museum, 1971, pp. 41–49; Hanfmann, Mitten, 1978, pp. 366, 368, note 30; Houser, 1979, pp. 58–59, no. 39; Vermeule, C., 1981, pp. 198–199, no. 164; Vermeule, C., 1978, p. 46; Mitten, Brauer, 1982, no. 43; Froning, 1981, pp. 48, 54, note 36, 140, note 1.

Purchase from the David M. Robinson Fund, 1970.25

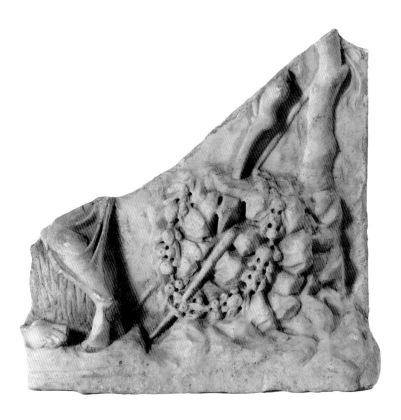

Lower Right Part of a Hellenistic-Type Landscape Relief, Dionysiac Scene

early second century A.D.
Marble, H. 0.273 m, W. 0.292 m

Sharp diagonal cut across the top from upper right to lower left. The left edge missing, the right edge is preserved. Drillwork visible around altar.

This copy has been dated early in the second century A.D. What remains comprises the lower part of a dancing maenad facing the foot of a seated satyr. At the right are a rustic altar, a herm, and a tree.

The scene can be reconstructed from another, complete Graeco-Roman relief, in Berlin, which came from Prusias ad Hypium in Bithynia. It shows that the satyr was grasping the maenad's right hand, which held a drinking horn.

The provenance of the relief in Berlin at a major Imperial city in northwest Asia Minor and the relationship to the bronze group known as the *Invitation to the Dance* suggest the original of these two reliefs was very likely made in a Bithynian or Mysian center such as Cyzicus, where the *Invitation to the Dance* appears on Greek Imperial coins. Pergamon under Marcus Aurelius (Emperor A.D. 161–180) also created a masterful numismatic reverse, a satyr and the young Dionysos, based on a relief related to these examples (Vermeule, C., 1983, p. 14, fig. 23).

Provenance: From the Estate of Joseph Brummer, New York.

Published: Hanfmann, 1966, pp. 371, 373, pl. 94: the Fogg and Berlin reliefs; Vermeule, C., 1981, p. 232, under no. 194; Houser, 1982, pp. 60–61, no. 40.

Purchase from the Alpheus Hyatt Fund, 1949.47.145

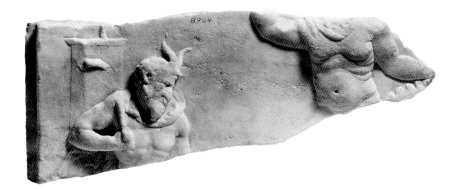

Fragment of a Dionysiac Relief, Pan and Silenus in a Rustic Setting

Graeco-Roman, Julio-Claudian Period (?),
A.D. 14–68.
Thasian (?) marble, H. (irregular as preserved)
0.14 m, W. (the same) 0.375 m, TH. 0.04 m

The left edge is preserved, with a cutting for insertion in a frame, as in the wall of a house. The other three edges are the result of irregular breaks. The back is smoothed and finished.

A Pan with *pedum* (shepherd's crook) in his right hand and a *nebris* (animal skin) around his shoulders appears to be prancing from right to left, looking back, in front of a tall, rectangular pillar with molded top. On this Doric pillar are two cloven feet from the small statue, cult image of Pan, which stood on top. At the right a plump Silenus raises his right arm and rests his left on an uncertain object, perhaps the neck of an ass. From the position of the two figures, Silenus higher than Pan, the former may be seated and riding backward on the animal.

A relief in the Museo Nazionale, Naples, Pan riding a mule or an ass in a rustic setting, shows the type of Graeco-Roman decorative panel represented by the Harvard fragment (Reinach, 1909–1912, III, p. 83, no. 5; Schreiber, 1894, pl. 54).

Unpublished.

Transfer from the Peabody Museum of Archaeology and Ethnology, 1978.495.235

Finger

probably Hellenistic period.
Marble from the Greek islands (Paros or Naxos), L. 0.09 m

The finger is incrusted. A break between the two joints has been mended.

This appears to be a right index finger from a slightly overlifesized statue. The hand was extended, with the fingers bent, as if an attribute had been on the palm of the hand. The statue was probably that of a goddess.

Published: Fogg Museum, 1961, p. 28, no. 216.

Bequest of David Moore Robinson, 1960.462

Relief of the Graeco-Roman Figural-Landscape Type

second century A.D.
Yellow marble (giallo antico), H. 0.062 m, W. 0.042 m

The stone is broken away at the left front. The original edge, with an incised vertical line, is preserved at the right. The piece is smoothed in back. The carved surfaces of the relief are worn, and a section has been gouged out from the subject's neck to his waist, including the left arm.

A tiny figure is seated, leaning on a staff. A table is in front of him. The relief is fragmentary. When complete, it may have been mounted like a large, decorative cameo, the *Grande Camée de France* for instance. The relief may be Roman, of the second century A.D. The somewhat emaciated old man was interpreted by David M. Robinson as Seneca. The left shoulder and lower part of his body are draped, and he is partly bald. The rendering of the pupil of the eyes and of the eyebrows suggest the date, within the century following the philosopher's forced suicide in the reign of his pupil Nero.

Provenance: From the collection of Dr. Paul Drey, allegedly from Rome, then Munich.

Published: Sieveking, 1921, pp. 351–354; Robinson, 1954, pp. 352–353, pl. 76, fig. 3; Fogg Museum, 1961, p. 28, no. 219.

Bequest of David Moore Robinson, 1960.465

Arm from a Small Statue

probably third century A.D.
Marble, L. (max. as preserved) 0.10 m, L. (stone part only) 0.07 m

The surfaces of the drapery over the upper part of this arm and the part of the arm preserved to the joint at the elbow are smoothly finished. The remains of large iron pegs, much corroded, protrude at either end, the peg closest to the shoulder having rusted into an irregular shape. The surfaces are stained brown from the iron pegs in either end. The marble is from Asia Minor.

This appears to be the left arm from a small statue of a ruler with cloak on his left shoulder and left upper arm, or of a hero similarly represented. It is impossible to say whether the subject was wearing a cuirass or was shown in the heroic nude.

Unpublished.

Gift of the Committee for the Excavation of Antioch and its Vicinity, 1940.131

Lycian Votive Relief

second or third century A.D.
Limestone, H. 0.36 m, W. 0.62 m

The right upper corner is broken away, with the heads of three and the upper bodies of two (at the extreme right) missing. There are other minor chippings around the edges.

The rectangular plaque is carved with two registers of figures, a thin fillet molding above the flat surfaces between and below, either side of the lower niche with the standing figure in the center. In the upper row, carved in sunken relief, are thirteen male figures standing frontally, holding spears vertically in the right hand and wearing helmets and what seem to be cloaks over cuirasses with skirts. The central figure

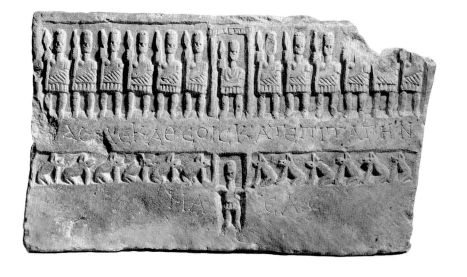

stands in a distyle baldachino with a fringed canopy and wears what seems to be an extra cloak *(paludamentum)* around his shoulders.

A similar male figure without the extra cloak and with arms spread out to the sides (in an *orans* gesture) stands frontally in the lower, central niche. On either side, in a long, thin, rectangular register, are six seated dogs (or possibly bears). They are shown in profile, each group facing toward the male figure in the center.

The inscription in Greek appears on the flat band between the two registers of relief, with the name MASAS divided on the flat surfaces left and right of the lower central niche:

ΔW ΔΕΚΑΘΕΟΙϹ
ΚΑΤΕΠΙΤΑΓΗΝ

The twelve Gods according to a Command
 Masas

The emperor or a chief divinity stands in the upper center, flanked by the twelve gods represented as warrior-hunters. The figure in the lower center is either the priest of the cult or a regional official. He may also be Masas, the dedicant.

The rustic style of these reliefs is paralleled in the reverses of Greek Imperial coins struck in the cities of Pisidia under Claudius II (A.D. 268–270) and Aurelian (A.D. 270–275). This may give a good clue as to the date of this class of dedication, a number of which, with different names on them, are carved by the same hands.

Published: *Christie's Sales Catalogue*, London, 2 December, 1970, p. 30, no. 94, plate (text from Dr. Klaus Parlasca); Comstock, Vermeule, 1976, p. 182, under no. 293: Museum of Fine Arts, Boston, no. 64.47, by the same hand. See also Robert, L., 1983, pp. 587–593.

Gift of William Kelly Simpson in memory of Michael C. Rockefeller, 1981.119

Fragment of a Relief

ca. A.D. 250–300
Fine grained marble, W. 0.174 m, H. 0.075 m

Two heads, facing center, are cut off at the neck. The noses are missing and the surfaces are worn.

The bearded head, in front of the strip of two-part molding, is turned to the right. The helmeted head of Athena or Roma-Virtus faces left, toward the man. Part of the man's shoulder seems to remain at the left, and the helmeted female figure may have been raising her arm to pat her helmet, as on the later Cancelleria relief in Rome.

The bearded man, who wears a fillet in his hair, could be a local man of letters, or he could be a representation of the Demos of Seleucia Pieria or Antioch, the latter city usually personified by her famous Tyche of Eutychides seated above the swimming river Orontes. This fragment of a figured panel with architectural molding certainly comes from a civic or commemorative rather than a funerary relief. If the bearded man were a famous private citizen rather than a god (like Asklepios) or a personification (like Boule or Demos), then the panel might have had a mixture of real people and divinities, like the Zoilos frieze at Aphrodisias in Caria or the Late Antique reliefs in the façade of the Temple of Hadrian at Ephesus.

The pair (part of a series) of limestone reliefs dedicated in A.D. 159 by a Palmyrene priest in the Temple of the Gaddé (or Fortunes) of Palmyra and Dura at Dura-Europos on the Euphrates, although Palmyrene in style, shows gods, heroes, and real people in frontal poses suggestive of what the Antiochene relief-fragment must have looked like when complete (Museum of Fine Arts, Boston, 1976, p. 48, under no. 63). It would be natural that, in the second and third centuries A.D. (save in times of military crisis), Antioch-on-the-Orontes and its port or suburbs would produce the Roman counterparts in marble to what the Palmyrenes created in their special styles in limestone.[1]

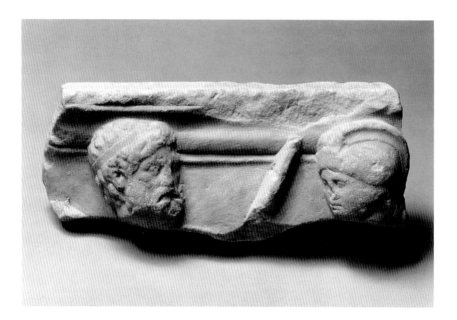

Provenance: From Seleucia Pieria.

Published: Stillwell, 1941, p. 124, no. 354, pl. 15; Walters Art Gallery, 1947, p. 35, no. 75.

1. Colledge, 1976, figs. 146 (the companion, Tyche relief at Yale), 32–43 (different subjects, in similar format, from Palmyra).

Gift of the Committee for the Excavation of Antioch and its Vicinity, 1940.126

Stele of a Lady and Her Servant

Attic or from the Greek islands, late Hellenistic to early Roman Imperial periods,
50 B.C.–A.D. 50
Greek island marble, H. (max.) 0.55 m,
w. (max.) 0.315 m, TH. (max.) 0.08 m

The surfaces are in good condition.

There are akroteria on the top of the molded pediment. The upper third of the relief is blank, the surface seemingly prepared for an

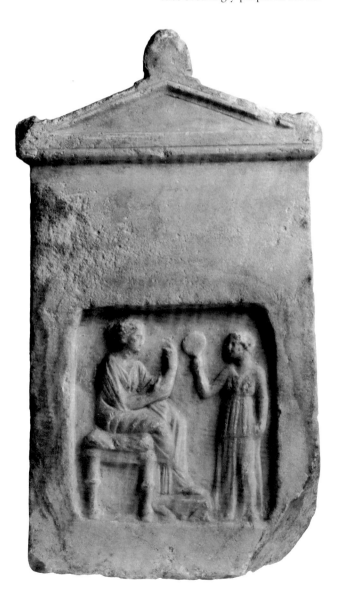

inscription. In the inset frame, a lady is seated to the right, spinning, on a backless seat with a cushion and a footstool. The maid facing her holds a mirror in her raised right hand.

Save that this stele appears to belong to the late Hellenistic period rather than firmly in the era of the Roman Empire, the remarks made in connection with and the parallels adduced for the companion stele from the Department of the Classics Collection, described below, could well apply here.

In addition to examples in Leiden (see below), the stele of Phila from the Cook collection at Richmond is a more elaborate, finished version of what we see here (Reinach, 1909–1912, II, p. 532, no. 3; Strong, 1908, pl. 12). The feeling is that, even when the provenance is not known, these stelai carved under Attic influence come from elsewhere on the mainland or the Greek islands, as a group in the National Museum in Athens, from such diverse places as Rhenea next to Delos, Hermione in the Peloponnesus, or the island of Tenos (Reinach, 1909–1912, II, p. 395, nos. 3, 4, and 7).[1]

Unpublished.

1. Compare also the stele of Chairestrate in Athens, from the Piraeus, where the mirror held up by the servant-girl is exceptionally large: Reinach, 1909–1912, II, p. 394, no. 1.

Transfer from the Department of the Classics, Harvard University, 1977.216.2185

Funerary Plaque

A.D. 41–54
Luna marble, H. 0.395 m, W. 0.29 m,
TH. 0.135 m

The surface of the face is fairly evenly obliter-
ated, with only the general outline of the face
and the inner corners of the eyes being visible.
The surface of the hand is destroyed, save for
the third and fourth fingers. The beads of the
necklace are broken on the surface, and the
robe is chipped on the right breast. The frame
is chipped at the top right corner and also a
little left of the center. It appears to have been
recut around the outer edge to imitate the
moldings of an Etruscan (Italic) to early
Roman cippus. In this case, the back was
smoothed off and the longer inscription added
in modern times.

The styles of the hair, eyes, face in
general, and clothing all suggest a
date in the time of Claudius (A.D.
41–54). The lady even looks some-
thing like Messalina.

The rectangular plaque has the
head of a woman in relief. Her hair
is drawn back, and the ends hang in
curls over each shoulder. She wears
a necklace of beads. Her right hand
clasps her garment below the left
shoulder.

The inscriptions[1] read:

(on the lower edge)
S T A T O R I A · M · F · Q A R Ā

(on the back)
C · S T A T O R I V S
S I P P O · M A N I L
M ' E · T E R T U L L A
S T A T O R I A E · C · F
A P P I A E A N · C · X X I I
C · S T A O R I O P R O C V
I O · E · A N N X X V

[1] As this book was going to press, John Bodel
of Harvard's Department of The Classics
brought to our attention a series of publi-
cations on the inscriptions, summarized in
G. Mennella, *Rivista di Studi Liguiri* 46
(1980): 195–197. The transcription of the
inscription is his reading.

Gift of Dr. Harris Kennedy, Class of 1894,
1932.56.129

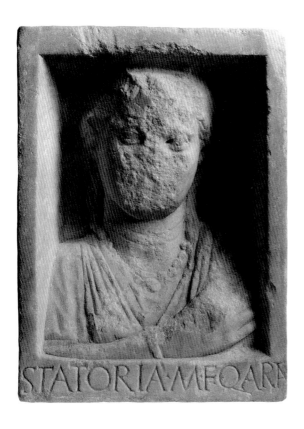

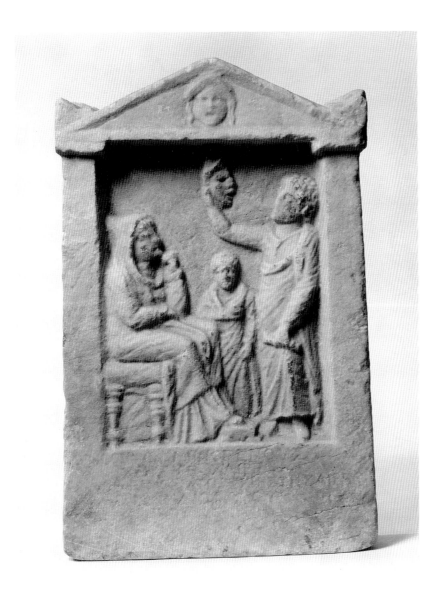

Funerary Relief

Graeco-Roman period, first or second century A.D.
Pentelic (?) marble, H. 0.565 m

The stele is complete. There is some surface abrasion and incrustations. The inscription of four lines has been nearly defaced. The upper half of the actor and his right arm/hand/mask may have been recut.

The naiskos or aedicula façade has a mask from the theater in the center of the pediment (where usually a round shield is shown). On the left, a seated woman, a pillow on her chair and her feet on a footstool, is raising her veil, the edge of her hooded cloak, with her left hand, and has her right hand across her lap. In the center, a child stands in orator's pose. On the right, a man faces a tragic mask that he holds up in his right hand; a scroll is in his lowered left hand.

This appears to be an Attic, or, more likely, a Greek island grave stele of the Roman Imperial period, perhaps the monument of an actor and his family. An example found in Piraeus and preserved in the museum there, only the lower half surviving, shows a mother with children in the same taste and complexity as this scene (Conze, 1911–1922, p. 97, no. 2110, pl. CCCCLXII; also pl. CCCXCII, no. 1868, pl. CCCCI, no. 1882).

Funerary stelai with playwrights or actors holding masks can begin with the famous Attic example of an elderly poet of the Middle Comedy, perhaps Aristophanes about 380 B.C., seated with one mask in hand, one above in the background (Bieber, 1961a, p. 48, fig. 201).[1]

Published: Fogg Museum, 1961, p. 28, no. 218.

1. Related reliefs with a figure holding up a mask turn up around the peripheries of the Greek world: Pfuhl, Möbius, 1977, pl. 138, fig. 923 (Sofia), pl. 167, fig. 1109 (Verona).

Bequest of David Moore Robinson, 1960.458

106

Funerary Stele

East Greek, early Roman Imperial
period, A.D. 14–68
Greek island marble, H. (as preserved)
0.655 m, W. 0.388 m, TH. 0.10 m

The relief is broken away and is missing at a
rough line of the two adults' heads. The fig-
ures are in the inset relief. The area below is
blank, prepared for the inscription. The boy's
face is somewhat weathered.

A man in a himation stands facing,
at the left; a woman in a chiton and
himation stands next to him. At the
extreme right is a small boy in a
short tunic and a cloak around his
left shoulder. The boy holds a hand-
ful of fruits in his cloak with his left
hand.

 The tombstone belongs to a
widespread class of funerary monu-
ments that represents the last mani-
festations of tradition going back
through the big East Greek Helle-
nistic tomb reliefs to the last Attic
stelai of the decade before their tra-
ditional curtailment in 317 B.C.
Tombstones such as this example
were commonly found in the Greek
islands (the Aegean), Crete, some-
times North Africa including Egypt,
and, above all, the cities along and
inland on the western coast of Asia
Minor. They also appear in Mace-
donia and Thrace, but these regions
soon changed to a form of monu-
ment with busts or just heads in rec-
tangular and circular (tondo)
frames.

 A good representative collec-
tion of these reliefs is in Leiden,
including examples from Smyrna
and Ilion on the plain of Troy (Bas-
tet, Brunsting, 1982, I, pp. 86–93,
nos. 163–173, II, pls. 44–47).

Unpublished.

Transfer from the Department of the Classics,
Harvard University, 1977.216.2186

107

Small Head of a God or Youth

first or second century A.D.
Greek island marble, H. 0.039 m

The nose is damaged, and there is a break
through the middle of the neck. The cap (or
the hair) behind curls around. The brow is
smooth, suggesting this area may have been
finished in paint.

This is a Severe Style head in minia-
ture, from a small statue, perhaps of
Hermes, with the petasos on his
head and the wings attached where
holes remain behind the ears. The
fifth century B.C. antecedents of this
head compare well with the so-
called Strangford Apollo from Lem-
nos in the British Museum, about
485 B.C. (Vermeule, C., 1982, p.
223, fig. 189). The athletic victor in
the Museo Civico, Agrigento, is the
Sicilian counterpart of this Attic or
Greek island god or youth (Hanf-
mann, 1967, p. 313, pl. 95).

 A number of decorative herms
flanking doorways in the houses of
Pompeii, Herculaneum, and sur-
rounding towns have something of
the general aspect of this head, sug-
gesting a date in the first century
A.D. before the eruption of Vesu-
vius. The small size indicates a
votive or funerary purpose, proba-
bly as part of a statuette. The
archaistic and Severe Style qualities
of this little head in a Pompeiian
decorative context can be illustrated
by a sculpture of unknown prove-
nance, definitely not a forgery, in
the Museum of Art, Rhode Island
School of Design (Ridgway, 1972,
pp. 123, 235, no. 52).

Published: Fogg Art Museum, 1982, p. 173.

Purchase from the David M. Robinson Fund
through the Estate of Therese K. Straus,
1979.401

Funerary Stele of
"Child Eirenaios"

second or third century A.D.
Crystalline Greek marble, probably from
Thasos, H. 0.3125 m, W. 0.34 m, TH. 0.12 m

The upper part, with the subject's bust, fron-
tally, in high relief, is preserved. The surfaces
are weathered and somewhat pitted. The
stone has a brown patina. The inscription is
in Greek.

EIPHNA IΣEIPH
NAIWT WΠAIΔ
WMNIAΣ ΠAPIN
(on either side of the head)

The half figure is represented with
head and body shown frontally,
arms firmly at the sides. The style of
the child's hair suggests a date in
the Hadrianic period, probably
about A.D. 120.

A stele of this type is in the
Archaeological Museum, Istanbul,
unfortunately without provenance.
An obese child's bust is shown in
middle to late second or third cen-
tury A.D. form, down almost to the
middle of the ribcage; the bust in
relief is also represented as mounted
on a small plinth or large pedestal
(Mendel, 1914, p. 162, no. 947). A
funerary relief of Alexandros in Lei-
den shows a similar, half-figure bust
of a boy and was brought from
Thera-Santorini; it has been dated
in the Roman Imperial period (Bas-
tet, Brunsting, 1982, pp. 91–92, no.
171, pl. 46). The purpose in these
reliefs is to suggest a portrait-bust
of the deceased.

These half-figure busts in relief
of fat little children came into the
art of the Graeco-Roman Imperial
East not only from Egypt or Attica,
or the Greek islands, but from
Roman sarcophagi created for
export to all parts of the Empire,
especially Macedonia and North
Africa. The busts of children on the
sarcophagus in Algiers, Musée
National des Antiquités, from Had-
rumetum and dated A.D. 225–250,
bears this out (Wrede, 1981, p. 200,
pls. 18, 19). Whether sophisticated,
as on sarcophagi, or rustic, as on
this stele, these funerary children
were part of the pan-Mediterranean
verism of the Roman Empire.

Published: Fogg Museum, 1961,
p. 28, no. 220.

Bequest of David Moore Robinson, 1960.471

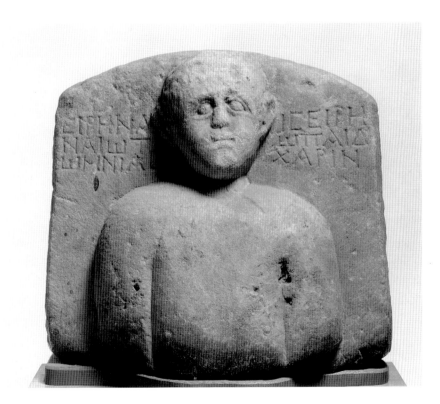

Section of a Pilaster

ca. A.D. 120?
Grayish marble with crystals, H. 0.248 m,
W. 0.14 m, TH. 0.035 m

The top molding is preserved, and the other three sides are broken irregularly. The back is smoothed with a slight forward angle at the top. The marble is from Proconnesus (Marmara) in the Propontis (Sea of Marmara).

Below two parallel fillet moldings at the top, a large acanthus leaf is shown flattened at the left. A plant curling upward into a rosette and a leafy tendril are at the right. Beyond at the lower right is the start of another plant.

Unpublished.

Transfer from the Department of the Classics, Harvard University, Pfeiffer-Hartwell Collection, 1977.216.196

Fragment of Molding

Roman (?), probably first century A.D.
Red stone, W. 0.08 m, H. 0.025 m

The ends are broken irregularly, and the topmost fillet has been damaged. The top surface is flat and finished, as are the back and the bottom edge, under the lowest fillet. The surfaces are weathered.

The molding comprises the damaged top fillet, a *cyma reversa* that forms the main profile, and a fillet at the bottom. The fragment looks as if it could have come from the wall of a house at Pompeii or in Rome. Such moldings were used as the framing for areas of frescoed walls, real elements to contrast with the painted panels, the pictures painted on the walls, and the simulated architectural elements.

As a stone revetment, which is the most likely use, this fragment could have jacketed the lower part of the wall and been an adjunct to the framing of slabs of colored marble, *giallo antico* or the like. The relief of the Lararium in the House of Lucius Caecilius Iucundus at Pompeii exhibits such molding, in white marble (Guadagno, Carafa, 1973, p. 10). Moldings like this, in white marble, colored stone, or similar stucco also span the spectrum of First and Second Style wall decoration, in the House of Sallust at Pompeii and the House of Lorcius Tiburtinus in the same town (Schefold, 1962, pls. 18, 82).

Unpublished.

Gift of the Misses Norton, 1920.44.209

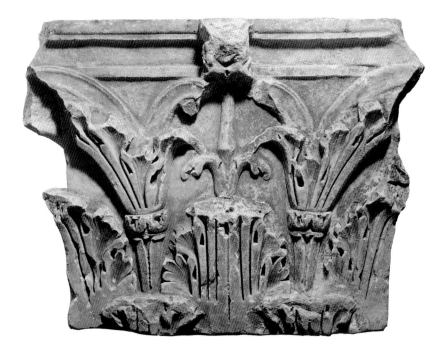

Capital from a Pilaster

Roman, probably A.D. 130–190
Marble, H. 1.015 m

The damage is extensive, especially at the ends of the volutes and leaves. The bottom has been cut away, as if the capital had been reused in a smaller setting.

At the time of acquisition or soon thereafter, the pilaster was said to have derived from the *Ara Pacis Augustae*. The Corinthian pilaster capitals on the outside precinct wall of the *Ara Pacis*, however, have broader, flatter leaves, without the bullet-shaped vertical cuttings and with less complex stems. The fragments of the internal pilasters were quite different (Kähler, 1963, pp. 66–69, pl. on p. 68; Moretti, 1948, I, p. 113, pl. E [general view as reconstructed], pp. 168–171).

The date of this pilaster capital would seem to be in the second century A.D., and stylistic details are similar to those of the capitals at the Forum Baths of Ostia (Heintze, 1971, pp. 59–60, pl. 56). On the Pantheon capitals the leaves have fan patterns, while the Harvard capital has more parallel channels (see generally, Heilmeyer, 1970, pl. 55). The detailing of the Forum of Trajan anticipates this pilaster capital (Heilmeyer, 1970, pl. 52); in turn the Temple of Vesta in the Forum anticipates Severan details (Heilmeyer, 1970, pl. 59).

Provenance: The capital was purchased from the dealer Augusto Frank in Rome

Unpublished.

Gift of Paul J. Sachs, 1926.31.2

Etruscan and Roman Sarcophagi and Urns

The Roman sarcophagi are all fragmentary, some large and fairly complete, others small and even broken to the point of being scrappy. The Etruscan examples, technically large urns, come complete, with reclining figures and bodies on the lids, but they belong to the latest examples, when the art had become routine and stereotyped. The Roman carved marble urns are complete, or at least fairly so, but their decoration is only a prologue to that on the decorative sarcophagi. The Attic Amazonomachy of around A.D. 200 (no. 121) is the capstone of this small collection, not without its interesting mythological fragments.

The fragment of an Attic sarcophagus showing the myth of Achilles on Skyros (no. 124) is the broken remainder of a great scene (with only the upper part of Odysseus and the cloak of Diomedes surviving), a piece first recorded on the island of Paros in the Cyclades. The popular Roman sepulchral composition of the abduction of Persephone by Hades appears at Harvard in a fragment (Hermes leading the quadriga) no. 123, which affords a magnificent opportunity for students of ancient mythological narration and antiquity's survival to be introduced to the details of ancient art at its best level of concern for the Roman patron at the height of the Empire.

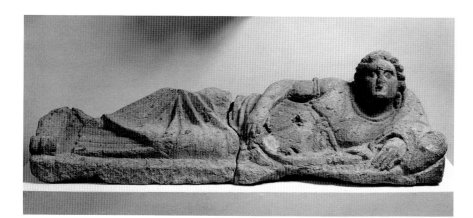

Late Etruscan Urn and Lid

second or first century B.C.
Volcanic stone, H. 0.67 m (with lid, 1.25 m),
W. 0.67 m, L. 2.17 m

The body is of peperino; the lid of tufa. The
lid has been broken in several sections and
repaired with a large metal bracket. The stone
and the surfaces are extremely friable.

A female figure half-reclines on the
lid, as if it were a couch. The
inscription on the edge of the lid
(first word uncertain ends in -*a Lar-
thal Larthia*. There are traces of red
paint on the pillow, drapery,
inscription, and sarcophagus.

Provenance: Excavated in the necropolis of
Musarna (Città Masarna) in the territory of
Viterbo, one of eight found.

Published: Whatmough, 1942, p. 431; Hanf-
mann, 1955, pp. 83, 256; Comstock, Ver-
meule, 1976, pp. 250–251, under no. 386.

Transfer from the Peabody Museum of
Archaeology and Ethnology, gift of the Amer-
ican Exploration Society, 1927.203a, b

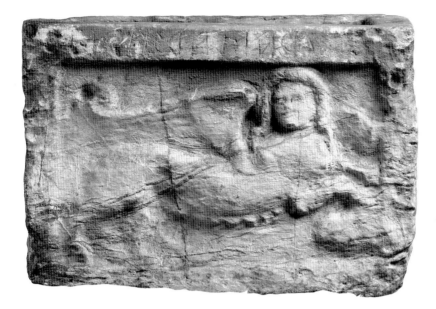

Late Etruscan Urn

third century B.C.
Volcanic stone, H. 0.45 m, W. 0.64 m,
TH. 0.28 m.

A winged genius appears on the front of the urn, in flying pose.

Winged monsters and genii are very popular as symbolic, funerary decorations, carved and painted, on the fronts of late Etruscan or Italic urns. The painted travertine urn in the Museum of Fine Arts, Boston, with an elegant lady on the lid, is dated in the third century B.C. and features a winged, fish-tailed female creature like Scylla on the front (Comstock, Vermeule, 1976, pp. 249–250, no. 385).[1] The full catalogue of what the Etruscans after 350 B.C. sought in winged "genii" appears on both long sides of a sarcophagus from Bomarzo in the British Museum. They are of both sexes and, demonstrably, of all ages— both young and elegant and old, grizzled, and wrinkled.[2]

Published: Whatmough, 1942, p. 431.

1. Scylla, in a similar figure, has eyes on her wings (like a peacock), on the front of an urn in Volterra. Reinach, III, 1909–1912, p. 466, no. 2.

2. Pryce, 1931, pp. 185–188, no. D 20, with extensive discussion of mythology, monsters, animals, and general symbolism.

Gift of Dr. Harris Kennedy, Class of 1894, 1932.56.118

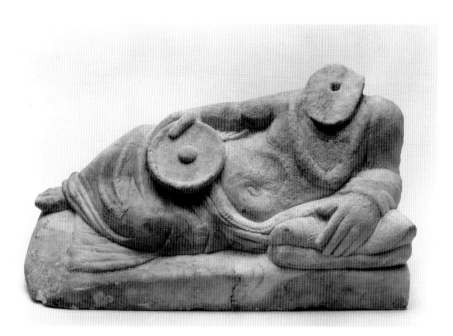

Lid of a Late Etruscan Urn

third century B.C. or later
Volcanic stone or alabaster, H. 0.372 m,
W. 0.532 m, H. (max. of head) 0.13 m

The stone is volcanic or alabaster, a lime-
stone-like material. The head and body are in
two parts. There are traces of paint for the
flesh on the head. The surfaces are dirty.

This urn is a rectangular box un-
decorated except for a sunken rec-
tangle on the front and on each end
(H. 0.27 m, W. 0.505 m). The male
figure, nude to the waist and with a
rope-like garland around his neck, is
reclining. The left arm rests on a
cushion, and the right hand holds a
phiale. The hair, represented by
straight lines, is bound by a fillet, or
rolled diadem of the type introduced
to the Mediterranean world in the
age of Alexander the Great. The left
ear is hardly preserved, being
mostly gouged away. The right ear
is summarily treated, as is the face,
with the head evidently carved to be
seen from its own right side only.
 A complete urn in the Museo
Civico at Chiusi has a similar lid
and a body with the Gates of Hades
in relief on the front (Giglioli, 1935,
pl. CCCCV, fig. 4).

Unpublished.

Gift of Dr. Harris Kennedy, Class of 1894,
1932.56.117a, b

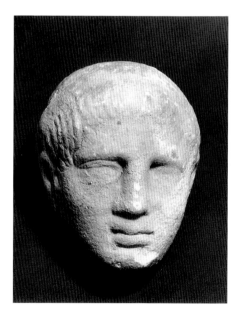
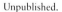

Etruscan Funerary Urn and Lid

second century B.C.
Volcanic tufa, lid: H. 0.40 m, W. 0.622 m;
urn: H. 0.43 m, W. 0.57 m

The urn and lid are worn, incrusted, and chipped.

The woman lies on her left elbow and holds a dish (phiale) in her right hand. She appears to wear a wreath around her neck. Her proportions are almost obese, the work poor and crude with frequent incision.

The urn itself is a deep, rectangular box on two short legs. The interior is roughly hewn out. The major late Etruscan or Italic sites have yielded many such funerary ensembles. Those from around Volterra are distinguished by the interesting and imaginative carving of the front of the funerary box (Cristofani, 1977, pp. 32–45).

Unpublished.

Gift of the Peabody Museum of Archaeology and Ethnology, 1942.210 a, b

Cinerarium

Italo-Etruscan, late Roman Republic
Alabaster, H. 0.31 m, W. 0.52 m, TH. 0.26 m

The surfaces are covered with an earthy incrustation, creating a mottled effect. The ground or molding below the horse's feet is broken away, as if hollowed out underneath. Most of the animal's left leg and the rider's left foot are also lost.

The front panel only is carved with a triple fillet molding above, Doric triglyphs left and right, with base moldings below. In the inset relief of the front panel, between the triglyphs a young person enveloped in a cloak rides to the left on a large horse.

The architectural arrangement and sculptural format of this urn can be visualized by the older, Hellenistic Etruscan monuments from Volterra, carved in volcanic or alabaster-like stone. Between the pilasters of one example, Scylla is seen in the conventional, frontal view of Greek metalwork of the fourth century B.C. The rider represents the deceased on his equestrian journey to the underworld, between two winged demons. The motif survived into monumental Roman Imperial funerary reliefs and sarcophagi (Giglioli, 1935, pls. CCCC, no. 3, and CCCXCVI, no. 1, both in the Museo Guarnacci; Haynes, 1939, pp. 27–32, pls. I, II).

Published: *Sotheby Sale*, London, 13 June, 1966, p. 77, no. 175.

Gift of Harry J. Denberg, 1969.177.3

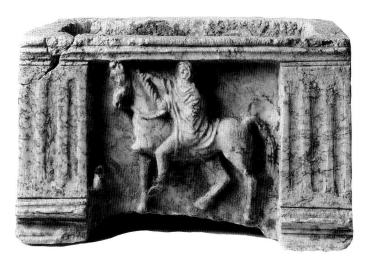

Rectangular Cinerarium with Lid

A.D. 98–117
Marble seemingly from the Greek mainland (Hymettan?), H. 0.175 m, W. 0.345 m, D. 0.299 m

The lid is missing but the urn is otherwise complete. There is some surface incrustation and chipping. Drillmarks are visible. The bottom of the urn is missing.

Heads of Zeus Ammon appear on each front corner. A garland with fillets runs from one head to the other, beneath the inscription plaque. Horned lion-griffins with ram's heads between their forepaws are seated on each side. The urn is dated from the inscription, which speaks of a freedman of the Emperor Trajan (ruled A.D. 98–117).

D · M ·
M · VLPIO AVG · LIB
CLEMENTI VLPIA · M · F
CLEMENTINA · FIL
PATRI PIISSIMO FEC

A companion cinerarium has long been in the collection of Dr. J. Disney of Cambridge University, in the Fitzwilliam Museum. This latter cinerarium was also inscribed for a freedman of Trajan, Marcus Ulpius Fortunatus, set up by his father, Philetus, and his widow Ulpia Plusias. There are also Ammon heads prominent in the enrichment.[1]

Heads of Zeus Ammon were popular enrichments on such urns because the garlands could be tied to their horns. They had been symbols of Roman Imperial majesty ever since their appearance in the centers of wall and ceiling panels of the Forum of Augustus in Rome, finished about 2 B.C. The cineraria of Trajan's freed families prove that such designs persisted in the decorative repertories available to the ordinary peoples of the capital as late as the beginning of the Antonine age (A.D. 138).

Provenance: The object came from Rome.

Published: *CIL* VI, 1968, no. 29157; *Sotheby Sale*, London, 13 June, 1966, p. 76, no. 173; Koch, Sichtermann, 1982, p. 51, pl. 44.

1. Accession no. GR 55-1850; *CIL* VI, 1968, no. 29203. Budde, Nicholls, 1964, p. 94, no. 153, pl. 51. See also the example in Sir John Soane's Museum, London and further parallels (including Mustilli, 1939, pl. XXIII, no. 80-17): Vermeule, C., 1953, p. 368, no. 331.

Gift of Harry J. Denberg, 1969.177.1

Rectangular Cinerarium with Gable-Shaped Lid

ca. A.D. 125–150
Marble, H. (urn) 0.245 m, H. (lid) 0.125 m,
W. 0.35 m, D. 0.28 m

The urn is complete. Drillmarks are visible.

Two genii stand on stylized bovine skulls (bucrania), and hold the fillets of a garland that runs across the front, below the inscription plate that they flank. Two ravens perch on the garland, their heads facing inward. The lid has a wreath and long fillets in the pediment, with floral akroteria on the corners.

The inscription reads:

D I S · M A N I B
A N N I A E · P · F · I S I A D I ·
V I X I T · A N N I S / X V I · M E N S I B ·
I I · D I E B · X V I I / P · C O R N E L I V S ·
P · L · M A M E R T I N V S / V I R ·
I N F E L I C I S S I M V S · F E C I T /
C O N I V G I · D V L C I · F I D E L I ·
P I A E / C O N I V G A L I · E T · S I B I

To the Manes of Annia who lived sixteen years, two months, seventeen days, daughter of Publius Isiadius. Publius Cornelius Mamertinus, freedman of Publius, a most unhappy husband made (this tomb) for his sweet, faithful and pious wife and for himself.

The design of genii, Amorini, or Erotes supporting the garland dates this urn in the Hadrianic or early Antonine periods (ca. A.D. 125–150) when garland-bearing children, with or without wings, were becoming standard on Roman sarcophagi. The composition is found on only a few cineraria, which were carved at the time when coffins for the body rather than urns for the ashes were becoming popular in the Classical world. A damaged example at Fenway Court shows the Erotes perched on Roman Imperial eagles of apotheosis (Vermeule, C., Cahn, Hadley, 1977, p. 40, no. 54 and further parallels). See also the urn of Lucius Antonius Dionysius at Castle Howard in Yorkshire (Oehler, 1980, p. 55, no. 23, pl. 84).

The bucrania as symbols of death were increasingly popular in Hadrian's reign, being a prominent feature on the rectangular base of his own mausoleum beside the Tiber.

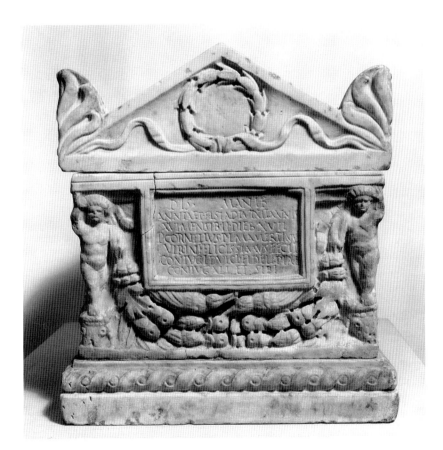

Provenance: From Rome, Palazzo or Villa Giustiniani.

Published: *CIL* VI, 1882, no. 11794; *Sotheby Sale*, London, 13 June, 1966, p. 77, no. 174.

Gift of Harry J. Denberg, 1969. 177.2

Fragment of a Cinerarium

probably late Julio-Claudian period, ca. A.D.
50
Marble, H. (as preserved) 0.173 m,
W. 0.178 m, TH. (max.) 0.038 m

Two sections of an architectural façade sur-
vive flanking a large Ionic pilaster. The mar-
ble is of architectural nature, probably
Hymettan. The fragment has been broken
irregularly across the top and bottom. The left
and right edges have been squared off, the
right edge more perfectly than the left. The
remaining mortar on the back amid the root
marks shows this fragment was recut as build-
ing material. At a date in the Renaissance or
later, it may have been inserted in a palazzo
or garden wall.

Two sepulchral portals are shown,
that on the left with a curved pedi-
ment or top, that on the right hav-
ing a triangular top. A large marble
cinerary urn of the late Julio-
Claudian or Flavian periods in the
J. Paul Getty Museum has complex
portals between pilasters on one of
the ends, all designed to make the
chest for the ashes of the deceased
look like a miniature temple or
sepulchral buiding (Vermeule, C.,
Neuerburg, 1973, pp. 38–39, no.
86). An example from the Mattei
collection in the Belvedere of the
Vatican, used by one Q. Vitellius,
has pedimented portals on all four
sides (Amelung, 1908, pp. 249–
250, pl. 15). The lid, as is usual
here, takes the form of a Greek
roof, with pediments, tiles, and
antefixes.

Unpublished.

Gift of Mr. Norman E. Vuilleumier, 1949.108

Fragment of a Cinerarium

probably Trajanic period, ca. A.D. 100–120
Marble, probably Hymettan, H. 0.117 m.,
W. 0.317 m, TH. (max.) 0.15 m

The double-fillet molding on the front and the
two sides survives. The upper surface and the
back are broken irregularly. The material is a
very low grade marble, probably Hymettan.
There is an ancient hole in the lower front, as
if the body had been reused as a small foun-
tain. The interior was plastered at the time of
this second use. The bottom is cut and fin-
ished roughly.

The front is decorated with a
looped garland of leaves and buds.
At each corner is a sphinx, shown in
double-image profile. A late Flavian
cinerarium, or a Trajanic monu-
ment for a freedperson of the Fla-
vian dynasty, in the Museum of Fine
Arts, Boston, shows how the Har-
vard cinerarium could be com-
pleted, with eagles above the
sphinxes to hold the ends of the gar-
land as it is draped around the sides
and bottom of the inscription plate
(Comstock, Vermeule, 1976, p.
148, no. 239).

Unpublished.

Gift of Dr. Harris Kennedy, Class of 1894,
1932.56.123

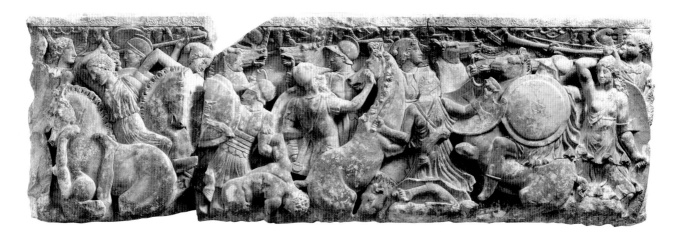

Front and side of an Attic Sarcophagus

late second to early third centuries A.D.
Pentelic marble, H. 0.635 m, W. (left end, as
preserved) 0.55 m, W. (front) 1.94 m

There are five sections, with pieces missing at
the breaks. They run from the left end to the
left front edge (or about so, with a section cut
away), to the turn of the corner at the right
front. The slabs look as if they had been cut
and broken apart for use, face down, as pav-
ing stones. The visible surfaces are fresh, save
where there is chipping.

The scene shows a battle between
the Greeks and the Amazons. Sarco-
phagi with scenes of combat
between Amazons and Greeks were
carved in Italy, Asia Minor, and
Attica. Those created around the
quarries near Athens were the most
satisfying in terms of classical Greek
sculpture because, as especially
here, they reflect the ideal scenes of
combat going back to the Parthenon
metopes, passing the era of the Bas-
sae frieze with its Lapiths and Cen-
taurs, and culminating in the friezes
of the Mausoleum at Halicarnassus.
Amazons were remembered for
campaigns in Phrygia, Lycia, and an
attack on Theseus at Athens, but
the presence of Achilles and the
dying Amazon Queen Penthesilea in
Roman Amazonomachies suggest
the focus was on the battle at Troy,
when, late in the war, the Amazons
came to aid their cousins Priam and
the Trojans.

A sarcophagus such as the
Forbes-Gould-Harvard example,
which once had a pedimented,
temple-roof-shaped lid, would have
appealed to a client in western Asia
Minor because of its strongly
Pheidian to Skopasian flavor. The
combats could be thought of as
symbolic of life's trials or the rav-
ages of death (many other mytho-
logical sarcophagi combined similar
themes). Otherwise, the Amazono-
machy may have appealed to those
persons, in Ionia or Italy, who cher-
ished scenes from the Trojan War
and, here, myths in which the Tro-
jan ancestors of the Romans or their
exotic allies were prominent.

While looking back to Athens
in the fourth century B.C. in pas-
sages and specific details, this com-
position (the long side) with its
crowded upper background, its
foreshortened casualties in the bot-
tom register, and its elongated com-
batants in the central area from end
to end also looks ahead to Late
Antique battle sarcophagi (the
Ludovisi Sarcophagus in the Museo
Nazionale Romano) when such
unclassical elements will mark the
beginning of the end of ancient art.

Provenance: From Smyrna (according to
Richard Norton) by way of the Barracco Col-
lection.

Published: Chase, 1924, p. 155, fig. 186; Phi-
lippart, 1928 p. 41; Rodenwaldt, 1930, p.
162, fig. 41 (detail); Ellis, 1936, p. 216
(abstract of thesis); Redlich, 1942, p. 49, pl.
3; Andreae, 1956, p. 35, no. 8: dated A.D.
190–200; Kallipolitis, 1958, p. 24, no. 118;
Giuliano, 1962, p. 70, no. 459; Fogg
Museum, 1971, The Checklist, p. 150; Hanf-
mann, Mitten, 1978, p. 366, fig. 9; Giuliano,
Palma, 1978, p. 30, no. II.7, p. XXVIII:68:
attributed, with twelve others, to the "Agri-
gento Master" (with older bibliography on
collections of Attic sarcophagi); Koch, Sich-
termann, 1982, pp. 391, 438 note 15, 458;
Mortimer, 1985, p. 109, no. 21.

Bequest of Charles W. Gould, 1932.49a,b
(right two)

Gift of Edward W. Forbes, 1899.9a, b, and c
(left three)

Head of a Warrior

Antonine or possibly early Severan period
Pentelic marble, H. 0.127 m

The nose is damaged, and there are chips over
the right brow, left ear, and back of the hel-
met. There are drillmarks in the interior cor-
ners of the eyes, nostrils, edges of the mouth,
ears, and curls of hair. The surface has been
reworked (Guntram Koch).

The helmeted head is tilted back
and to the left. The face has a
pained expression, with furrowed
brow and a slightly opened, Skopaic
mouth.

There are many parallels for
this head, which came from an Attic
battle sarcophagus. One (tilted
downward instead of upward)
belongs to the Greek on horseback,
raising his sword to strike, on the
Attic sarcophagus with Amazono-
machy in the Museum at Thessalo-
niki (Giuliano, 1962, p. 44, no.
217, photograph on cover). A simi-
larly helmeted head of identical
dimensions, with a polish to the sur-
faces, was thought to be perhaps an
Amazon from a sarcophagus of the
late Antonine to early Severan
periods (Johnson, 1931, p. 120, no.
243).

Published: Fogg Museum, 1969a, The Check-
list, p. 256.

Bequest of Grenville L. Winthrop, 1943.1314

Fragment of Sarcophagus Relief

ca A.D. 160
Crystalline Greek island marble (perhaps
from Thasos), H. 0.254 m, W. 0.318 m, TH.
(at the top) 0.09 m

This fragment is broken on a diagonal axis.
The head of Hermes is broken at the neck, as
is the head of one of the horses. A portion of
the molding remains above Hermes' head.

Hermes is seen with two horses.
The horses are facing to the right,
and the head of one is two-thirds
missing. Hermes is facing to the left.
The section of heavy, fillet molding
is preserved above the god's petasos.

Guntram Koch illustrates two
Rape of Persephone sarcophagi,
once in the Palazzo Barberini, which
give an excellent idea as to how the
composition once looked. The figure
of Hermes and the horses of the
quadriga are usually at or just
before the extreme right front end
or corner of the sarcophagus. A
geographical personification, Tellus
(Earth) or Oceanus reclines right to
left under the unquadrated, gallop-
ing legs of the horses (Koch, 1976,
p. 108, figs. 20, 21a).

Provenance: From the art market in Rome
(1968), along with a companion fragment,
now in a private collection in London, show-
ing the heads of Persephone's sisters witness-
ing her abduction by Hades, assisted by
Athena (Koch, 1976, fig. 22a).

Published: Fogg Museum, 1976, p. 84; *Art
Quarterly* 35, 1972, p. 186; Koch, 1976, pp.
108–109, no. 21, fig. 22b (then in the art
market in Rome); Koch, Sichtermann, 1982,
p. 176.

Gift of Mr. and Mrs. Benjamin Rowland, Jr.,
1971.92

Fragment of an Attic Sarcophagus

Roman, late second or early third century A.D.
Pentelic marble, H. 0.35 m, W. 0.35 m

All edges are broken. The top of the head and forehead is broken away. The face is badly abraded. Other surfaces are chipped and discolored.

The original sarcophagus portrayed the myth of Achilles on Skyros. Now the upper part of the body of Odysseus, moving to the left, survives, the head and neck of a horse visible over his left shoulder. The cloak of Diomedes can be seen to the right of Odysseus. A section of the molding survives at the top.

The ultimate provenance of this fragment, like the Amazon sarcophagus from Smyrna, is evidence of the widespread export of Attic mythological sarcophagi. The Achilles on Skyros sarcophagus fragment brought to the Isabella Stewart Gardner Museum at Fenway Court, Boston, in 1986 from the Renaissance gardens at Green Hill (the Gardner estate in Brookline, Massachusetts) is seemingly from an earlier presentation of the subject. This splendid fragment of Achilles and one or two of the daughters of King Lykomedes recalls that these Attic Achilles on Skyros sarcophagi went to Italy, like the great sarcophagus of "Alexander Severus," as well as to the Greek East. The earlier examples usually had temple-form lids, but the later sarcophagi from Attic ateliers featured the deceased reclining on the lid as if on a couch. Achilles was hidden by his mother Thetis among the king's daughters to prevent him going to the Trojan War and certain death. Disguised as itinerant merchants, Odysseus and Diomedes placed a sword amid trinkets for the daughters. Achilles snatched up the sword and was thus revealed. The whole episode on a sarcophagus symbolizes the beginning of the Greek hero's ill-fated journey to war and death, a fate that befell many Romans, especially in the third century A.D.

Provenance: First recorded on the island of Paros (Guntram Koch's identification). From the Estate of Joseph Brummer, New York.

Published: Robert, C., 1890, p. 220, no. 221; Giuliano, 1962, p. 34, no. 79; Koch, Sichtermann, 1982, p. 383.

Purchase from the Alpheus Hyatt Fund, 1949.47.151

Fragment of a Figure in Relief

ca. A.D. 160–235
Pentelic marble (?), H. 0.26 m, TH. (of background) 0.095 m

All of the edges are broken. The right arm and chest from shoulder to waist remain.

A lock of hair is visible on the shoulder of this figure, moving from left to right like Virtus on a large hunting sarcophagus. A bracelet is also visible on the right, upper arm, and the drapery (himation) has fallen around the waist, although the chiton (pinned on the right shoulder) covers the right breast. This is not a characteristic of Amazonian figures on big sarcophagi.

The sarcophagus with symbolic hunting scenes, about A.D. 230, in the Palazzo Mattei, Rome, has a figure of Virtus following the imperatorial hunter on horseback. Although the chiton has slipped from the right breast, the pose is identical with that of this fragment (Vermeule, C., 1978, pp. 140–141, 198, 365, fig. 148).

This figure may also be identified as a fragment from a sarcophagus depicting the myth of Achilles on Skyros. It shows a daughter of Lykomedes rather than an Amazon, Roma, or similar symbolic figure. The thickness of the background suggests a large sarcophagus or commemorative relief.

On other sarcophagi representing Achilles on Skyros, one of the daughters of Lykomedes typically holds out her arm in the gesture seen in the Harvard fragment. A good example is the late Antonine or Severan sarcophagus at Woburn Abbey depicting Achilles on Skyros. On the Woburn Abbey sarcophagus, the third daughter from the left assumes this pose, identifiable despite the fact that her arm has been restored without the bracelet which, in the original story, the girls grabbed while Achilles was busy with the martial equipment (McCann, 1978, pp. 67–68, fig. 73).

Provenance: From the estate of Joseph Brummer, New York.

Unpublished.

Purchase from the Alpheus Hyatt Fund, 1949.47.144.

Right Upper Corner of the Front of a Fluted Sarcophagus

ca. 150–200 A.D.
Italian marble (?), H. 0.35 m

The right part of the relief is missing. The figure of a standing woman is cracked on a line going across the breast, with another on a line along the right arm and across to the waist. The surfaces are worn, the modeling indistinct. Three holes are drilled in the base. The piece was reused in the Middle Ages (Guntram Koch, according to notes in object file). The back was cut down, and a mosaic with two red bands and black patterns was inserted.

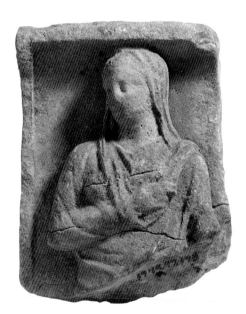

The woman is fully draped and holds the himation with her right hand, in a version of the so-called *pudicitia* gesture, or the pose of a Muse. Her head is turned to the left.

Her position and general pose can be visualized by the lady on the left front of the large, columnar sarcophagus with portals, in Cordoba (Himmelmann, 1973, p. IX, pl. 7). On a fluted sarcophagus of the fourth century A.D., a similar lady stands in the rectangular frame of the left front, with Orpheus charming the beasts in the center panel and the husband as a philosopher in the frame on the right front corner

(Pesce, 1957, pp. 102–103, no. 57, figs. 113–116, at Porto Torres, Basilica di San Gavino, in the crypt). Usually the women are on the left instead of the right front corner, unless two women are involved. Compare, for style and date, the lady in *orans* pose on the left front of a fragmentary strigilar sarcophagus in Bonn (Bieber, 1977, p. 251, fig. 892).

There are, of course, many illustrations of Roman sarcophagi reused in Medieval times, usually as coffins. Those brought from the Ostia necropolis to the Campo Santo at Pisa are classic examples. Sarcophagi were also used as storage chests and as fountain basins, particularly in Renaissance times when their carving was appreciated for historical and literary as well as symbolic reasons. Sarcophagi cut into slabs and carved or inlaid on the flattened interior surfaces are rather rarer. A spectacular example is in the Isabella Stewart Gardner Museum, a section of strigilar front with an Amorino supporting an *imago clipeata* at the left, turned on its right end and carved with two Neapolitan, French-style, Late Gothic saints (Agnes and ?) in a setting of two arches supported in the center by a slender column (Vermeule, C., Cahn, Hadley, 1977, pp. 42–43, no. 58, and p. 68, no. 96).

Provenance: From the Estate of Joseph Brummer, New York.

Unpublished.

Purchase from the Alpheus Hyatt Fund, 1949.47.148

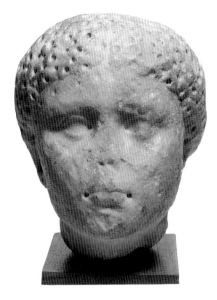

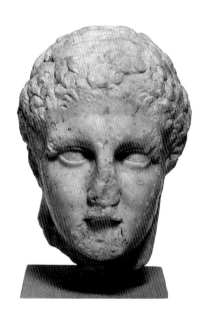

Head of a Lady

(top left)
first or early second century A.D.
Crystalline marble, from Asia Minor (?), H.
0.215 m

There is extensive use of the drill in the hair, creating a honeycomb pattern. The top of the head has been broken at the back, and there is a horizontal dowel-hole back to front.

This head came perhaps from a large stele or the couch-figure of a sarcophagus of Sidamara type. A head in Istanbul from Ovabayındır Balikesir, in western Phrygia or eastern Lydia, has been dated in the Neronian to Flavian periods and gives a more elegant, curlier-headed version of how ladies like the Harvard example developed in Asia Minor, suggesting, too, that the Harvard head could be one of the last examples of the honeycomb hair style and might have been produced under Trajan (A.D. 98–117) or Hadrian (A.D. 117–138) (Inan, Rosenbaum, 1966, pp. 108–109, no. 110, pl. LXIV, figs. 3, 4; compare also, pp. 112–113, nos. 116, 117, pl. LXX, two Flavian women in Bergama, from Pergamon).

There are also many such women on couches from finds in the area of Rome, but they usually lie flat on their pillows and do not have the fullness of this head, unless they are little children, servants, or seasonal genii (Wrede, 1981a, Heft 1, pp. 89–96, figs. 3–7).

Unpublished.

Gift of Mr. and Mrs. Benjamin Rowland, Jr., 1970.145

Head of a Young God or Hero

(lower left)
Roman copy of a second century B.C. type
Crystalline marble from Asia Minor,
H. 0.125 m

The nose and chin are damaged. The break runs across the neck just below the chin. The flesh of the face has a high polish, and there are traces of reddish color in the hair. The drill has been used at the corners of the eyes and mouth. Both ears were sketchily represented and are now damaged, especially the subject's left ear. A dent on the back of the head could be for attachment.

This head could be from a large sarcophagus, one showing the Labors of Hercules and with the figures almost free-standing in niches. The head is certainly worked completely in the round.

The god or hero (perhaps Herakles) has the sunken eyes and upturned face of the Skopaic tradition in Greek sculpture of the fourth century B.C. There is a fillet in the form of curled strands of rope in the hair. The hair is treated in short, lumpy curls. The brows are heavy, and the neck is well muscled. The subject's left side appears to have been treated with slightly more care than the right, which might suggest the head was turned toward the viewer's left.

The tradition of representation is derived from Attic funerary and decorative sculpture around the year 200 B.C., as the seated Herakles on the left front of the relief in the Alsdorf Collection from near Syrian Antioch (Vermeule, C., 1981, p. 246, no. 206). Here the god is seated in profile to the right. The heads of Achilles and Patroklos (?) on the right short side of the high-relief Attic sarcophagus in Adana from Tarsus are nearly identical with the head at Harvard (Budde, 1964, pp. 9–26, pls. 1–14; Bielefeld, 1968, p. 354, no. 4900).

Unpublished.

Gift of the Peabody Museum of Archaeology and Ethnology, 1934.196

Fragment of a Sarcophagus with a Winged Eros

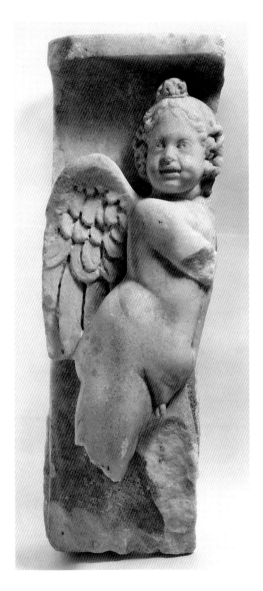

Roman, third century A.D.
Marble, H. 0.495 m

The fragment is from the left front with part of the left short side remaining. The fragment is broken down the left side of the Eros. His right arm is broken off just above the elbow. The right leg from above the knee is missing, and the left leg is almost obliterated.

The winged Eros moves to the right, tossing his head backward and laughing. His arms were probably stretched out in front of him. His hair is long and curly, and is gathered in a knot at the top and tied. The drill has been used liberally in the pupils of the eyes, hair, mouth, nostrils, and wing. The head of Eros is based on a type created about 200 B.C. and connected both with the statue of the child squeezing a goose, identified with Boethus, and with the groups of Eros and Psyche, the latter a century later (*Ars Antiqua* A.G., Auktion 7, Lucerne, 2 May, 1959, p. 15, no. 34, pl. 21).

At the left of the Eros, where the corner turned to start the left end of the sarcophagus, an animal's paw appears in low relief, at the bottom. This sphinx or lion or griffin paw rests on rocky ground, and there are traces of the creature's head above the paw.

This appears to be a section of a sarcophagus showing Erotes with the arms of Ares rather than a garland sarcophagus, or one with *imago clipeata*, with Erotes supporting the fillets of the festoons or the setting for the shield. Although near the left front corner of the sarcophagus, the pose of Eros is that of supporting an *imago clipeata* (a portrait-bust in or on a shield) or an inscribed plate (Hanfmann, 1951, II, p. viii, no. 29 in the illustrations, and fig. 32, no. 530, in Pisa).

There are a number of sarcophagi with Erotes or children engaged in athletic pursuits which show their subjects in similar poses (Vermeule, C., Cahn, Hadley, 1977, pp. 49–50, no. 68). And on a sarcophagus in the Musée du Louvre, Erotes stand also frontally, turned slightly inward, and hold the ends of fillets that extend toward two larger, flying Erotes who support a Gorgon shield in the center. The positions of the hands of these smaller Erotes could postulate a similar role for the fragment in the Harvard Museums (Reinach, 1897–1930, I, p. 80, no. 2). On a flying Erotes with *imago clipeata* sarcophagus from ancient Osca (modern Huesca) in Spain, the smaller Eros on the left front is in a pose similar to that of the Harvard fragment, and he is playing the double flutes (Garcia y Bellido, 1949, pp. 280–283, no. 277, pl. 232).

Sarcophagi showing Erotes carrying the arms and armor of Ares offer the best suggestions for the origins of this fragment. The figure on the left front is usually extending his arm to grasp a spear, often held by the Eros just beyond him. There are examples in the Uffizi and the British Museum (Reinach, 1909–1912, III, p. 26, no. 5; II, p. 471, no. 1, holding the spear across his chest).

Finally, there is at least one sarcophagus in which an Eros in precisely this pose can support an *imago clipeata* on the left front end. It is, or was, in the Mattei collection, and three *imagines* are shown flanked by four Erotes (Reinach, 1909–1912, III, p. 297, no 1).

Unpublished.

Gift of Dr. Harris Kennedy, Class of 1894, 1932.56.128

Part of the Front of the Lid of a Large Sarcophagus

third century A.D.
Proconnesian marble, H. 0.41 m, W. (as preserved) 0.915 m, TH. 0.06 m

The fragment is the section from the inscription plate (*tabula*) to and including a bit of the head on the left corner. A section of the left molding of the *tabula* survives at the right, and part of the molding at the bottom also remains. The fragment was broken and clamped together in modern times.

The scene is that of an elephant facing left, in a struggle with lions and a woolly bull, the bull being gored by a tusk, one lion fleeing, and one lion lying dead at the lower left. The carving and parallels suggest a date in the last quarter of the third century A.D. This lid ought to have been part of a large strigilar sarcophagus with trainers encouraging lions to devour other beasts on the rectangular ends of the slightly curved front sections near the left and right ends. Such sarcophagi were partly symbolic in theme (and therefore suitable for any Late Antique pagan thinker) and partly a reflection of the many Romans involved in the Late Antique commerce in animals for urban show and pleasure hunts and combats.

The source for this composition can be found in Graeco-Roman decorative reliefs, such as the example in the Sala degli Animali of the Vatican showing an elephant goring a panther while a bull assists and three other panthers crouch in the landscape or attack the elephant from behind. The lid of the sarcophagus takes its composition from the lower register of a first or second century relief of this type (Reinach, 1909–1912, III, p. 414, no. 3).

A humped bull or ox confronts a lion in an animal paradise, in a mosaic from Antioch-on-the-Orontes (Toynbee, 1973, p. 286, pl. 143). The wild bull being captured in the "Great Hunt" mosaic at Piazza Armerina has similar tufts of fur on the back and legs (Toynbee, 1973, p. 150, pl. 74). And the elephant with the personification of Africa and a tigress in the apse of the same hunt has the same crisscross lines for the crinkles of the hide (Toynbee, 1973, pp. 29, 34, pl. 1).

Provenance: From the Estate of Joseph Brummer, New York.

Published: Parke-Bernet Galleries, Inc., *Joseph Brummer Collection,* New York, Part I, April 1949, p. 64, lot 265.

Gift of the Hagop Kevorkian Foundation in Memory of Hagop Kevorkian, 1975.41.115

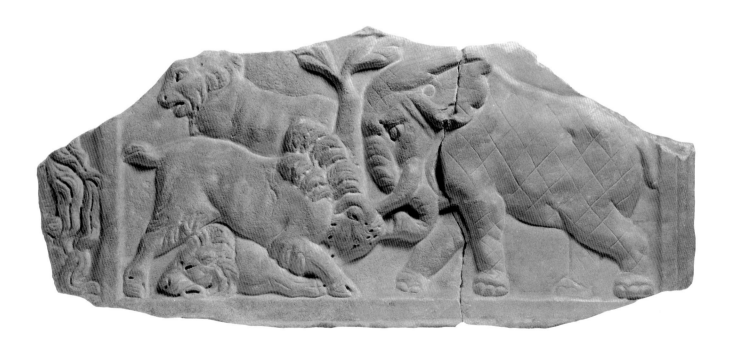

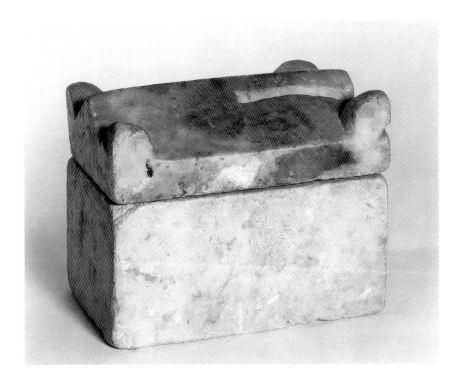

Graeco-Roman Osteotheke

late antique period, third century A.D.
Marble, H. (with lid) 0.14 m, (without) 0.083
m, L. (max.) 0.172 m, W. (max.) 0.112 m

The soapy, alabaster-like marble is of the type
used for small statues in Alexandria in Roman
times. The surfaces of the body and lid are
incrusted with cement. There is a deep,
slightly curved channel cut from one end of
the top of the lid to the middle.

The form is that of an Attic sarco-
phagus, and the date might be in the
third century A.D., or later. The
piece of marble may have been
reused, or the carefully cut-out area
on the lid may have been designed
for some form of vertical attach-
ment, perhaps a cross. Some such
reliquaries have a depression in the
gable of the roof or an opening for
pouring a libation.[1] They were often
used for the relics of saints as well
as the cremated remains of loved
ones. This example may have had
decoration painted on the outer sur-
faces. A similar marble reliquary
chest from under the altar of a
ruined sixth-century church near
Varna (Odessos) in Bulgaria had
relics, perhaps of the True Cross, in
a gold box set with precious stones
inside a silver sarcophagus of tradi-
tional Attic shape, all placed in the
marble chest with its gabled lid
(Weitzmann 1979, pp. 631–633,
under no. 569).

Unpublished.

1. For comparable osteothekai in stone and
metal, with or without crosses carved on
them, see Comstock, Vermeule, 1976, p. 172,
no. 275.

Gift of the Misses Norton, 1920.44.140

Roman Portraits: Republic to Late Antique

The Roman portraits are dominated by the statue of Trajan (no. 138), but the Wilton House Antonia (no. 136), the Tiberius (no. 135) owned jointly with the Department of the Classics, the unusual Lucius Verus (no. 139) from Sicily, and the two men of the third century A.D. (no. 140, no. 142) have been studied in depth for their unusual qualities. The Republican head in the Egyptian veristic tradition (no. 133) forms a good beginning. There are several heads that have been hardly studied, but this catalogue will doubtless produce further thoughts and parallels.

The head of a man (no. 132) that begins the chapter on Roman Portraits may have been part of a Hellenistic funerary or commemorative monument somewhere in the Greek world, but chances are it belongs to a Roman ensemble in the East, something like the building and sculptures in honor of the magistrate Memmius at Ephesus. The tradition of these ideal but specific likenesses was developed in the Peloponnesian stele honoring the Greek general and historian Polybius (died after 118 B.C.), in the statues and reliefs for the Roman victors over the Macedonians at Pydna in 168 B.C., and ultimately in the portraits of Roman merchants and their Greek partners on Delos before Mithradates sacked the island in 88 and 69 B.C.

Head of a Man

Hellenistic, late second century B.C. to late
first century A.D.
Marble from mainland Greece (?), H. 0.305
m, TH. 0.255 m

The head is probably from a large funerary
stele, civic monument, or commemorative
relief. The marble, from mainland Greece (?),
has a yellow patina. The nose is missing. The
back of the head terminates in the back of the
relief. There are chips on the surface.

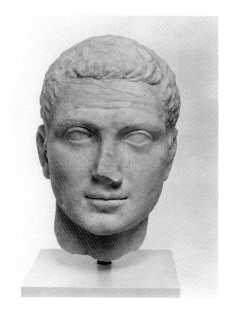

The head was made to be viewed
almost frontally, but it is turned
slightly to the subject's own left.
The head is of a man of early mid-
dle age at the oldest and has the
closely carved curly hair characteris-
tic of the height of the Hellenistic
period or the end of the Roman
Empire.

A famous head of about 50 B.C.
in the Ny Carlsberg Glyptotek,
Copenhagen (no. 461), from Cyzi-
cus shows the point of departure for
the Harris Kennedy head, which
must represent a man reasonably
prominent in some municipality's
affairs, or even in the political
world on a broader scale from Italy
to the East, at the end of the Roman
Republic or the Julio-Claudian
decades of the Roman Empire (Haf-
ner, 1954, p. 48, no. NK2, pl. 20;
Poulson, 1973, p. 49, no. 11, pl.
XIX).

The big stele from the Ionian
coast, in the Kunsthistorisches
Museum, Vienna, gives an excellent
illustration of the type of himation-
clad man who would have been rep-
resented in the complete monument
containing the Kennedy head. The

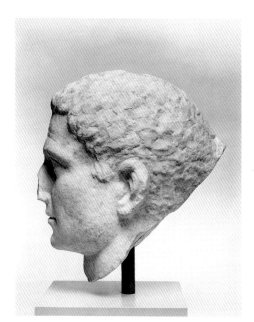

suggested date is around 200 B.C.
(Pfuhl, Möbius, 1977, I, pp. 109–
110, no. 261, II, pl. 49). Another
example, in the Kos Museum, pre-
sents the male subject in the heroic
pose of a Pergamene statue. The
date is 150–125 B.C. (Pfuhl, Möb-
ius, 1977, I, p. 82, no. 117, II, pl.
28).

Unpublished.

Gift of Dr. Harris Kennedy, Class of 1894,
1932.56.127

Man of the Late Roman Republic

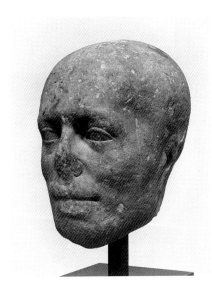

ca. 50–30 B.C.
Attic Hymettan marble, H. 0.243 m

The portrait is probably from a funerary bust or statue. The head is broken away irregularly at the start of the neck. The surfaces of the bald head and face are weathered. Ears, nose, and mouth have suffered likewise. The circles of the pupils were carved lightly and must have been finished in paint. Drill points mark the inner corners of the eyes and outer corners of the mouth. The head is worked all around, indicating it came from a free-standing ensemble rather than a tomb monument with figures in high relief.

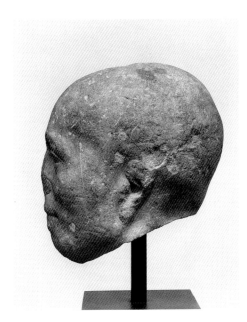

A similar sculpture, the old soldier Publius Gessius, from a three-person family tomb-relief in the Museum of Fine Arts, Boston, is more drawn in his facial features, and has the same lightly carved eyes finished with paint. The man in Boston, carved in limestone-like Italian marble, shows something of the same ethos on a cruder level. The portrait in Palombino from Rome has a nearly similar delineation of the inner corners of the eyes and the outer ends of the mouth (Comstock, Vermeule, 1976, pp. 200–202, nos. 319–321).

The date suggested, 50–30 B.C., may be a decade or two too early, although this head belongs without any doubt to the decades before the classicism of the Augustan age influenced private portraiture. Roman tomb-reliefs with older people in this veristic style and younger persons in the new fashions based on the Polykleitan to Hellenistic Greek tradition indicate such a stylistic shift was in full swing by about 2 B.C. (Richter, 1948, nos. 2, 3, 4 [veristic style], nos. 5, 6 [Augustan influences]).[1] This head, however, belongs to the most "fact-bound" style of late Roman Republican portraiture. While Greek sculptors had carved such heads on ideal bodies at Delos and elsewhere in places where Roman clientele settled, the origins of this portraiture combined Egyptian taste and traditions of carving with the conventional Roman leaning to truth and simplicity and directness in representing specific individuals. Such concepts of portraiture can be traced back through Italic art to Etruscan funerary monuments around 300 B.C.[2]

Published: Wood, 1987.

1. Kleiner, 1977, pp. 196–197, especially fig. 3, the die-cutter or jeweler relief of the P. Licinii, with the father in the old style and the son in the new.

2. Comstock, Vermeule, 1976, pp. 246–249, no. 384: the sarcophagus from Vulci with an almost-veristic couple as if in bed as the subjects on the top of the couch-like lid.

Purchase from the Marian H. Phinney Fund and David M. Robinson Fund, 1983.69

Head of a Man from the End of the Roman Republic

ca. 40 B.C.
Coarse Greek island marble, H. 0.16 m

The head was partly restored in post-Classical times, receiving a new outer nose (now missing) and ends of the ears (also gone). The neck was worked for insertion in a bust.

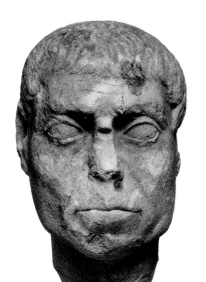

There are a number of portraits in marble and volcanic Italian stone, of much finer quality than this example, that show the genesis of this type of face in the period of the Second Triumvirate (Schweitzer, 1948, pp. 126–127, figs. 192–196).

A head on an alien Antonine bust, the ensemble from the Villa Celimontana (Mattei) in Rome, shows how these portraits relate to the heads of Julius Caesar of the type in the Camposanto, Pisa (Righetti, 1981, pp. 13–14, no. I, 11). Another head, with pupils expressed and possibly late Hellenistic rather than Flavian or Hadrianic, is the Greek Imperial counterpart of the Harvard portrait, borrowing its Italic physiognomy for the wider eastern Mediterranean world (Huskinson, 1975, p. 35, no. 65, pl.

26). Vagn Poulsen discussed portraits of this urban and suburban Roman type in connection with the head found after World War I in the Hudson River near the old Lackawanna Ferry slips (23rd Street) and now in the Milles collection in Stockholm and in connection with a head in Copenhagen. The man in the Ny Carlsberg Glyptotek, Copenhagen (no. 565), has the same form of face and, if he were the same person, he is shown in an older portrait of greater quality in carving. Moreover, he seems to smile rather than to set his lips into a grimace, as does the man in the Harvard collection (Poulsen, V., 1973, I, p. 56, no. 23, pl. xxxv).

Published: Fogg Museum, 1968, p. 76, illus. p. 158; Winkes, 1989, p. 124, no. 119.

Gift of Stuart Cary Welch, Jr., 1966.135

Head and Start of the Right Shoulder of the Emperor Tiberius (A.D. 14–37)

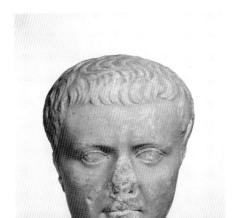

A.D. 22–23
Greek mainland marble, probably Pentelic, H. 0.313 m

The head is turned slightly to the right and downward. Areas with damage include the nose, lips, and the right side of the chin. There is some chipping on the ears and eyebrows and some surface pitting. The head was worked for insertion into a statue.

The type of face and arrangement of hair is a conflation of known Tiberius portraits and should be dated in the early 20s, when the Emperor was about sixty to sixty-five years old. The most popular group of portraits of this period, A.D. 22–23, is the Clementia Tiberii group, so named by Luigi Polacco (*Il volto di Tiberio*, Padua, 1954) from the coins. The Jovian statue of Tiberius in the Ny Carlsberg Glyptotek, Copenhagen (no. 538) found in an exedra with three niches at the shrine of Diana at Nemi, and evidently set up with similar statues of Germanicus (no. 644) and Drusus Jr. (no. 529), shows how this Harvard head and start of the right shoulder would have looked as part of a heroic, half-draped figure intended for veneration. Vagn Poulsen deduced that the Nemi triad,

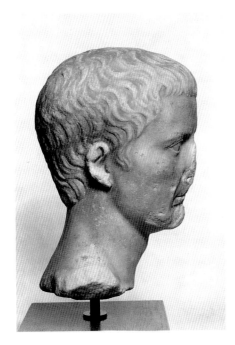

with an altar in front of the hemicycle with its rectangular niches, was dedicated after the death of Germanicus in A.D. 19 and before the death of the younger Drusus in A.D. 23.[1]

Provenance: Said to have been found near Rome.

Published: Fogg Museum, 1964, p. 114, half plate, p. 26; Vermeule, C., 1964, pp. 102, 123, figs. 10a, b; Vermeule, C., 1981, p. 286, no. 243; Mitten, Brauer, 1982, p. 15, no. 48; Massner, 1982, pp. 148, note 421, 150; Fittschen, Zanker, 1985, p. 14, note 8, i in list.

1. Poulsen, V., 1973, pp. 84–85, no. 47, pls. LXXXI–LXXXII. See also the discussion of these "standard image(s)" of the second emperor from the 20s of the first century A.D., under the Lansdowne Tiberius, in Malibu: Frel, Morgan, 1981, p. 36, no. 22.

Purchase from the David M. Robinson Fund and the Alice Corinne McDaniel Fund, Department of the Classics, Harvard University, 1963.54

Bust of Antonia

ca. A.D. 50
Parian marble, H. (including the draped bust)
0.545 m

The bust was said to have been carved in
Italian marble, but the head seems to be too
crystalline and is therefore Greek, specifically
Parian. The surfaces have been treated like
most marbles surviving from the Renaissance,
namely, the end of the hair at the back and
the left shoulder were restored in Carrara
marble. The remainder of the bust, the sub-
ject's right shoulder and lower left breast "are
also made of Parian marble, although unre-
lated to the head, and may possibly have been
taken from another classical statue (i.e.,
another bust)."[1]

Antonia was the daughter of Mark
Antony, niece of Augustus, wife of
Nero Drusus and mother of Clau-
dius and Germanicus (born 36 B.C.,
died A.D. 39). This portrait of the
courtesy "Empress (Augusta)" in
her later years parallels the numis-
matic likenesses struck in her mem-
ory by her grandson Caligula and

her son Claudius (third and fourth
emperors). The somewhat ideal pre-
sentation of a noble lady is based on
a prototype probably created late in
the reign of Augustus and known in
other versions. Like Queen Eliza-
beth II on coins, she was not por-
trayed as aging as rapidly in art as
in reality. As Erika Simon has
observed in connection with a pair
of marble busts of great sensitivity,
Antonia and Augustus, such por-
traits were made late in the reign of
Tiberius and until A.D. 39 under
Caligula because Antonia Minor
succeeded Livia as priestess of Divus
Augustus in A.D. 29 (Simon, 1982,
pp. 236–243, under nos. 166–167).

This replica of the mature like-
ness of the aristocratic matron
Antonia is sometimes confused in
the post-Renaissance and modern
literature with the bust from the
collection of the Hon. Robert
Erskine. In the latter instance, how-
ever, the bust is entirely restored or,
at least, alien (*Sotheby Sale,* Lon-
don, 10 July, 1979, pp. 134–135,
no. 284).

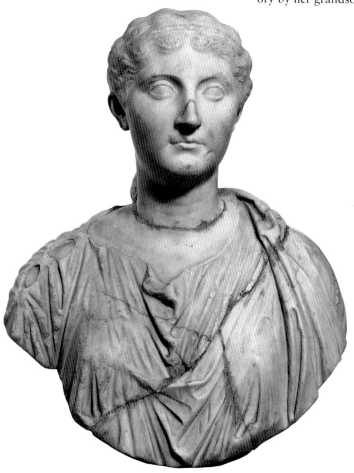

Provenance: From Wilton House, Wiltshire,
Earls of Pembroke, 1758, catalogue.

Published: Michaelis, 1882, p. 678, no. 25;
Poulsen, F., 1923, pp. 59–60. pl. 39; *Münzen
und Medaillen* A.G., Auktion XXVI, Basel,
5 October, 1963, p. 99, no. 190, pl. 67; Pol-
aschek, 1973, cover, pp. 19–24, pls. 2.1, 4.1,
and 6.1, etc.; Fogg Museum, 1976, p. 73,
illus., 103; Fittschen, 1977, pp. 58–61, under
no. 18; Erhart, 1978, pp. 193–212; Hanf-
mann, Mitten, 1978, p. 366, fig. 10; Childs,
1979, p. 30, no. 428; Herz, Wenner, Sept./
Oct. 1981, pp. 14–21, illus. p. 16; *Biblical
Illustrator,* Summer, 1982, p. 20, illus.; Mit-
ten, Brauer, 1982, p. 15, no. 47; E. Garred,
Harvard Gazette, 80, December 14, 1984, pp.
1, 16, illus.; Shear, 1984, p. 699, no. 9827;
Mortimer, 1985, p. 106, no. 118.

1. Herz, Wenner, 1981, pp. 16, 21.

Purchase from the Fund in Memory of John
Randolph Coleman III, Harvard Class of
1964, 1972.306

Head of a Child

first or second century A.D.
Marble, from Italy or North Africa,
H. 0.152 m, TH. 0.064 m

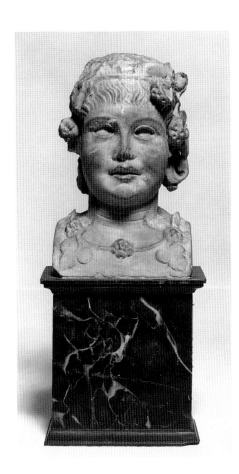

The back of the bust is flat. The right side of the head and the left side of the nose are chipped. There are also chips on the right eyebrow, forehead, and right cheek. A crack runs vertically down the full side of the right cheek, and there is an incision going almost at right angles across the crack. The right side of the bust is finished, as is a curved section under the left side, as if for placement against a curved frame.

The pose is frontal, with the hair worn in curled bangs and a heavy wreath around the head. The cheeks are fat, and the chin pointed, the eyes hollowed out and mouth wide open. There are two incised ridges on the front of the neck. There is also a wreath with rosettes and leaves around the shoulders.

There is a possibility that these rosettes are intended to be bunches of grapes and that the ideal subject, a smiling child of the Neronian to Trajanic periods (A.D. 55–115), is the infant Dionysos or a satyr-child. The tops of the ears are covered by the vines and leaves. Save for the manner of representing the hair around the forehead, this bust is similar to the small, decorative herms set on shafts against walls in Pompeiian houses. Such herms vary widely as to subject matter, including older satyrs, Silenus, bearded Dionysos, and early Hellenistic kings who were represented in the fashions of these bearded divinities.[1]

Unpublished.

1. Herrmann, 1983, pp. 3–5, under nos. 2 (bearded satyr), 3 (ruler with horned helmet), and 4 (bearded god). A similar, small bust of decorative, terminal form in Sir John Soane's Museum, London, has been related to eight examples in bronze from Pompeii or Herculaneum. The Soane example, in Parian marble and of unrecorded provenance, has been classed as the infant Dionysos and has further parallels in stone from the buried cities around the Bay of Naples: Vermeule, C., 1953, p. 456, no. 407; Ruesch, n.d. (1900), nos. 537–539.

Gift of the Misses Norton, 1920.44.222

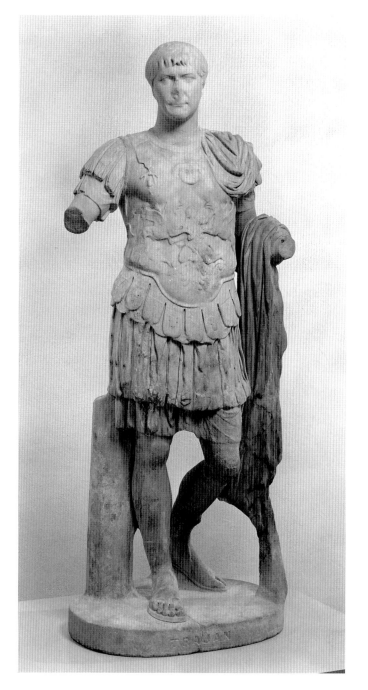
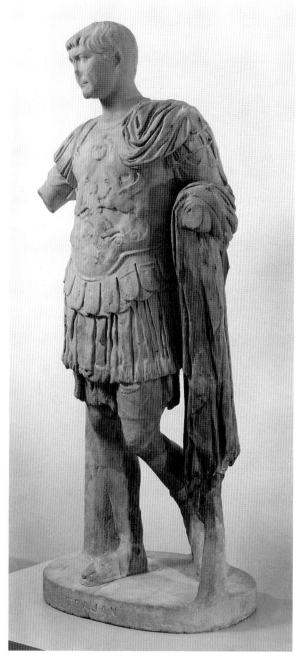

Statue of the Emperor Trajan

ca. A.D. 120
Pentelic marble, H. 1.91 m (with plinth)

The right shoulder and section of the chest, also the remaining section of the upper arm, have been broken and rejoined. The head and neck were made separately and inset. The statue was taken apart completely, cleaned, redoweled, and reconstituted at the Fogg Museum during 1983–1985.

Marcus Ulpius Traianus, of Roman Spanish ancestry and son of a distinguished Roman magistrate, was adopted by the aged Senator Nerva (emperor, A.D. 96–98) and ruled as emperor from A.D. 98 to 117. It was in this time, with the conquest of Dacia and military expeditions on the eastern frontier from Armenia to Arabia, that the Roman Empire reached its maximum geographical area. This statue shows Trajan in ceremonial armor (in contrast to the field equipment seen on the Column of Trajan in Rome), standing or stepping forward as if in the act of addressing his troops. His elaborate cuirass or breastplate has long tabs or *pteryges*, leather straps at the shoulders, and longer leather straps around the thighs. A tunic is visible under this ensemble, and a long cloak or *paludamentum* is worn on the left shoulder and around the left arm. The open-toed sandals are purely ceremonial, in keeping with the symbolic nature of the statue as suggested here and in previous publications.

In recent years, studies of important Roman Imperial cuirassed statues have been concerned with the meaning of scenes and objects on the ceremonial armor of these images.[1] This statue of Trajan, presumably brought to England from Italy in the eighteenth century,

is no exception. Here the decorative enrichment of the cuirass and of the tabs below appears to allude to the emperor's untimely death from natural causes at Selinus (Trajanopolis) in Cilicia at a time when the wars on the Parthian frontier were going badly for the Roman armies. This was also the period when the Jewish communities of North Africa, Mesopotamia, and Cyprus were developing a major revolt, which devastated cities such as Cyrene and parts of Alexandria in Egypt (Lepper, 1948, pp. 89–92; Magie, 1950, pp. 609–613). After Trajan's widow Plotina had engineered Hadrian's alleged adoption and his recognition as emperor (ruled A.D. 117–138), and after the Roman East was pacified and the frontiers stabilized, Rome and the surrounding towns were awash with monuments to the deified Trajan, the greatest of these being the Trajaneum at the end of the Forum Traiani. The provinces were similarly embellished—witness the Trajaneum at Pergamon. While this statue is not the heroic, semi-nude, Jovian image of a true Divus, in the traditions of the Primaporta Augustus, it has enough of the subtle allusions of cuirassed iconography to show this was a statue of Trajan in his period of transition from emperor to god.

The main scene on the breastplate is an Amazon or female Arimaspe fighting two griffins, all symbolic of wars on the eastern frontiers of the Roman Empire. On the tabs of the skirt below, at the bottom of the breast plate and above the leather straps, bovine skulls alternate with palmettes. The skull, rather than the bull's or cow's head, very often suggests death and funerary commemoration. Combined here with a portrait of Trajan based on a model created fairly late in his reign, this iconography suggests the statue was a posthumous

commemoration of the *Optimus Princeps*, the "best of princes", as Trajan was hailed by the Roman Senate. The statue was carved in the months or years immediately after the emperor's death, when monuments such as the Arch of Trajan at Beneventum were completed to honor the military and civic acts of the ruler who brought the Roman Empire to its greatest heights. That the cuirassed statue is one of a vigorous commander addressing his troops, rather than an ill, old man, is emphasized in the pose and proportions of the body, based on the ideal statue of Achilles by Polykleitos, a bronze known as the *Doryphoros* or *Spear-Bearer*.

Provenance: From Shugborough, Staffordshire, Lord Anson's Collection (where it was seen in 1782). Later (ca. 1880) in the possession of Mr. J. A. Crane, Birmingham, and (1951) in the garden of Mr. K. J. Hewett, Chelsea-Hammersmith, London.

Published: Pennant, 1782, p. 68; Michaelis, 1882, p. 213, no. 1; Fogg Museum, 1955, pp. 6f., plate, also p. 23; *Art Quarterly* 18:2, Summer 1955, pp. 195–196, fig. 1; Hanfmann, et al., 1957, pp. 223–253, pls. 68–75; Museum of Fine Arts, Boston 1959, no. 49; Vermeule, C., 1959, p. 53, no. 168, pl. XIII, fig. 42; Oehler, 1961, p. 70; Simon, 1962, p. 175, pl. 48; Niemeyer, 1968, p. 96, no. 50; Hanfmann, Mitten, 1978, p. 366, note 28; Stemmer, 1978, pp. 58–59, no. V 4, 170, pl. 35, fig. 3; Vermeule, C., 1980b, p. 6; Vermeule, C., 1981, p. 302, no. 258; Fittschen, Zanker, 1985, p. 41, no. 8, in list; Mortimer, 1985, p. 108, no. 120.

1. Besides the books on cuirassed statues cited in the publications of the Harvard Trajan, see Foerster, 1985, pp. 139–160, pls. XXIII–XXVIII, the image found 12 km south of Beth Shean. Gergel, 1986, pp. 3–15.

Purchase from the Alpheus Hyatt Fund, 1954.71

Head of Lucius Verus

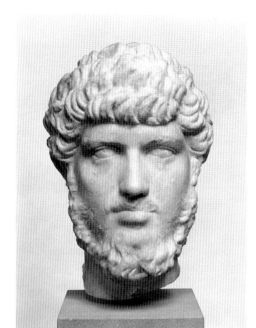

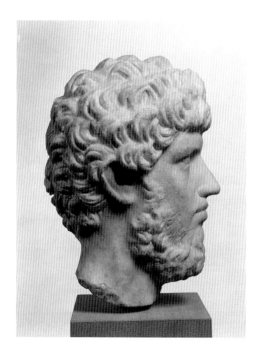

ca. A.D. 150–200
Greek island marble, H. 0.28 m

The head is from a statue or bust slightly smaller than lifesize. Much of the nose is restored. There are slight damages to the upper lip, the hair, and the beard. The slightly incised pupils gaze straight ahead. Hair and beard are carved out with gouges, and there are traces of the drill, expecially in the latter.

Despite a relatively short reign as co-emperor with Marcus Aurelius (A.D. 161–169), Lucius Verus was a popular subject for portraiture from childhood (as son of Aelius Verus) to beyond his death (as he was deified). This head, simple and almost summary in treatment, appears to depend on models made in Greece about A.D. 161–163. The surviving Athenian versions have more drillwork and, in one instance, a fuller beard, but this may indicate a later recension. As Lucius Verus advanced in years, his hair was arranged in a larger mass of puffy curls, and his beard grew longer.

If the Sicilian provenance for the Harvard head is correct, the portrait was probably carved in a workshop on an island such as Naxos or near the Piraeus and imported into Sicily.[1]

A battered marble bust of Lucius Verus—a masterpiece from a luxurious Roman house at Patras—was undoubtedly carved in an Attic or Cycladic workshop and gives the point of aesthetic departure from the Greek models for the head at Harvard. Hair and beard are arranged in identical fashion, manifesting more detail and the characteristic drillwork (Catling, 1974, pp. 17–18, fig. 28).

Provenance: Acquired in London; said to have come from Sicily.

Published: Hanfmann, 1950a, p. 16, no. 47; Hanfmann, 1953, pp. 9ff., figs. 1–2; Fogg Museum, 1977, p. 6; Hanfmann, Mitten, 1978, p. 366; Mitten, Brauer, 1982, p. 15, no. 50.

1. Compare Wegner, 1939, p. 226, pl. 45, especially 45b, from the Theater of Dionysos in Athens; 45a, from the foundations of a building in downtown Athens, is a later version of the Greek type.

Anonymous gift, 1976.36

Head of a Bearded Man

ca. A.D. 220–240
Greek mainland marble, H. 0.24 m

Much of the nose, the outer part of the right ear, and the entire top of the left ear are missing.

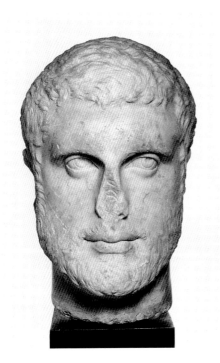

This portrait conveys a strong, frontal feeling. The hair is cut short, and occasionally the details of the curls are incised. The closed mouth conveys the suggestion of a smile.

There are a number of contemporary portraits of Romans and others similar to this bearded man, varying only in the shapes of their heads and the degrees to which hair and beard are cut or incised. The one-eyed man in Schloss Erbach is slightly older in years and sat for his veristic likeness, with more incision of hair and beard, nearly a decade or more later (Fittschen, 1977, pp. 92–93, no. 35, pl. 41, dated A.D. 250). In the Depot at Aydin (ancient Tralles), the bust of an older man has a noble and forceful face, with parallel grooves in the hair and greater "stippling" in the beard at the face (Inan, Rosenbaum, 1966, p. 175, no. 234, pl. CXXX, figs. 1, 2). A man from Rome, in the Metropolitan Museum of Art, New York, is likewise older, more emaciated, and represented with greater incision of what stringy hair remains (Richter, 1948, no. 94). Such men are the focal figures on the large sarcophagi marking the transition from earlier Severan styles to the incised verism of the middle of the century, as a head of the A.D. 230s to 240s in Leningrad bears witness (Voshchinina, 1974, p. 191, no. 76, pl. XCVII).

The younger contemporary of this man is in the National Museum, Athens, and begins to show the slight shift of the eyes sideways, as characterizes portraiture of the period from the Emperor Maximinus the Thracian through the short reign of the Emperor Traianus Decius (A.D. 235–251) (Catling, 1982, pp. 6–7, fig. 3).

Provenance: From the Estate of Joseph Brummer, New York.

Published: *Parke-Bernet* Sale, 1949, no. 202; Hanfmann, 1950a, p. 17, no. 56; Hanfmann, 1953, pp. 13–16, pl. II, figs. 3–4; Schweitzer, 1954, p. 177; Rose Art Museum, 1968, p. 47, no. 5; Hanfmann, Mitten, 1978, p. 366; Mitten, Brauer, 1982, p. 15, no. 50; Wood, 1986, p. 55, pl. XIV, fig. 20 (same artist as a bust in Munich).

Purchase from the Grace Nichols Strong Memorial Fund, 1949.83

Small Head of a Boy

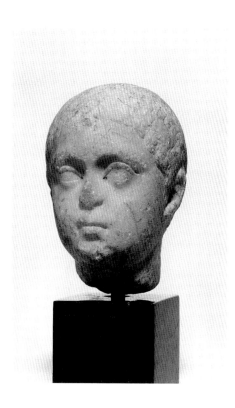

ca. A.D. 250–260
Marble, H. (head) 0.096 m, H. (head and neck) 0.0115 m

The surfaces are slightly damaged and abraded. The end of the nose is missing. Drill points have been used in the ears and the tearducts of the eyes. The marble is from the northern Greek islands or western Asia Minor.

The boy has short hair, not deeply incised, and somewhat puffy jowls. The pupils of the eyes were doubtless finished in paint and seem to have been lightly incised, with large circles. The hair lies like a tight-fitting cap around the head.

The small size of this portrait suggests it was made as a memorial in a household shrine or a dedication at a small sanctuary, or in a tomb of modest proportions. It may have come from a draped figure standing in an aedicula or niche.

A slightly larger head of an older man, in the Museum of Fine Arts, Boston, comes from central Italy and could well have been made at the same time, for the same purpose (Comstock, Vermeule, 1976, p. 240, no. 376). Among the many comparable contemporary heads of Roman boys in the age of Imperial crisis, there is a head in the Ny Carlsberg Glyptotek, Copenhagen (no. 766b), which Vagn Poulsen has identified as a novice in the cult of Isis, because of the long ringlets at the back, and as from the Greek provinces of the empire, because of the style (Poulsen, V., 1974, pp. 181–182, no. 187, pl. CCCIV). If the head in the Prince of Hesse's collection at Schloss Fasanerie near Fulda is really Severus Alexander between A.D. 223–225, then the Harvard portrait could be earlier and perhaps have Imperial connections (Heintze, 1968, pp. 69–70, 107, no. 46, pls. 76, 132 a–c). Once the simple, veristic style of the post-Severan-baroque third century was established, portraits of boys aged about ten to fourteen tended to take on a certain timelessness, depending mostly on physical characteristics for individuality. Such seems to be the case here.

Published: Fogg Museum, 1982, pp. 42, 72, 173; Winkes, 1989, pp, 140–141, no. 132.

Gift of Mr. and Mrs. Charles D. Kelekian in Honor of Professor George M. A. Hanfmann, 1979.414

Head of a Bearded Man

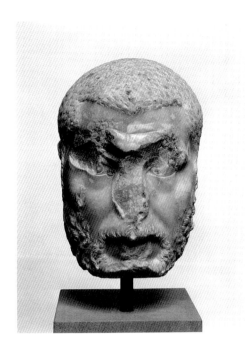

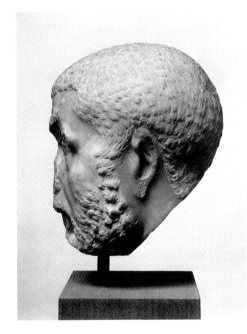

ca. A.D. 270–280
Luna marble, H. 0.28 m

The head is a badly battered masterpiece. Most of the nose, the areas of the eyes, the ears, and the lower part of the beard around the chin are missing or damaged. Where preserved, the surfaces are in excellent condition, characterized by the beautiful, high polish of the skin.

This powerful countenance has a superficial resemblance to several portraits identified as the Emperor Macrinus (A.D. 217–218) or, possibly, a high official of around A.D. 243. In the Harvard portrait, however, the forms are more solidified and the treatment of incised and sculpted hair is more pronounced and beautifully handled yet entirely devoid of life. This confirms a date near the last years of the Emperor Gallienus (A.D. 260–268) or even into the following decade.

Both quality and condition have given this Roman portrait public popularity and scholarly attention, as the long list of exhibitions, monographs, and articles suggest. Professor Hanfmann discovered the head in the basement storage of Harvard's Busch-Reisinger Museum, lying among the large lot of medieval and other, mostly architectural fragments puchased in New York a few months previously at the epic, four-part sale of the famous dealer Joseph Brummer's stock. The head's debut was in the 1950 exhibition of *Ancient Sculpture* that Professor and Mrs. Hanfmann arranged with the graduate students in ancient art. Full publication came in Professor Hanfmann's *Latomus* XI monograph, where the portrait was placed in the time of Valerian or Gallienus (A.D. 253–260, 260–268). The catalogues of two major exhibitions, Rose Art Museum, Brandeis University, 1968–1969, and the Ackland Art Center, University of North Carolina, April 5–May 17, 1970, confirmed these dates, with minor variations. Vagn Poulsen in 1974 was the scholar who first mentioned Macrinus; the debate has continued and will do so.

The use of Luna or Carrara marble localizes the portrait in the Latin West, presumably Italy. As emperor (A.D. 217–218), Macrinus never came closer to Rome than Chalcedon on the Bosphorus where he was overtaken by the soldiers of Elagabalus (A.D. 218–222) and killed, but he did have an extensive Roman Imperial coinage, and so his image was available in Italy. All this throws smoke in the face of the fact that the Brummer-Harvard portrait combines a type of "barbered head" with "plastic accentuation of each curl" (of the lower beard) (noted by Charlotte Robl, Ackland Art Center, 1970) which can only belong to the decades of transition to the Late Antique. Although more sensitive in spirit than the numismatic portraits of Claudius II (A.D. 268–270), Aurelian (A.D. 270–275), or Probus (A.D. 276–282), tough soldiers all, similarities in hair and beard have led to the date proposed here. The subject was a private person, like the men of success and intellect represented on the big sarcophagi of the time.[1]

Provenance: From the Estate of Joseph Brummer, New York.

Published: Hanfmann, 1950a, p. 17, no. 50; Hanfmann, 1953, pp. 17–25, pl. III, figs. 5–6; Ackland Art Center, 1970, no. 23 (C. Robl); Rose Art Museum, 1968, p. 48, no. 10, pl. V; Hanfmann, Mitten, 1978, p. 366; Vermeule, C., 1981, p. 370, no. 321. Mentioned: Wiggers, Wegner, 1971, p. 137; Poulsen, V., 1974, p. 139, under no. 138, a portrait among those identified as Macrinus, emperor A.D. 217–218; Bergmann, 1977, p. 123; Wood, 1983, pp. 489–496, pls. 66–69; Salzmann, 1983, pp. 362–363, fig. 11; Salzmann, 1983a, pp. 384–385, no. 4; Fittschen, Zanker, 1985, p. 112, under no. 95; Mortimer, 1985, p. 110, no. 122; Wood, 1986, pp. 31, 32, 70–72, 95–96, 123, pl. XXV, fig. 37 (Macrinus?).

1. Lawrence, 1972, p. 302, pl. 93 a (wedding scene on a columnar sarcophagus in Copenhagen). Kähler, 1963, pp. 178–179, pl. 17 ("Plotinus" sarcophagus in the Lateran-Vatican Museums collection).

Purchase from the Alpheus Hyatt Fund, 1949.47.138

Feet of a Man Beside a Container of Scrolls

third century A.D. or slightly earlier
Marble seemingly from western Asia Minor,
H. 0.075 m, W. (base) 0.12 m, Depth 0.067 m

The left foot above the ankle and the right foot below the ankle remain. There is an inscription along the front of the base.

A container of scrolls sits next to the left foot. The curled object, mostly drapery, by the right foot suggests the bottom of a serpent-entwined staff, partly covered by or ending in a section of drapery, and indicates the subject was possibly portrayed as Asclepius. The character of the footgear adds evidence that this small statue portrayed a mortal rather than the god himself. Such statuettes were usually votive, as here, or funerary in nature, like the noble image of the boy L. Julius Magnus in the British Museum (Vermeule, C., von Bothmer, 1956, p. 333, pl. 110, fig. 25).

Usually it is the *omphalos* of Apollo that appears beside Asclepius, as in the statue of an early Antonine physician as the god, in the Braccio Nuovo of the Vatican (Bieber, 1957, pp. 74–77, fig. 8).

The little boy as Asclepius, in Athens from the god's sanctuary at Epidauros (inscribed in the dedication by Ktesias), is on a qualitative level with the Harvard fragment (Bieber, 1957, pp. 87–88, fig. 34). It is also "late Roman."

Mason Hammond has kindly restudied the small fragment and provided provenance, aesthetic and archaeological details, and a corrected recording of the lettering, which is:

P · S · C · V · L · S M

Professor Hammond also writes that "the back of the left leg and scrinium is perfectly flat; clearly the piece was made for a niche where the back would not be seen" (letter dated 10 May, 1984). He feels the piece was made for votive rather than funerary purposes. The suggested reading of the abbreviations would corroborate this.

He has noted the descriptive label, base, and feet, and proposes the following expansion of the abbreviations, a suggestion given tentatively and based on the Asclepian character of the statue:

P(ro) S(alute) C(oniugis) V(otum) L(ibens) S(oluit) M(erito)

This interpretation translates as a dedication in payment of a vow for a spouse's recovery (this information seemingly supplied by Professor Herbert Bloch, 19 May, 1984).

Provenance: From the Collection of Clifford Moore (died August 1931), seemingly purchased by Moore in Rome in 1905 or 1906 in an antique dealer's shop.

Published: Moore, 1909, p. 14, no. 37; *CIL* VI, 1902, p. 3052, under no. 31805 (with sketch, described by H. Dressel, edited by Ch. Huelsen).

Gift of Norman E. Vuilleumier, on behalf of Mrs. Clifford Moore's Estate, 1949.78

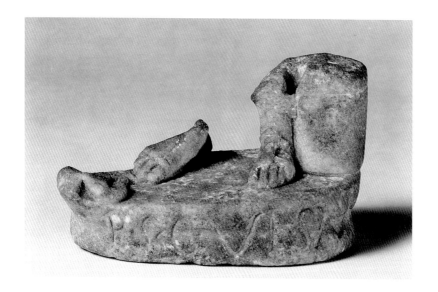

Fragment of a Right Foot

Roman, A.D. 50–200
Luna marble, H. 0.102 m, L. 0.127 m

The fore part of the bottom of the shoe is smooth, while the rear part at the instep is hollowed out, and the back is broken away.

This would appear to be the foot from a small seated statue of a Roman emperor, official, or citizen dressed in civic rather than military garb. The shoe consisted of an outer part tied across the ankle and an inner tongue that ended in an upper molding, where the drapery of the garment appears to have begun.

A lady as the Hera of Polykleitos, in Boston, has her left foot protruding forward and slightly downward, in a pose similar to that of this fragment. She is, of course, wearing only a sandal with straps (Comstock, Vermeule, 1976, p. 95, no. 148).

Unpublished.

Gift of Norman E. Vuilleumier, 1949.112

Fragment of a Small Head of a Woman

Late Roman, A.D. 325–375–450
Constantinian or Theodosian (to Valentinian III)
Proconnesian marble, H. 0.152 m

The head from the lower eyelids back through the ears to the center of the back of the head is missing. The remains of the nose and the face are chipped. The condition of the back of the head suggests it may have been reused as a building block. There are drill points in the corners of the mouth, eyes, and ears.

The lady has a plump, round face with ample jowls. Her hair is plaited symmetrically in back, and has a net of incised cross-hatching. Enough of the incised pupils of the eyes survives to show that the lady, who is middle-aged or older, was glancing sideways, to her right. The ears are well modeled, and there are four incised lines in front of the earlobes.

Among the good number of portraits in marble of women that relate to this fragment, there is a lady of much thinner, longer face in the Ny Carlsberg Glyptotek, Copenhagen (Poulsen, F., 1951, p. 529, no. 762, pl. LXV; Poulsen, V., 1974, pp. 192–193, no. 199, pls. CCCXXIV, CCCXXV, as a possible Helena from Asia Minor). The plump face of the Harvard head is present in a head of an elderly woman with her garment drawn up over the back of the hairnet with its crisscross lines; this portrait is in the Museum at Side in Pamphylia (Inan, Rosenbaum, 1966, pp. 201–202, no. 277, pl. CLIV).

Provenance: From the Estate of Joseph Brummer, New York.

Unpublished.

Purchase from the Alpheus Hyatt Fund, 1949.47.67

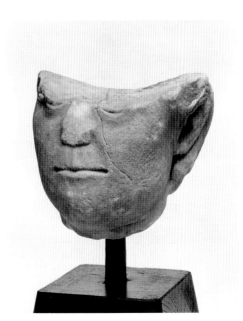

Head of a Woman

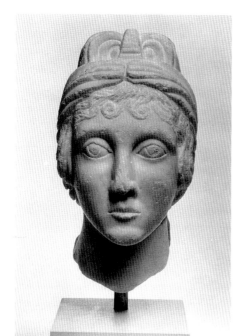

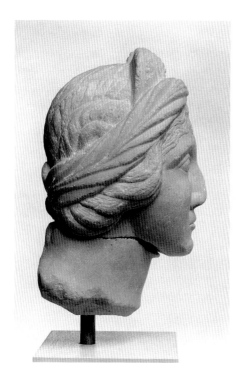

ca. A.D. 325 or possibly to 425
Marble, H. 0.27 m

The surfaces have been considerably abraded, probably through cleaning. The head has been mended under the chin.

The statue is in the East Greek Imperial and provincial style. The youthful portrait is characterized by an elaborate coiffure of tight curls. A hair-band encircles the head and is knotted twice at the back, above the chignon.

Although more "Sapphoesque" in arrangement of the hair, something of the same local and Late Antique qualities are seen in a small head in Boston, from mainland Greece or the Aegean islands (Comstock, Vermeule, 1976, p. 122, no. 188). With hair designed to recall the age of the great Trajanic ladies, rather than the partly Antonine, partly Palmyrene styles seen here, the more elegant counterpart of the Harvard lady is a head in the Hermitage, Leningrad (Voshchinina, 1974, pp. 193–194, no. 79, pls. CII–CIV). The lady has ample hair, perhaps only partly her own, worn in braids with a loop in the back, and all above and around her forehead. This coiffure shows how this fourth-century style grew out of the age of the Tetrarchs. The head in question was published when in the Depot at Perge (Inan, Rosenbaum, 1966, p. 198, no. 273, pl. CL).

The head is also a more rustic version of the elegant little head of a lady of high rank, from Greece and in the Art Institute of Chicago, a portrait that James D. Breckenridge has associated with Constantinople about A.D. 370–380 (Weitzmann, 1979, pp. 289–290, under no. 268). The fragmentary head in the Museum at Aphrodisias seems to have combined all the hair styles represented in these heads, including the Harvard example; the level of craftsmanship is, again, something higher or, at least, less stiff and frontal. The date suggested is about A.D. 400 (Inan, Rosenbaum, 1966, p. 179, no. 241, pl. CXXXIII, figs. 3, 4).[1] Earlier in this group of Constantinian and later portraits of courtly young ladies, and their eastern provincial derivatives (as the Harvard head), is a portrait, possibly Helena the Younger (a daughter of Constantine the Great and Fausta), dated around A.D. 325 and in the William Rockhill Nelson Gallery, Atkins Museum of Fine Arts, in Kansas City. Here the hair spirals around the top of the head in a double braid and a crisscross net (Vermeule, C., 1974, pp. 318–319, no. 10, figs. 10, 10a).

Unpublished.

1. Termed a priestess and with Imperial bust(s) on her diadem.

Gift of the Hagop Kevorkian Foundation in Memory of Hagop Kevorkian, 1975.41.112

Head from a Small Portrait, a Statue of a Woman, or a Small Statue of the Good Shepherd

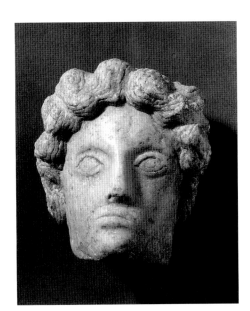

ca. A.D. 375–450
Greek marble, H. 0.10 m

The very crystalline marble is from Thasos or northwest Asia Minor. The strands of hair have been sharpened with an engraver's tools (in post-Classical times?).

The workmanship is cursory, with the features irregularly placed. The hair and the large eyes are indicated by incised lines, the latter protruding also. The mouth is wide and turned downward. Thick plaits of hair are wound around the top and back of the head, with no relation to its shape. These plaits of hair come together in a horizontal "V" leading to a vertical line down the middle of the back of the head.

A small statue of the Good Shepherd found in the ruins of Caesarea Maritima on the Palestinian coast gives a good illustration of how the complete figure from Daphne must have appeared. There is a second such figure, where the head is only in relief against the animal's back, from near Gaza (Vermeule, C., Anderson, 1981, p. 16, fig. 34).

As a head from a small statue of the Good Shepherd, this creation is the eastern Mediterranean successor to the first images of the youth with a ram or sheep around his shoulders. The first group came out of Hellenistic Asia Minor around A.D. 275 or somewhat earlier and gave the *Bonus Pastor* the idealized features of Alexander the Great.[1] The sarcophagi of the period from A.D. 250 to 325 in Rome constitute the second group of representations of the Good Shepherd, and they include youths derived from the Alexander the Great image and those who look toward the round-faced, curly-headed types from Syrian Antioch and those from the

Holy Land (Weitzmann, 1979, pp. 318–319, nos. 463 and 462). When a Phrygian cap is worn, the Good Shepherd depends on the older iconography of Orpheus taming the beasts with music (Weitzmann, 1979, pp. 320–322, nos. 464–466).

An idea of when such "Little Orphan Annie" heads of the Good Shepherd can be dated comes from the hair and faces of the mahouts on the elephants in the diptych leaf of A.D. 431 in the British Museum, the scene depicting the consecration of a deceased emperor (Weitzmann, 1979, pp. 70–71, under no. 60). These small statues of the Good Shepherd were produced as table or shelf supports in Late Antiquity for tombs, chapels, and, doubtless, household shrines, as pagan groups had been employed in earlier centuries (Ganymede and the Eagle, Bellerophon and Pegasos, etc.) (Frel, n.d., p. 38, no. V 83). There were other iconographic types used for the youthful Good Shepherd in the Latin West. A small statue found near the Aurelian Wall at the Porta San Paolo in Rome mixes the Alexander the Great ideal with third-century Greek Imperial portraiture in a head that stands forth from the sheep on his shoulder (Jones, 1912, p. 361, no. 1, pl. 93).

Provenance: Said to have come from Daphne, evidently not from the excavations but a purchase from a local landowner.

Published: Stillwell, 1938, p. 179, no. 240.

1. See under the group of sculptures in The Cleveland Museum of Art from Antioch in Pisidia: W. D. Wixom, in Weitzmann, 1979, pp. 408–411, under no. 364.

Purchase from the Committee for the Excavation of Antioch and Its Vicinity, 1939.139

Roman-Egyptian and Syrian (Palmyrene) Sepulchral Reliefs

This small group of truly regional sculptures comprises mostly funerary portraits, beginning with the lively Antonine lady from Egypt. The three Palmyrene panels with nearly half-figure busts of women and a man are splendid examples of their type, again dating around the middle of the second century A.D., when Edward Gibbon spoke about the peace and prosperity of the Roman Empire under the Emperor Antoninus Pius (A.D. 138–161). One of the reliefs showing a woman (no. 149) and the one with the bust of a man who patently lived in Hadrian's time (A.D. 117–138) (no. 151) include little children flanking or beside the busts, an extra touch of humanism absent from most of these Palmyrene portraits.

Finally, in this section has been placed the splendid acanthus-leaf frieze (no. 153) from the monastic complex at Bawid (Bawit) in Egypt, carving of high quality from the world of Coptic art about A.D. 450 to 550 for the time when the Roman Empire was expiring in the Latin West. For reasons of space, we have catalogued only two of the approximately 156 fragments of Coptic architectural sculptures from the collection of Hagop Kevorkian. All these sculptures are important because they anticipated or paralleled the transition from the Classical world to the Middle Ages, both the Byzantine world in the East and the Latin kingdoms of Europe. The time of initial contact came in the Tetrarchy, in the late A.D. 280s and 290s when Aurelian's conquest of Zenobia and Palmyra in the early A.D. 270s combined with the destruction of the Mint and artistic colony in Rome brought artists from the East into the heart of the Roman Empire. The flattened, linear styles of Syria came to official fruition in the so-called "cubistic" style of the Tetrarchy and were turned ultimately, in the time of the sons of Constantine the Great (337–361), into the art of the Late Antique Empire in East and West, and the eastern frontiers into northwest India, Pakistan and beyond.

148

Stele of a Woman

Roman from Egypt, ca. A.D. 160
Nummulitic limestone, H. 0.68 m,
W. 0.36 m, TH. 0.19 m

There are chips on and deterioration of the
surfaces. The left (facing) pilaster and the
lower right pilaster by the woman's left hand
are restored. The figure and the architecture
are missing below the waist.

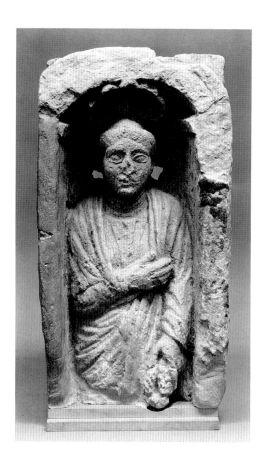

She wears a chiton and himation
and is shown facing, a lei-like
wreath clutched in her lowered left
hand. Her hair is arranged around
her forehead and is brought up to a
peak or knot at the back of her
head. She also wears earrings, a
choker-like necklace, a bracelet on
her right hand that emerges from
the fold of her cloak, a ring on her
right ring finger, and one or more
rings on her left fingers. The niche
takes the form of a curved apse with
entablature running behind the
woman's head near the top of her
hairdo and a large, fluted shell
against the semicircle of the top of
the niche, like a halo above the
woman's hair.

The large, almond eyes, once
painted, indicate the primitivism of
the carving. The style of wearing the
hair was influenced by the iconogra-
phy of Faustina I, wife of Antoninus
Pius (died A.D. 141), and, allowing
for a generation in the transmission
of styles, this similarity suggests the
date for this relief, a tombstone.

The costume, pose, and setting
document the Hellenistic influences
on Romano-Egyptian sculpture and
mark the transition toward the lin-
ear, decorative style of so-called
"Coptic" sculpture, carving of the
Christian period in Egypt.

The quality of such funerary
monuments in painted limestone
varies considerably. A high-relief,
fragmentary bust of a young lady in
Boston stands at the top end of the
scale (Comstock, Vermeule, 1976,
p. 231, no. 364), while a full-length
figure of a woman is even flatter,
almost like a proto-Coptic painted
panel or textile. The full-length,
painted-stone lady in the Museum
of Fine Arts comes from Behnessa-
Oxyrhynchas (Museum of Fine
Arts, Boston, 1973, p. 49,
1972.875). Such limestone figures of
Egyptians of the Roman Imperial
period, in or out of their niches,
stand at the end of the evolutionary
process in Egyptian painted,
sculpted, and multi-media funerary
portraitures (Parlasca, 1966, pl. 1,
fig. 2, pl. 62).[1]

Unpublished.

1. Klaus Parlasca discusses and illustrates the
related Syrian funerary monuments, in
Parlasca, 1982, especially pl. 14.

Gift of Charles D. Kelekian, 1977.197

Palmyrene Sepulchral Relief

ca. A.D. 150
Limestone, H. 0.70 m

The surfaces are in good condition. The fore-finger of her left hand is chipped. There is a crack across the torso below the left arm. Some red paint remains in the inscriptions.

The relief depicts a woman in elaborate costume flanked by two children above, left and right. The monument has been dated by Harald Ingholt. The woman in the center is touching the edge of her veil with the usual gesture of her raised right hand; she holds a ceremonial object, like a cord with pomegranate tassels, against her upper stomach with the left hand. She wears jewelry wherever it is possible for display, from gold bands in the hair to triple-pendant earrings, to four different types of necklaces, to

bracelets on both wrists, and, finally, to rings on her fingers.

The children behind her seem to be a young girl with a necklace or apron of fruits, on her right, and a slightly older boy, a ceremonial tassel in his left hand, on her left.

There are three inscriptions on the relief. The one belonging to the woman is located to the right of the veil and extends to the left side of the head of the child on the right. It reads "daughter of Hayran, Alas!" The inscription to the right of the child on the right, belongs to that child and reads "Hayran, her son." The inscription on the left, belonging to the child on the left, reads "Simon, her son."[1]

A head of a lady carved in the same style but with hair arranged somewhat differently has been placed by Harald Ingholt in Group II of the Palmyrene funerary monuments and dated about A.D. 150–200 (Comstock, Vermeule, 1976, p. 258, no. 404).[2]

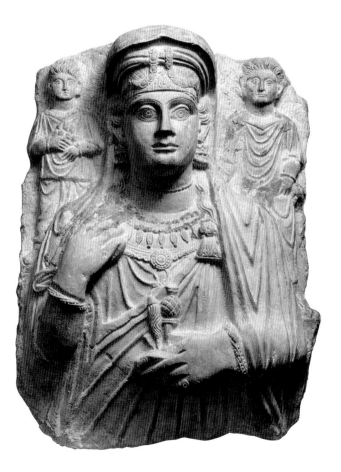

Provenance: Purchased by Richard Norton in Damascus

Published: Chase, 1924, pp. 190–191, fig. 242; Deonna, 1923, p. 52; Deonna, 1923a, p. 231; Ingholt, 1928, pp. 132, ps 374, 158; Fogg Museum, 1971a, The Checklist, p. 150; Vermeule, C., 1981, p. 380, no. 329.

1. Translation by Elizabeth Kessin Berman, August 1983.

2. It has been observed that the object in the left hand of the Harvard relief might be a distaff or similar tool for spinning, but 'Ala the daughter of Iarḥai in the Ny Carlsberg Glyptotek, Copenhagen, holds a similar thing almost horizontally, and it looks like a folded whip with a pinecone top. See Colledge, 1976, fig. 64. Since other Palmyrene men and women hold a variety of complex, symbolic objects in the left hand (although one man, in Paris, is clearly a scribe with stylus and tablets), it seems likely that this folded-over length of tassel on the end of a stick is a ticket of passage to a religious cult or the world beyond the tomb rather than a mere object of domestic industry. The pomegranates held in Palmyrene peoples' hands fall into the same category.

Gift of Alden Sampson, Richard Norton, and Edward Forbes, 1908.3

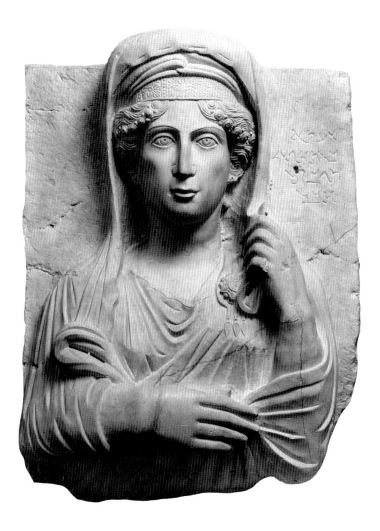

Palmyrene Sepulchral Relief

second century A.D.
Limestone, H. 0.60 m, W. 0.455 m

The missing part of the back of the left hand and the adjacent sleeve are filled in with plaster along the line of the major crack.

The inscription reads: "Ra' Ta, daughter of Hairan, (son of) Taibal, Alas!"[1] This half-figure of a veiled woman wears an enriched diadem, a brooch, and three rings. She also has a string of jewelry, gold discs and pearls or stones, running from either side of her forehead, under the diadem and back down on top of the hair above the ears. Her chiton and himation are both rather rubbery in treatment, especially the ample folds of the latter. She has a thinnish face with a small mouth, giving her an almost petulant, spoiled look.

Save for the specific, individual characteristics just mentioned, this is as "standard," as conventional a Palmyrene funerary relief bust of a woman as one can encounter. Parallels abound. Tibnan with her child on her left hand, in the Musée du Louvre, Paris, has the same qualities of drapery, in the period A.D. 150–200 (Colledge, 1976, pp. 70–71, pl. 86). Her hair cascades out from under the veil like that of " 'Ala, Iarḥai's daughter," in the British Museum, a likeness bearing the date A.D. 113–114 (Colledge, 1976, pp. 62, 70, pl. 64).

Unpublished.

1. Translation by Elizabeth Kessin Berman, August 1983.

Gift of the Hagop Kevorkian Foundation in Memory of Hagop Kevorkian, 1975.41.116

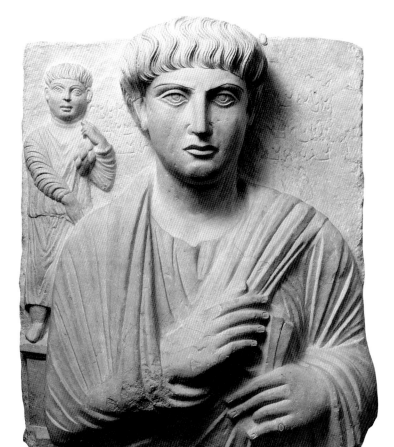

151

Palmyrene Sepulchral Relief

ca. A.D. 150
Limestone, H. 0.66 m

Surfaces in good condition with some minor chipping.

A small child stands at the young man's side on a pedestal to the left of the man's right shoulder. The man wears his hair in the combed-forward manner popular in the Roman Empire under Hadrian (A.D. 125–135). He has a ring with an inset stone on the smallest finger of the left hand. His costume consists of a himation over a loose chiton, the former concealing all of the right arm except for the hand and all of the left arm save for the hand that holds a *rotulus*. The child wears a long tunic with overfold at the waist, covering both arms. He holds a cluster of fruit or a flower in the left hand.

The inscription to the right of the man reads "Male, son of Maliku, son of Bagad, Alas!" The boy's inscription reads "Maliku, his son, Alas." [1]

With the child omitted and the hair arranged in somewhat more early Antonine fashion, this man is identical in costume and sculptural treatment to the monument of Moqīmū in the Museum of Fine Arts, Boston. If individual sculptor's hands are to be isolated in Palmyrene funerary sculpture, two monuments by the same carver seem to survive in both the Harvard University Art Museums and the Museum of Fine Arts (Comstock, Vermeule, 1976, p. 256, no. 399).

Published: Fogg Museum, 1983, no. 6, illus.

1. Translation by Elizabeth Kessin Berman, August 1983

Loan from the Semitic Museum, Harvard University, 593.1941

Decorative Frieze with Wolves Chasing Gazelles

Coptic, fourth to sixth century A.D.
Limestone, H. 0.270 m, W. 0.665 m

The stone is seemingly good-grain limestone with some overall surface chipping, especially around the edges.

A large, scrolled vine fills this fragment, creating three separate circular zones. The beginning of another vine can be seen in the upper left corner. In the rightmost zone can be seen the heads and necks of two charging wolves and the head, neck, and torso of a third wolf. In the middle zone, a fourth wolf has caught the hind leg of a gazelle in his teeth. The gazelle, whose front half is in the left zone, turns its head and looks back and up over its shoulder. The hind part of a second gazelle can be seen fleeing to the left.

This work, currently installed in the stairwell of the Arthur M. Sackler Museum, is an exceptionally fine and sensitive rendering of a figured vine rinceau, a motif that occurs widely throughout the eastern Mediterranean from the Roman period on. Compare the example from the Malcove Collection, University of Toronto, M82.313 (Friedman, 1989, p. 259, no. 173).

Unpublished.

Gift of Professor Nelson Goodman, 1983.83

Decorative Frieze with Acanthus Leaf Motif

Coptic, fifth or sixth century A.D.
Stone, seemingly limestone, H. 0.355 m,
W. 0.711 m

The stone is seemingly a good grade of lime-
stone. There are damages to the upper fillet
molding, to the thin fillet at the right end, and
to the broader, lower fillet.

Although dated in the sixth century,
it is equally likely a work of the fifth
century. This block is the right sec-
tion of a longer frieze or panel, the
first scroll at the left having been
continued on the adjoining section.
The enrichment is a flattened, only
somewhat stylized version of good
Roman Imperial frieze decoration
going back to the age of the *Ara
Pietatis Augustae* in Rome, the reign
of the Emperor Claudius (A.D. 41–
54). A continuous acanthus scroll
forms three major loops from left to
right, the missing section of leaf
curling into the first half-scroll

seems to end in a leafy bud not
unlike an artichoke. The acanthus
leaves vary in their manner of carv-
ing, sometimes being almost incised.

Acanthus of similar style and
quality is seen on a section of frieze
from El Bahnassa with a deer at the
left and the young Herakles advanc-
ing to the right, club in hand (Eisen-
berg, 1960, pp. 24, 26, no. 34, fifth
to sixth centuries A.D.). An earlier,
or perhaps nearly contemporary
version of the Harvard frieze comes
from a church at Ahnas (Ahnas el-
Medineh = Herakleopolis) and has
been dated around the year A.D. 400
(Strzygowski, 1904, pp. 48–49, no.
7306, fig. 57, see also pp. 49–50,
no. 7308, fig. 59).

The right end of a limestone
frieze in Mr. Hagop Kevorkian's
possession in 1941, also said to be
from Bawit, and dated around A.D.
500 (H. 0.31 m, W. 1.50 m), is
fairly close to the corresponding
section of the Harvard carving
(Cooney, 1941, p. 26, no. 52,
illus.). (In 1975 approximately 156
fragments of Coptic architectural
sculptures in relief from the collec-
tion of Hagop Kevorkian came to
the Harvard University Art
Museums. Unfortunately, space lim-
itations prohibit us from including
this collection in the present cata-
logue. In 1985, 19 fragments from
this collection were installed in the
main stairwell of the Arthur M.
Sackler Museum at Harvard Univer-
sity.)

Provenance: From an old monastery at Bawid
(Bawit), Egypt.

Unpublished.

Purchase from the Alpheus Hyatt Fund,
1935.22

Fragment of a Palmyrene Head

probably second half of the second
century A.D.
Limestone, H. 0.203 m

The bottom of the face is preserved from
under the left part of nose down. The break is
diagonal through the middle of the head with
the upper part missing.

It is difficult to ascertain whether
the subject was male or female,
although it was probably a man
rather than a well-constructed Pal-
myrene lady, but this is far from
certain. This lower part of a face is
like that of a priest, an aging man of
about A.D. 140–170 in Boston
(Comstock, Vermeule, 1976, p.
255, no. 397). With a bit of imagi-
nation, the grooves and slightly
roughened area on either side of the
chin might suggest a beard, proba-
bly finished in paint. Palmyrene men
usually have beards carved in low
relief with rows of tight curls (Com-
stock, Vermeule, 1976, p. 255, no.
396), but the two older men playing
a board game to either side of a
young man in a relief also in Bos-
ton, dated about A.D. 225, have
simple, roughened beards in antici-
pation of the Tetrarchic style late in
the third century (Comstock, Ver-
meule, 1976, p. 259, no. 406).

Published: Fogg Museum, 1971, p. 132; Fogg
Museum, 1971a, The Checklist, p. 150.

Gift of Edward W. Forbes, 1969.188

Bust of a Boy of the Time of Trajan

Marble, H. 0.305 m

The right side of the nose is broken off, and
the right earlobe is chipped, also one or two
locks of hair, and minor chips at the edges of
the arms. It has an uneven brown surface,
especially around the ears and sides of the
neck.

The bust includes the chest to just
below the nipples. The head is
turned to the left on the shoulders,
and the hair is combed forward
from the crown in the typical Tra-
janic coiffure, a stylistic date con-
firmed by the depth of the bust.

There are a number of such
ancient busts, mostly from Rome
but including an example reputed to
have been found in Essex and now
in Copenhagen (Poulsen, F., 1951,
p. 470, no. 674b, second supple-
ment, pl. X). The Vatican, Museo
Chiaramonti, no. 417, is one of a
pair of busts found near S. Balbina
in Rome in 1838 and romantically
named Caius and Lucius Caesar(s)
(Amelung, 1903, p. 382, nos. 417,
419, pl. 61).

A bust of an older boy in the
same style and perhaps from the
same workshop was consigned to
auction by a New Jersey private col-
lector (*Sotheby Sale*, New York, 19
May, 1979, no. 229). The bust in
Berlin (no. 1467–R48) has the late
Julio-Claudian or Flavian rather
than the Trajanic form of the chest
and shoulders; this portrait also
represents a slightly older boy (Rob-
ertson, M., 1975, p. 606, pl. 192a).

Provenance: From Rome.

Published: Hanfmann, 1950a, no. 55.

Purchase from the Frederick Grace Fund,
1949.31

Colossal Head of a Goddess or Woman

after a type of the fifth century B.C.
Red stone (*rosso antico* not "porphyry"),
H. 0.692 m

The eyes are hollowed out, and the body has been worked for insertion in a statue. There are large cuts across the back of the hair and neck. The stone is incrusted with whitish material. The surface is dull.

This head appears to be a forgery after a type of the fifth century B.C., such as the Roman Imperial statue of a mourning captive (province?), known as the "Medea" and in the Loggia dei Lanzi in Florence.

The head is turned to the right and is slightly lowered, with its gaze falling downward to the subject's left. The locks of hair are long and fall onto the shoulders, and the casually waved tresses come down low on the forehead, on either side of the central part. The lady wears a broad fillet across the top of the head. It disappears under the hair at the side.

Richard Norton saw the head not long before he wrote to Edward Forbes on May 29, 1899, "outside Rome in a vineyard. . . . It must have been in some Villa or Forum— that's why I call it 'decorative . . . '. It represents, I take it, some conquered province and is not unlike the famous Ludovisi 'Medusa.' "

Over the years various persons who have studied the head have adduced parallels, ancient and modern. One of the latter is the restored head and upper shoulders, in high relief, of the male captive, of Celtic or Germanic origin, standing against a trophy and with a boar-topped standard at his right side in an architectural panel now placed, as no. 605, on the landing outside the entrance to the Galleria dei Candelabri of the Vatican. According to Edward W. Forbes, in notes on a European trip in 1905, Adolf Furtwängler said the head conflated aspects of the Lemnian Athena (as represented by the head in Bologna) and the Antinous Mondragone in the Louvre. Professor Furtwängler had viewed the head with Mr. Forbes on 4 October, 1904, and he studied it again with Matthew S. Prichard of the Museum of Fine Arts, Boston, on the following day. Professor Furtwängler summed up his feelings in a note written to Mr. Forbes after his departure from Boston: "Though it is always a beautiful thing, nourished with the beauty of Phidias' Lemnian Athena; and the difference is only, that the artist, who made this extract, did not live so far off from us."

Provenance: Acquired in Rome through Richard Norton. Said to have been dug up in a vineyard at Porta Salaria in 1898 or 1899.

Published: Forbes, 1909, p. 30.

Gift of Edward W. Forbes, 1900.4

Bibliography

Ackland Art Center, 1973
Ackland Art Center. *Ancient Portraits*. Chapel Hill, North Carolina: William Hayes Ackland Memorial Art Center, University of North Carolina, 1973.

Albertson, 1979
Albertson, Karla, K. In *Aspects of Ancient Greece*. Allentown N.Y.: Allentown Art Museum, 1979.

Amelung, 1897
Amelung, Walther. *Führer durch die Antiken in Florenz*. Munich: 1897.

Amelung, 1903
Amelung, Walther. *Die Sculpturen des Vaticanischen Museums*, I. Berlin: 1903.

Amelung, 1908
Amelung, Walther. *Die Sculpturen des Vaticanischen Museums*, II. Berlin: 1908.

André Emmerich Gallery, Inc., 1970
André Emmerich Gallery, Inc. *Art of Ancient Italy, Etruscans, Greeks and Romans*. New York: André Emmerich Gallery, Inc., 1970.

André Emmerich Gallery, Inc., 1975
André Emmerich Gallery, Inc. *Classical Antiquity*. New York and Zurich: André Emmerich Gallery, Inc., 1975.

Andreae, 1956
Andreae, Bernard. "Ein Amazonengemälde." *Römische Mitteilungen*, 63, Mitteilungen des Deutschen Archäologischen Instituts, pp. 32–45. Heidelberg: F. H. Kerle, 1956.

Arias, 1952
Arias, Paolo Enrico. *Skopas*. (Quaderni e Guide di Archeologia, I). Rome: L'Erma di Bretschneider, 1952.

Arndt, Amelung, Lippold, 1893–1950
Arndt, Paul, Walther Amelung, and Georg Lippold. *Photographische Einzelaufnahmen antiker Sculpturen*. Munich: 1893–1950.

Arnold, 1969
Arnold, Dorothea. "Die Polykletnachfolge." *Jahrbuch des Deutschen Archäologischen Instituts*. Ergänzungsheft 25. Berlin: Walter De Gruyter, 1969.

Ashmole, 1929
Ashmole, Bernard. *A Catalogue of the Ancient Marbles at Ince Blundell Hall*. Oxford, England: 1929.

Atalay, Türkoğlu, 1976
Atalay, Erol and Sabahattin Türkoğlu. "Ein frühhellenistischer Porträtkopf des Lysimachos aus Ephesos." *Jahresheften des Österreichischen Archäologischen Instituts*, pp. 125–150. Band L, Beiblatt (50), 1976.

Art Quarterly, 1955
"Accessions of American and Canadian Museums." *Art Quarterly* XCIII, no. 2 (Summer 1955) pp. 195–206, illus.

Bastet, Brunsting, 1982
Bastet, Frederick L. and H. Brunsting. *Catalogus van hef Klassieke Beeldhouwwerk in het Rijksmuseum van Oudheden te Leiden*. Leiden and Zutphen: 1982.

Becatti, 1951
Becatti, Giovanni. *Problemi fidiaci*. Milan: Electa, 1951.

Beck, 1984
Beck, Irmgard. *Ares in Vasenmalerei, Relief und Rundplastik* (Archäologische Studien Band 7). Frankfort am Main: Verlag Peter Lang, 1984.

Bergmann, 1977
Bergmann, Marianne. *Studien zum römischen Porträt des 3. Jahrhunderts n. Chr*. Bonn: Habelt, 1977.

Biblical Illustrator, 1982
Biblical Illustrator, Summer, 1982, p. 20

Bieber, 1915
Bieber, Margarete. *Die antiken Skulpturen und Bronzen des königl. museum Fridericianum in Cassel*. Marburg: Elwert, 1915.

Bieber, 1957
Bieber, Margarete. "A Bronze Statuette in Cincinnati and its Place in the History of the Asklepios Types." *Proceedings of the American Philosophical Society*, 101, no. 1, pp. 70–92, figs. 1–38, 1957.

Bieber, 1961
Bieber, Margarete. *The Sculpture of the Hellenistic Age* (2nd ed.) New York: Columbia University Press, 1961.

Bieber, 1961a
Bieber, Margarete. *The History of the Greek and Roman Theater* (2nd ed. rev.). Princeton: Princeton University Press, 1961.

Bieber, 1977
Bieber, Margarete. *Ancient Copies: Contributions to the History of Greek and Roman Art.* New York: New York University Press, 1977.

Bielefeld, 1968
Bielefeld, Erwin. "IV. The Hellenistic World and the Eastern Provinces, 1. Hellenistic and Hellenistico-Romano Civilization and Art." *Fasti Archaeologici, Annual Bulletin of Classical Archaeology, 1963–1964, XVIII-XIX,* p. 354, no. 4900. Florence: International Association of Classical Archeology, 1968.

Blanco, 1957
Blanco, Antonio. *Catalogo de la escultura,* Museo del Prado. Madrid: Museo Nacional de Pintura y Escultura, 1957.

Blümel, 1931–1938
Blümel, Carl. *Römische Kopien griechischer Skulpturen des fünften Jahrhunderts v. Chr.* (Staatliche Museen zu Berlin, Katalog der Sammlung antiker Skulpturen, Band IV, v). Berlin: H. Schoetz and Co., Verlag für Kunstwissenschaft, 1931–1938.

Boardman, 1978
Boardman, John. *Greek Art.* London: Thames and Hudson, 1978.

Boëthius, Ward-Perkins, 1970
Boëthius, Axel, and J. Bryan Ward-Perkins. *Etruscan and Roman Architecture.* Baltimore and Hammondsworth: Penguin, 1970.

Boni, 1901.
Boni, G. "Roma." *Notizie degli Scavi di Antichità,* pp. 6–144. Roma: R. Accademia dei Lincei, 1901.

Borsari, 1895
Borsari, L. "Santa Marinella." *Notizie degli Scavi di Antichità,* pp. 195–201, figs. 1,2. Roma: R. Accademia dei Lincei, 1895.

Brinkerhoff, 1970
Brinkerhoff, Dericksen Morgan. *A Collection of Sculpture in Classical and Early Christian Antioch.* New York: New York University Press, 1970.

Brinkerhoff, 1971
Brinkerhoff, Dericksen Morgan. "Figures of Venus, Creative and Derivative." *Studies Presented to George M. A. Hanfmann,* pp. 9–16. Cambridge, Mass.: Fogg Art Museum, 1971.

Brinkerhoff, 1978
Brinkerhoff, Dericksen Morgan. *Hellenistic Statues of Aphrodite; Studies in the History of their Stylistic Development.* New York and London: Garland Publishing, 1978.

Brizzolara, 1982
Brizzolara, Anna Marie. *Le Sculture del Museo Civico Archeologico di Bologna: La collezione Marsili.* Bologna: 1982.

Budde, 1964
Budde, Ludwig. "Ein Achilleus-Sarkophag aus Tarsus in Adana." in *Festschrift für Eugen von Mercklin,* pp. 9–26, taf. 1–14. Waldsassen Bayern: Stiftland Verlag K. G., 1964.

Budde, Nicholls, 1964
Budde, Ludwig, and Richard Nicholls. *A Catalogue of the Greek and Roman Sculpture in the Fitzwilliam Museum.* Cambridge: University Press, 1964.

Buschor, 1928
Buschor, Ernst. "Varianten." *Antike Plastik, Walther Amelung zum sechzigsten Geburtstag,* pp. 53–56, pls. 1–4. Berlin and Leipzig: Walter de Gruyter and Co., 1928.

Calza, 1964
Calza, Raissa. *Scavi di Ostia: I ritratti,* pt. 1: *Ritratti greci e romani fino al 160 circa d.C.,* vol. 5. Rome: 1964.

Caputo, Traversari, 1976
Caputo, Giacomo, and Gustavo Traversari. *Le sculture del teatro di Leptis Magna.* Rome: L'Erma di Bretschneider, 1976.

Catling, 1974
Catling, Hector W. "Archaeology in Greece, 1973–1974." *Archaeological Reports for 1973–1974,* pp. 3–41, figs. 1–86. London: Council of the Society for the Promotion of Hellenic Studies and the Managing Committee of the British School at Athens, 1974.

Catling, 1982
Catling, Hector W. "Archaeology in Greece, 1981–1982." *Archaeological Reports for 1981–82,* pp. 3–62, figs. 1–136. London: Council of the Society for the Promotion of Hellenic Studies and the Managing Committee of the British School at Athens, 1982.

Chamay, 1975
Chamay, Jacques. *Art Antique, Collections privées de Suisse romande.* Geneva and Mainz: 1975.

Chapel Arts Center, 1970
Chapel Arts Center. *Man in the Bronze Age* (Exhibition: January 5–28, 1970). Manchester, N.H.: St. Anselm's College, 1970.

Charbonneaux, 1972
Charbonneaux, Jean, *et al. Classical Greek Art.* New York: Braziller, 1972.

Chase, 1917
Chase, George H. "The Meleager in the Fogg Museum and Related Works in America." *The Art Bulletin* 3, pp. 109–116, illus. 1917.

Chase, 1924
Chase, George H. *Greek and Roman Sculpture in American Collections.* Cambridge, Mass.: Harvard University Press, 1924.

Chase, Post, 1925
Chase, George H., and Chandler Rathbone Post. *History of Sculpture.* New York and London: Harper and Brothers, 1925.

Childs, 1979.
Childs, W. "1. General, 1. General Practices." *Fasti Archaeologici, Annual Bulletin of Classical Archaeology, 1973–1974, XXVIII-XXIX,* p. 30, no. 428. Florence: International Association of Classical Archaeology, 1979.

Chittenden, Seltman, 1947
Chittenden, Jacqueline, and Charles Seltman. *Greek Art.* London: Faber and Faber, 1947.

CIL VI, 1882
Corpus Inscriptionum Latinarum, Academiae Litterarum Regiae Borussicae, vol. VI, part 2. Eugenius Bormann, Guilelmus Henzen, Christianus Huelsen, eds., p. 1491, no. 11794. 1882.

CIL VI, 1902
Corpus Inscriptionum Latinarum, Academiae Litterarum Regiae Borussicae, vol. VI, part 4, 2. Christianus Huelsen ed., p. 3052, no. 31085. 1902.

CIL VI, 1968
Corpus Inscriptionum Latinarum, Academiae Litterarum Regiae Borussicae, vol. VI, part 4. Christianus Huelsen, ed., p. 2830, no. 29157. Berlin: Walter de Gruyter and Co., 1968.

Cima, 1982
Cima, Maddalena. In Antonio Giuliano, *et al. Museo Nazionale Romano, Le Sculture,* I, 3, pp. 138–139, no. VI.2. Rome: De Luca Editore s.r.l., Ministero per i Beni Culturali e Ambientali Soprintendenza Archeologica di Roma, 1982.

Colledge, 1976
Colledge, Malcolm A. R. *The Art of Palmyra.* Boulder, Colorado: Westview Press, 1976.

Collignon, 1911
Collignon, Maxime. *Les Statues Funéraires dans l'Art Grec.* Paris: E. Leroux, 1911.

Comstock, Vermeule, 1976
Comstock, Mary B., and Cornelius C. Vermeule. *Sculpture in Stone, The Greek, Roman and Etruscan Collections of the Museum of Fine Arts, Boston.* Boston: Museum of Fine Arts, 1976.

Comstock, Vermeule, 1988
Comstock, Mary B., and Cornelius Vermeule III. *Sculpture in Stone and Bronze in the Museum of Fine Arts, Boston.* Boston: Museum of Fine Arts, 1988.

Conze, 1891
Conze, Alexander. *Königliche Museen zu Berlin: Beschreibung der Antiken Skulpturen mit Ausschluss der pergamenischen Fundstücke.* Berlin: W. Spemann, 1891.

Conze, 1900
Conze, Alexander. *Die Attischen Grabreliefs,* II. Berlin: W. Spemann, 1900.

Conze, 1911–1922
Conze, Alexander. *Die Attischen Grabreliefs,* IV. Berlin and Leipzig: Walter de Gruyter and Co., 1911–1922.

Cook, Blackman, 1971
Cook, John M., and David J. Blackman. "Archaeology in Western Asia Minor, 1965–1970." *Archaeological Reports for 1970–71,* pp. 33–62, figs. 1–31. London: Council of the Society for the Promotion of Hellenic Studies and the Managing Committee of the British School in Athens, 1971.

Cooney, 1941
Cooney, John D. *Pagan and Christian Egypt, Egyptian Art from the First to the Tenth Century A.D.* New York: Brooklyn Museum, 1941.

Cristofani, 1975
Cristofani, Mauro. *Corpus delle urne etrusche di età ellenistica, 2, Urne Volterrane, 2, Il Museo Guarnacci, Parte prima.* Florence: Centro Di, 1977.

Crowfoot, Crowfoot, Kenyon, 1957
Crowfoot, John W., and Grace M. Crowfoot, and Kathleen M. Kenyon, *et al. The Objects from Samaria.* London: Palestine Exploration Fund, 1957.

Deane, 1922
Deane, Sidney. "Archaeological Discussions." *American Journal of Archaeology* 26, pp. 193–236, illus. 1922.

Deonna, 1923
Deonna, Waldemar. "Collections archéologiques et historiques, Collections Fol, Salle des Armures, Collections lapidaires." *Genava I, Bulletin du Musée D'Art et D'Histoire,* pp. 34–67. 1923.

Deonna, 1923a
Deonna, Waldemar. "Monuments Orientaux du Musée de Genève," *Syria, Revue d'Art Oriental et d'Archéologie,* 4, pp. 224–233, pls. XXXI-XXXIII. 1923.

Diepolder, 1931
Diepolder, Hans. *Die Attischen Grabreliefs des 5. und 4. Jahrhunderts v. Chr.* Berlin: H. Keller, 1931.

Dikaios, 1961
Dikaios, Porphyrios. *A Guide to the Cyprus Museum.* Nicosia: Republic of Cyprus, Department of Antiquities, 1961.

Dohrn, 1957
Dohrn, Tobias. *Attische Plastik vom Tode des Phidias bis zum Wirken der grossen Meister des IV Jahrhunderts v. Chr.* Krefeld: Scherpe, 1957.

Dwyer, 1981
Dwyer, Eugene J. "Pompeian Oscilla Collections." *Römische Mitteilungen*, pp. 247–306, figs. 80–130. Mitteilungen des Deutschen Archäologischen Instituts 88, 1981.

Eisenberg, 1960
Eisenberg, Jerome. *A Catalogue of Late Egyptian and Coptic Sculptures*. New York: Royal-Athena Galleries, 1960.

Ellis, 1936
Ellis, Alice Whiting. "Reliefs from a Sarcophagus Decorated with an Amazonomachy in the Fogg Museum." *Harvard Studies in Classical Philology*, 47, pp. 216–218. Cambridge, Massachusetts: Harvard University, 1936.

Erhart, 1978
Erhart, K. Patricia. "Portrait of Antonia Minor in the Fogg Museum and its Iconographical Traditions." *American Journal of Archaeology*, 82, pp. 193–212, illus. 1978.

Faison, 1982
Faison, Samson Lane, Jr. *The Art Museums of New England*. New York: Harcourt Brace, 1958. (New ed. Boston: D. R. Godine, 1982.)

Felletti Maj, 1951
Felletti Maj, B. M. "Afrodite Pudica: Saggio d'arte ellenistica." *Archeologia Classica III*, 1951.

Fittschen, 1977
Fittschen, Klaus. *Katalog der antiken Skulpturen in Schloss Erbach*. Berlin: Mann, 1977.

Fittschen, Zanker, 1983
Fittschen, Klaus, and Paul Zanker. *Katalog der römischen Porträts in den Capitolischen Museen und den anderen kommunalen Sammlungen der Stadt Rom*, I. Mainz: Philipp von Zabern, 1983.

Flusser, 1975
Flusser, D. "The Great Goddess of Samaria." *Israel Exploration Journal*, 25, no. 1, pp. 13–29, pl. 2. Jerusalem: 1975.

Foerster, 1985
Foerster, Gideon. "A Cuirassed Bronze Statue of Hadrian." *'Atiqot* (English Series) xxiii–xxviii, pp. 139–160, pls. XXIII–XXVIII. 1985.

Fogg Museum, 1921
Fogg Art Museum Notes, vol. 1, no. 1, Cambridge, Massachusetts: Harvard University, December 1921.

Fogg Museum, 1936
Fogg Art Museum. *Handbook*. Cambridge, Massachusetts: Harvard University, 1936.

Fogg Museum, 1954
Fogg Art Museum. *Ancient Art in American Private Collections, 1954–1955*. Cambridge, Massachusetts: Harvard University, 1954.

Fogg Museum, 1955
Fogg Art Museum. *Annual Report, 1953–1954*. Cambridge, Massachusetts: Harvard University, 1955.

Fogg Museum, 1961
Fogg Art Museum. *David Moore Robinson Bequest of Classical Art and Antiquities, A Special Exhibition*. Cambridge, Massachusetts: Harvard University, 1961.

Fogg Museum, 1963
Fogg Art Museum. *Acquisitions, 1959–1962*. Cambridge, Massachusetts: Harvard University, 1963.

Fogg Museum, 1964
Fogg Art Museum. *Acquisitions, 1962–1963*. Cambridge, Massachusetts: Harvard University, 1964.

Fogg Museum, 1965
Fogg Art Museum. *Memorial Exhibition. Works of Art from the Collection of Paul J. Sachs, 1878–1965*. Cambridge, Massachusetts: Harvard University, 1965.

Fogg Museum, 1968
Fogg Art Museum. *Acquisitions, 1966–1967*. Cambridge, Massachusetts: Harvard University, 1968.

Fogg Museum, 1969
Fogg Art Museum. *Acquisitions, 1968*. Cambridge, Massachusetts: Harvard University, 1969.

Fogg Museum, 1969a
Fogg Art Museum. *Grenville L. Winthrop: Retrospective for a Collector*. Cambridge, Massachusetts: Harvard University, 1969.

Fogg Museum, 1971
Fogg Art Museum. *Acquisitions, 1969–1970*. Cambridge, Massachusetts: Harvard University, 1971.

Fogg Museum, 1971a
Fogg Art Museum. *Edward Waldo Forbes, Yankee Visionary*. January 16–February 22, 1971, Introduction by Agnes Mongan. Cambridge, Massachusetts: Harvard University, 1971.

Fogg Museum, 1973
Fogg Art Museum. *Frederick M. Watkins Collection*. Cambridge, Massachusetts: Harvard University, 1973.

Fogg Museum, 1975
Fogg Art Museum. *Annual Report 1971–1972*. Cambridge, Massachusetts: Harvard University, 1975.

Fogg Museum, 1976
Fogg Art Museum. *Annual Report, 1972–1974*. Cambridge, Massachusetts: Harvard University, 1976.

Fogg Museum, 1977
Fogg Art Museum. *Newsletter*, vol. 14, no. 4, June, p. 6. Cambridge, Massachusetts: Harvard University, 1977.

Fogg Museum, 1982
Fogg Art Museum. *Annual Report, 1978–1980*. Cambridge, Massachusetts: Harvard University, 1982.

Fogg Museum, 1983
Fogg Art Museum. *Gandharan Art and its Classical Connections.* August 19, 1982–January 30, 1983. Cambridge, Massachusetts: Harvard University, 1983.

Forbes, 1909
Forbes, Edward W. *Bulletin of the Museum of Fine Arts, Boston* VII. Boston: Museum of Fine Arts, 1909.

Fraser, 1925
Fraser, A. D. "A Myronic Head in the Fogg Museum of Art." *American Journal of Archaeology,* 29, pp. 314–320, figs. 1–2, 1925.

Frel, 1969
Frel, Jiří. *Les sculpteurs attiques anonymes, 430–300 B.C.* Prague: Universita Karlova, 1969.

Frel, n.d.
Frel, Jiří. *Antiquities in the J. Paul Getty Museum, A Checklist, Sculpture II, Greek Portraits and Varia.* Malibu: J. Paul Getty Museum, n.d.

Frel, Morgan, 1981
Frel, Jiří, and Sandra K. Morgan. *Roman Portraits in the Getty Museum.* Malibu: J. Paul Getty Museum, 1981.

Friedman, 1989
Friedman, Florence. *Beyond the Pharaohs: Egypt and the Arts in the 2nd to 7th Centuries A.D.* Providence, Rhode Island: Museum of Art, Rhode Island School of Design, 1989.

Froning, 1981
Froning, Heide. *Marmor-Schmuckreliefs mit griechischen Mythen im 1. Jh. v. Chr.: Untersuchungen zu Chronologie und Funktion.* Mainz: Philipp von Zabern, 1981.

Fuchs, 1969
Fuchs, Werner. *Die Skulptur der Griechen.* Munich: Hirmer Verlag, 1969.

Furtwängler, 1905
Furtwängler, Adolf. *Antiken in den Museen von Amerika.* Sitzungsberichte der K. Bayer. Akad. der Wissenschaft, vol. 3. Munich: 1905.

Galerie Koller A.G., 1979
Galerie Koller A.G. *The Ernst Brummer Collection, Ancient Art,* vol. II. Zurich: Galerie Koller and Spink & Son, 1979.

García y Bellido, 1949
García y Bellido, Antonio. *Esculture Romanas de España y Portugal.* Madrid: Consejo Superior de Investigaciones Científicas, 1949.

Garred, E., 1984
Garred, Eileen. *Harvard Gazette,* 80, Dec. 14, 1984, pp. 1, 16, illus. Cambridge, Massachusetts: Harvard University, 1984.

Gauckler, 1895
Gauckler, Paul. *Musée de Cherchel.* Paris: 1895.

Gergel, 1986
Gergel, Richard A. "An Allegory of Imperial Victory on a Cuirassed Statue of Domitian." *Record of the Art Museum, Princeton University* 45, no. 1, pp. 3–15. Princeton: 1986.

Getz-Preziosi, 1966
Getz-Preziosi, Patricia. "Cycladic Art in the Fogg and Farland Collections." *American Journal of Archaeology* 70, pp. 105–111, pls. 27–32. 1966.

Getz-Preziosi, 1985
Getz-Preziosi, Patricia. *Early Cycladic Sculpture, An Introduction.* Malibu: The J. Paul Getty Museum, 1985.

Getz-Preziosi, 1987
Getz-Preziosi, Patricia. *Early Cycladic Art in North American Collections.* Richmond: Virginia Museum of Fine Arts, 1987.

Giglioli, 1935
Giglioli, Giulio Quirino. *L'arte etrusca.* Milan: Fratelli Treves, 1935.

Giuliano, 1962
Giuliano, Antonio. *Il commercio degli sarcofagi attici.* Rome: L'Erma di Bretschneider, 1962.

Giuliano, Palma, 1978
Giuliano, Antonio, and Beatrice Palma. *La maniera ateniese di età romana: I maestri dei sarcofagi attici, Studi Miscellanei 24.* Rome: L'Erma di Bretschneider, 1978.

Grimm, Johannes, 1975
Grimm, Gunter, and Dieter Johannes. *Kunst der Ptolemäer und Römerzeit im Ägyptischen Museum Kairo.* Mainz: Philipp von Zabern, 1975.

Guadagno, Carafa, 1973
Guadagno, G., and R. Carafa. *Pompeii, Herculaneum and Stabiae, The Buried Cities.* Venice: 1973.

Hadzi, 1983
Hadzi, Martha Leeb. *Transformations in Hellenistic Art.* South Hadley, Massachusetts: Mount Holyoke College Art Museum, 1983.

Hafner, 1954
Hafner, German. *Späthellenistische Bildnisplastik.* Berlin: Gebr. Mann, 1954.

Hamdi Bey, Reinach, 1892
Hamdi Bey, Osman, and Théodor Reinach. *Une Nécropole royale à Sidon.* Paris: E. Leroux, 1892.

Hanfmann, 1950
Hanfmann, George M. A. *Greek Art and Life, An Exhibition Catalogue.* Cambridge, Massachusetts: Fogg Art Museum, 1950.

Hanfmann, 1950a
Hanfmann, George M. A. *An Exhibition of Ancient Sculpture.* Cambridge, Massachusetts: Fogg Art Museum, 1950.

Hanfmann, 1951
Hanfmann, George M. A. *The Seasons Sarcophagus in Dumbarton Oaks*. Cambridge, Massachusetts: Harvard University Press, 1951.

Hanfmann, 1953
Hanfmann, George M. A. "Observations on Roman Portraiture." *Latomus* XI, pp. 9–50, pls. I-III. Brussels: Revue d'Études Latines, 1953.

Hanfmann, 1957
Hanfmann, George M. A., et al. "A New Trajan." *American Journal of Archaeology* 61, pp. 223–253, pls. 68–75. 1957.

Hanfmann, 1966
Hanfmann, George M. A. "A Hellenistic Landscape Relief." *American Journal of Archaeology* 70, pp. 371–373, pl. 94. 1966.

Hanfmann, 1967
Hanfmann, George M. A. *Classical Sculpture*. Greenwich, Ct. and London: New York Graphic Society, George Rainbird, 1967.

Hanfmann, Mitten, 1978
Hanfmann, George M. A., and David G. Mitten. "The Art of Classical Antiquity." *Apollo* XCVII, no. 195, May 1978. pp. 362–369, 10 illus. 1978.

Hanfmann, Pedley, 1964
Hanfmann, George M. A., and John Griffiths Pedley. "The Statue of Meleager." *Antike Plastik* III, pp. 61–66. Taf. 58–72. 1964.

Hanfmann, Ramage, 1978
Hanfmann, George M. A., and Nancy H. Ramage. *Sculpture from Sardis: The Finds through 1975*. Cambridge, Massachusetts: Harvard University Press, 1978.

Harrison, 1965
Harrison, Evelyn B. *The Athenian Agora* XI, *Archaic and Archaistic Sculpture*. Princeton: American School of Classical Studies at Athens, 1965.

Haskell, Penny, 1981
Haskell, Francis, and Nicholas Penny. *Taste and the Antique: The Lure of Classical Sculpture 1500–1900*. New Haven: Yale University Press, 1981.

Havelock, 1979
Havelock, Christine M. *Hellenistic Art, The Art of the Classical World from the Death of Alexander the Great to the Battle of Actium*. Greenwich, Connecticut: New York Graphic Society, 1979.

Haynes, 1939.
Haynes, Denys E. L. "Mors in Victoria," *Papers of the British School at Rome* XV, pp. 27–32, pls. I, II. 1939.

Heilmeyer, 1970
Heilmeyer, Wolf-Dieter. *Korinthische Normalkapitelle. Studien zur Geschichte der römischen Architekturdekoration. (Römische Mitteilungen*, Suppl. 16). Heidelberg: Kerle, 1970.

Heintze, 1968
Heintze, Helga von. *Die antiken Porträts in Schloss Fasanerie bei Fulda*. Mainz: Philipp von Zabern, 1968.

Heintze, 1971
Heintze, Helga von. *Roman Art*. New York: Universe Books, 1971.

Herrmann, 1983
Herrmann, Ariel. *Ornamenta*, 12–29 July, 1983. London: J. Ogden Ltd., 1983.

Herz, Wenner, 1981
Herz, Norman, and David B. Wenner. "Tracing the Origins of Marble," *Archaeology*, 34, no. 5, Sept/Oct. 1981. pp. 14–21, illus. p. 16. 1981.

Himmelmann, 1973
Himmelmann, Nikolaus. *Typologische Untersuchungen an römischen Sarkophagreliefs des. 3. und 4. Jahrhunderts nach Christus*. Mainz: Philipp von Zabern, 1973.

Hoffmann, 1970
Hoffmann, Herbert. *Ten Centuries that Shaped the West, Greek and Roman Art in Texas Collections*. Houston: Rice University, 1970.

Hoffmann, 1971
Hoffmann, Herbert. *Collecting Greek Antiquities*. New York: C. N. Potter, 1971.

Homann-Wedeking, 1968
Homann-Wedeking, Ernst. *The Art of Archaic Greece*. New York: Crown Publishers, 1968.

Houser, 1979
Houser, Caroline. *Dionysos and His Circle*. Cambridge, Massachusetts: Fogg Art Museum, 1979.

Houser, 1982
Houser, Caroline. "Alexander's Influence on Greek Sculpture as Seen in a Portrait in Athens." *Studies in the History of Art*, Symposium Series I, *Macedonia and Greece in Late Classical and Early Hellenistic Times*, vol. 10, pp. 228–238, figs. 1–21. Washington, D.C.: National Gallery of Art, 1982.

Hus, 1961
Hus, Alain. *Recherches sur la statuaire en pierre étrusque archaique*. Paris: De Boccard, 1961.

Huskinson, 1975
Huskinson, J. *Corpus of the Sculptures of the Roman World, Great Britain*, vol. II, Fascicule I, *Roman Sculpture from Cyrenaica in the British Museum*. London: 1975.

Inan, 1975
Inan, Jale. *Roman Sculpture in Side*. Ankara: Türk Tarih Kurumu Basımevi, 1975.

Inan, 1975a
Inan, Jale. *Antike Plastik* XII, pp. 69–71. Berlin: 1975.

Inan, Rosenbaum, 1966
Inan, Jale, and Elisabeth Rosenbaum. *Roman and Early Byzantine Portrait Sculpture in Asia Minor*. London: Oxford University Press, 1966.

Ingholt, 1928
Ingholt, Harald. *Studier over pal-myrenske skulptur.* Copenhagen: C. A. Reitzel, 1928.

Jenkins, 1972
Jenkins, G. Kenneth. *Ancient Greek Coins.* London: Barrie and Jenkins, 1972.

Johnson, 1931
Johnson, Franklin P. *Sculpture, 1896–1923. Corinth.* vol. IX, American School of Classical Studies at Athens. Cambridge, Massachusetts: Harvard University Press, 1931.

Jones, 1912
Jones, H. Stuart. *A Catalogue of the Ancient Sculptures Preserved in the Municipal Collections of Rome, The Sculptures of the Museo Capitolino.* Oxford: Clarendon Press, 1912.

Kähler, 1963
Kähler, Heinz. *Rome and her Empire.* London: Methuen, 1963.

Kallipolitis, 1958
Kallipolitis, Vasileios G. *Chronologike Katataxis ton meta mythologikon parastaseon attikon sarcophagon tes rhomaikes epoches.* Athens: 1958.

Karageorghis, 1973
Karageorghis, Vassos. *Cypriote Antiquities in the Pierides Collection, Larnaca, Cyprus.* Larnaca: 1973.

Karageorghis, 1984
Karageorghis, Vassos. "Dionysiaca and Erotica from Cyprus." *Report of the Department of Antiquities Cyprus,* pp. 214–217. pl. XXXIX, 2. 1984.

Karageorghis, Vermeule, 1964
Karageorghis, Vassos, and Cornelius C. Vermeule. *Sculptures from Salamis, I.* Nicosia: Department of Antiquities, Cyprus, 1964.

Kater-Sibbes, 1973
Kater-Sibbes, G. J. F. *Preliminary Catalogue of Sarapis Monuments.* Leiden: Brill, 1973.

Kleiner, 1977
Kleiner, Diana E. E. *Roman Group Portraiture, The Funerary Reliefs of the Late Republic and Early Empire.* New York: Garland Publishing Co., 1977.

Koch, 1976
Koch, Guntram. "Verschollene Mythologische Sarkophage." *Archäologischer Anzeiger,* Deutsches Archäologisches Institut, pp. 101–110. Berlin: Walter de Gruyter and Co., 1976.

Koch, Sichtermann, 1982
Koch, Guntram, and Helmut Sichtermann. *Römische Sarkophage.* Munich: C. H. Beck, 1982.

Lattimore, 1975
Lattimore, Steven. "Two Statues of Herakles." *The J. Paul Getty Museum Journal* II, pp. 17–23, figs. 1–5. Malibu: The J. Paul Getty Museum, 1975.

Lawrence, 1927
Lawrence, Arnold W. *Later Greek Sculpture and its Influence on East and West.* London: J. Cape, 1927.

Lawrence, 1929
Lawrence, Arnold W. *Classical Sculpture.* London: J. Cape, 1929.

Lawrence, 1972
Lawrence, Arnold W. *Greek and Roman Sculpture.* London: J. Cape, 1972.

Lepper, 1948
Lepper, F. A. *Trajan's Parthian War.* Oxford: Oxford University Press, 1948.

Lippold, 1950
Lippold, Georg. *Handbuch der Archäologie VI, 3, Die Griechische Plastik.* Munich: C. H. Beck, 1950.

Lippold, 1956
Lippold, Georg. *Die Skulpturen des Vaticanischen Museums* III, 2. Berlin: Walter de Gruyter and Co., 1956.

Magie, 1950
Magie, David. *Roman Rule in Asia Minor* I. Princeton: Princeton University Press, 1950.

Mansuelli, 1941
Mansuelli, Guido Achille. "La Statua Piacentina di Cleomene Ateniese." *Jahrbuch des Deutschen Archäologischen Instituts,* Band 56, p. 151–162, figs. 1–11. Berlin: Walter de Gruyter and Co., 1941.

Marcadé, 1969
Marcadé, Jean. *Au Musée de Délos, Étude sur la sculpture hellénistique en ronde bosse découverte dans l'île* (Bibliothèque des Ecoles Françaises, d'Athènes et de Rome, Fascicule 215). Paris: De Boccard, 1969.

Massner, 1982
Massner, Anne-Kathrein. *Bildnisangleichung, Das Römische Herrscherbild* Abt. IV. Berlin: Mann, 1982.

Matz, von Duhn, 1882
Matz, Friedrich, and F. von Duhn. *Antike Bildwerke in Rom.* Leipzig: Breitkopf and Hartel, 1882.

McCann, 1978
McCann, Anna Marguerite. *Roman Sarcophagi in the Metropolitan Museum of Art.* New York: Metropolitan Museum of Art, 1978.

McCredie, 1962
McCredie, James R. "Two Herms in the Fogg Museum." *American Journal of Archaeology* 66, no. 2, pp. 187–189, pl. 56, figs. 3, 4. 1962.

Mendel, 1914
Mendel, Gustave. *Catalogue des Sculptures* III. Constantinople: Musées Impériaux Ottomans, 1914.

Merkel Guldan, 1988
Merkel Guldan, Margarete. *Die Tagebücher von Ludwig Pollak, Kennerschaft und Kunsthandel in Rom 1893–1934*. Wien: Österreichische Akademie der Wissenschaften, 1988.

Michaelis, 1882
Michaelis, Adolf. *Ancient Marbles in Great Britain*. Cambridge: University Press, 1882.

Mitten, Brauer, 1982
Mitten, David G., and Amy Brauer. *Dialogue with Antiquity, The Curatorial Achievement of George M. A. Hanfmann*. Cambridge, Massachusetts: Fogg Art Museum, 1982.

Moore, 1909
Moore, Clifford. "Latin Inscriptions in the Harvard Collection of Classical Antiquities." *Harvard Studies in Classical Philology* 20, p. 1–14, no. 37. 1909.

Moretti, 1948
Moretti, Giuseppe. *Ara Pacis Augustae*. Rome: La Libreria dello Stato, 1948.

Mortimer, 1985
Mortimer, Kristen A., and William G. Klingelhofer. *Harvard University Art Museums: A Guide to the Collections*. New York: Abbeville Press, 1985.

Müfid, 1931
Müfid, (Mansel) Arif. "Erwerbungsbericht des Antikenmuseums zu Istanbul seit 1914." *Archäologischer Anzeiger*, Deutschen Archäologischen Instituts, cols. 173–210, abb. 1–28. Berlin: Walter de Gruyter and Co., 1931.

Müfid, 1963
Müfid, (Mansel) Arif. *Die Ruinen von Side*. Berlin: Walter de Gruyter and Co., 1963.

Museum of Fine Arts, Boston, 1959
Museum of Fine Arts. *Greek and Roman Portraits*. Boston: Museum of Fine Arts, 1959.

Museum of Fine Arts, Boston, 1973
Museum of Fine Arts. *The Museum Year: 1972–1973*. Boston: Museum of Fine Arts, 1973.

Museum of Fine Arts, Boston, 1976
Museum of Fine Arts. *Romans and Barbarians*. Boston: Museum of Fine Arts, 1976.

Museum of Fine Arts, Boston, 1982
Museum of Fine Arts. *The Museum Year: 1981–1982*. Boston: Museum of Fine Arts, 1982.

Mustilli, 1939
Mustilli, Domenico. *Museo Mussolini*. Rome: La Libreria dello Stato, 1939.

Mylonas, 1959
Mylonas, George E. *Aghios Kosmas, An Early Bronze Age Settlement and Cemetery in Attica*. Princeton: Princeton University Press, 1959.

Neils, 1988
Neils, Jenifer. "The Quest for Theseus in Classical Sculpture." *Praktika*, 1983, part B, pp. 155–158. Athens: 1988.

Newark Museum, 1980
The Newark Museum. *Ancient Greece: Life and Art*, February 2-March 16. Newark, New Jersey: The Newark Museum, 1980.

Newell, 1978
Newell, Edward Theodore. *The Coinage of Demetrios Poliorcetes*. Chicago: Obol International, 1978.

Nicholls, 1961
Nicholls, Richard V. "Recent Additions at the Fitzwilliam Museum, Cambridge." *Archaeological Reports for 1961–1962*, pp. 47–52, figs. 1–11. London: The Council of the Society for the Promotion of Hellenic Studies and the Managing Committee of the British School at Athens, 1961.

Nicholls, 1971
Nicholls, Richard V. "The Trinity College Collection and other Recent Loans at the Fitzwilliam Museum." *Archaeological Reports for 1970–1971*, pp. 77–85, figs. 1–14. London: The Council of the Society for the Promotion of Hellenic Studies and the Managing Committee of the British School at Athens, 1971.

Niemeyer, 1968
Niemeyer, Hans-Georg. *Studien zur statuarischen Darstellung der römischen Kaiser*. Berlin: Mann, 1968.

Oehler, 1961
Oehler, Hansgeorg. *Untersuchungen zu den männlichen römischen Mantelstatuen. Der Schulterbauschtypus*. Berlin: Mann, 1961.

Oehler, 1980
Oehler, Hansgeorg. *Foto Skulptur, Römische Antiken in englischen Schlossern*. Cologne: Römisch-Germanisches Museum Köln, 1980.

Orlandos, 1958
Orlandos, Anastasios K. "Brauron." *Ergon*, pp. 30–39, figs. 33–41. Athens: The Greek Archaeological Society, 1958.

Paribeni, E., 1959
Paribeni, Enrico. *Catalogo delle sculture di Cirene, Statue e rilievi di carattere religioso*. Rome: L'Erma di Bretschneider, 1959.

Paribeni, Em., 1981
Paribeni, Emanuela. In Antonio Giuliano, *et al. Museo Nazionale Romano, Le Sculture*, I, 2. Rome: De Luca Editore s.r.l., Ministero per I Beni Culturali e Ambientali. Soprintendenza Archeologica di Roma, 1981.

Paribeni, R. 1902
Paribeni, Roberto. "Pompeii." *Notizie degli Scavi di Antichità*, fascicule 4, pp. 201–213. Roma: Accademia dei Lincei, 1902.

Parlasca, 1966
Parlasca, Klaus. *Mumienporträts und verwandte Denkmäler*, Deutsches Archäologisches Institut. Wiesbaden: Steiner, 1966.

Parlasca, 1982
Parlasca, Klaus. *Syrische Grabreliefs hellenistischer und römischer Zeit, Fundgruppen und Probleme* (Trierer Winckelmannsprogramme, Heft 3). Trier-Mainz: Philipp von Zabern, 1982.

Pedley, 1965
Pedley, John Griffiths. "An Attic Grave Stele in the Fogg Art Museum." *Harvard Studies in Classical Philology* 69, pp. 259–267. Cambridge, Massachusetts: Harvard University Press, 1965.

Pedley, Gazda, 1981
Pedley, John Griffiths, and Elaine Gazda. *Greek Sculpture in Transition*, January 30 to April 19. Ann Arbor: University of Michigan, 1981.

Pennant, 1782
Pennant, Thomas. *Journey From Chester to London*. London: 1782.

Pesce, 1957
Pesce, Gennaro. *Sarcofagi romani di Sardegna*. Rome: L'Erma di Bretschneider, 1957.

Pfuhl, Möbius, 1977
Pfuhl, Ernst, and Hans Möbius. *Die ostgriechischen Grabreliefs*. Mainz: Philipp von Zabern, 1977.

Philippart, 1928
Philippart, Hubert. *Collections d'antiquités classiques aux États-Unis*. Brussels: Revue de l'Université de Bruxelles, Supplement, 1928.

Picard, 1926
Picard, Charles. *La sculpture antique de Phidias à l'ère byzantine*, 2. Paris: H. Laurens, 1926.

Picard, 1939
Picard, Charles. *Manuel d'archéologie grecque, La Sculpture* II, parts I and 2. Paris: Auguste Picard, 1939.

Polaschek, 1973
Polaschek, Karin. "Studien zur Ikonographie der Antonia Minor." *Studia Archaeologica* 15. Rome: L'Erma di Bretschneider, 1973.

Poulsen, F., 1923
Poulsen, Frederik. *Greek and Roman Portraits in English Country Houses*. Oxford: The Clarendon Press, 1923.

Poulsen, F., 1951
Poulsen, Frederik. *Catalogue of Ancient Sculpture in the Ny Carlsberg Glyptotek* (second supplement). Copenhagen: Ny Carlsberg Glyptotek, 1951.

Poulsen, V., 1962
Poulsen, Vagn. *Les portraits romains* I. Copenhagen: Ny Carlsberg Glyptotek, 1962.

Poulsen, V., 1974
Poulsen, Vagn. *Les portraits romains* II. Copenhagen: Ny Carlsberg Glyptotek, 1974.

Pryce, 1931
Pryce, Frederick Norman. *Catalogue of Sculpture in the Department of Greek and Roman Antiquities of the British Museum*, vol. II, part II, *Cypriote and Etruscan*. London: Oxford University Press, 1931.

Redlich, 1942
Redlich, Roman *Die Amazonensarkophage, des II und III Jahrhunderts nach Chr.* Berlin: Archäologisches Institut des Deutschen Reiches, 1942.

Reinach, 1897–1930
Reinach, Salomon. *Répertoire de la statuaire grecque et romaine*, vols. 1–6. Paris: E. Leroux, 1897–1930.

Reinach, 1909–1912
Reinach, Salomon. *Répertoire de reliefs grecs et romains*. vols. 1–3. Paris: E. Leroux, 1909–1912.

Richter, 1948
Richter, Gisela M. A. *Roman Portraits*. New York: The Metropolitan Museum of Art, 1948.

Richter, 1950
Richter, Gisela M. A. *The Sculpture and Sculptors of the Greeks*. rev. ed. New Haven: Yale University Press, 1950.

Richter, 1954
Richter, Gisela M. A. *Catalogue of Greek Sculptures*. Cambridge, Massachusetts: Harvard University Press, 1954.

Richter, 1965
Richter, Gisela M. A. *The Portraits of the Greeks* I, II, III. London: Phaidon Press, 1965.

Richter, 1970
Richter, Gisela M. A. *The Sculpture and Sculptors of the Greeks*, 4th ed. rev. New Haven: Yale University Press, 1970.

Richter, 1984
Richter, Gisela M. A. *The Portraits of the Greeks*. (Abridged and revised by R. R. R. Smith). Ithaca, New York: Cornell University Press, 1984.

Ridgway, 1970
Ridgway, Brunilde S. *The Severe Style in Greek Sculpture*. Princeton: Princeton University Press, 1970.

Ridgway, 1972
Ridgway, Brunilde S. *Classical Sculpture*. Providence: Museum of Art, Rhode Island School of Design, 1972.

Ridgway, 1979
Ridgway, Brunilde S. "1. General, 2. Aids and Collective Publications." *Fasti Archaeologici, Annual Bulletin of Classical Archaeology*, (1973–1974, *XXVIII–XXIX*, p. 70, no. 1143. Florence: International Association of Classical Archaeology, 1979.

Righetti, 1981
Righetti, Piera. In Antonio Giuliano, *et al. Museo Nazionale Romano, Le Sculture* I, no. 2. Rome: De Luca Editore s.r.l., Ministero per I Beni Culturali e Ambientali, Soprintendenza Archeologica di Roma, 1981.

Robert, 1890
Robert, Carl. *Die Antiken Sarkophag-reliefs,* II. Berlin: Grote, 1890.

Robert, 1983
Robert, Louis. "Documents d'Asie Mineure," *Bulletin de Correspondance Hellénique* CVII, pp. 497–599, pls. XXIII-XXVIII. 1983.

Robertson, 1969
Robertson, Donald S. *Greek and Roman Architecture,* 2nd ed. Cambridge: Cambridge University Press, 1969.

Robertson, 1975
Robertson, Martin. *A History of Greek Art.* Cambridge: Cambridge University Press, 1975.

Robinson, 1927
Robinson, David M. "A Graeco-Parthian Portrait Head of Mithradates I." *American Journal of Archaeology* 31, pp. 338–344, figs. 1–6. 1927.

Robinson, 1939
Robinson, David M. "Three Marble Heads from Anatolia." in *Anatolian Studies Presented to W. H. Buckler,* W. M. Calder and Josef Keil, eds., pp. 249–268, pls. 6–9. Manchester: University of Manchester Press, 1939.

Robinson, 1955
Robinson, David M. "Unpublished Sculpture in the Robinson Collection." *American Journal of Archaeology* 59, no. 1, pp. 19–29, pls. 11–22. 1955.

Rodenwaldt, 1930
Rodenwaldt, Gerhart. "Der Klinensarkophag von S. Lorenzo." *Jahrbuch des Deutschen Archäologischen Instituts* 45, heft 1/2, pg. 116–189. 1930.

Rose Art Museum, 1968
Rose Art Museum. *Art of the Late Antique from American Collections.* Waltham: Brandeis University, 1968.

Rowland, 1963
Rowland, Benjamin Jr. *The Classical Tradition in Western Art.* Cambridge, Massachusetts: Harvard University Press, 1963.

Royal Ontario Museum, 1983
Royal Ontario Museum. *The Search for Alexander, Supplement to the Catalogue,* 5 March to 10 July 1983. Toronto: The Royal Ontario Museum, 1983.

Ruesch, n.d. (1900)
Ruesch, Arnold. *Guida illustrata del Museo Nazionale di Napoli.* n.d. (1900)

Rühfel, 1984
Rühfel, Hilde. *Das Kind in der griechischen Kunst* (Kulturgeschichte der Antiken Welt, Band 18). Mainz: Philipp von Zabern, 1984.

Salzmann, 1983
Salzmann, Dieter. "Die Bildnisse des Macrinus." *Jahrbuch des Deutschen Archäologischen Instituts* Band 98, pp. 351–381, figs. 1–38. Berlin: Walter de Gruyter and Co., 1983.

Salzmann, 1983a
Salzmann, Dieter. *Spätantike und frühes Christentum.* Frankfurt: Liebieghaus Museum alter Plastik, 1983.

Schefold, 1962
Schefold, Karl. *Vergessenes Pompeji.* Bern and Munich: Francke, 1962.

Schefold, Cahn, 1960
Schefold, Karl and Herbert A. Cahn. *Meisterwerke griechischer Kunst.* Basel and Stuttgart: Schwabe, 1960.

Schmaltz, 1970
Schmaltz, Bernhard. *Untersuchungen zu den attischen Marmorlekythen.* Berlin: Mann, 1970.

Schreiber, 1894
Schreiber, Theodor. *Die hellenistischen Reliefbilder.* Leipzig: W. Engelmann, 1894.

Schweitzer, 1948
Schweitzer, Bernhard. *Die Bildniskunst der römischen Republik.* Leipzig: Koehler and Amelang, 1948.

Schweitzer, 1954
Schweitzer, Bernhard. "Altrömische Traditionselemente in der Bildniskunst des dritten nachchristlichen Jahrhunderts." *Nederlands Kunsthistorisch Jaarboek* 5, pp. 173–190, abt. 1–8. Bussum: C. A. Van Dischoeck, 1954.

Scrinari, 1972
Scrinari, Valnea, S. M. *Museo Archeologico di Aquileia, Catalogo delle Sculture Romane.* Rome: Ministero della pubblica istruzione, Direzione generale delle antichità e belle arti, 1972.

Sellwood, 1971
Sellwood, David. *An Introduction to the Coinage of Parthia.* London: Spink and Son, 1971.

Shear, 1984
Shear, Ione Mylonas. "v. The Roman West, I. Roman Civilization and Art." *Fasti Archaeologici, Annual Bulletin of Classical Archaeology,* (1977–1978), XXXII-XXXIII, p. 699, no. 9827. Florence: International Association of Classical Archaeology, 1984.

Sieveking, 1921
Sieveking, Johannes. "Ein Darstellung des Seneca?" *Archäologischer Anzeiger,* Band XXXVI, pp. 351–354, abb. 1. Deutschen Archäologischen Instituts. Berlin and Leipzig: Walter de Gruyter and Co., 1921.

Simon, 1954–1955
Simon, Erika. "Zum Bruchstück eines Weihreliefs in Eleusis." *Athenische Mitteilungen* 69–70, pp. 45–50, beilage 24–25. Deutsches Archäologischen Instituts. Berlin: Gebr. Mann, 1954–1955.

Simon, 1962
Simon, Erika. "Zur Bedeutung des Greifen in der Kunst der Kaiserzeit." *Latomus* 21, fasc. 4, pp. 749–780, pls. 1–11. 1962.

Simon, 1982
Simon, Erika. *The Kurashiki Ninagawa Museum, Greek, Etruscan and Roman Antiquities.* Mainz: Philipp von Zabern, 1982.

Six, 1912
Six, Jan. "Amastria, Koenigin von Amastris." *Römische Mitteilungen* 27, pp. 86–93, pl. 1. Mitteilungen des Deutschen Archäologischen Instituts. Rome: Loescher and Co., 1912.

Soldner, 1986
Soldner, Magdalene. *Untersuchungen zu liegenden Eroten in der hellenistischen und römischen Kunst* vol. 2. Frankfurt: Peter Lang, 1986.

Stemmer, 1978
Stemmer, Klaus. *Untersuchungen zur Typologie, Chronologie und Ikonographie der Panzerstatuen.* Berlin: Mann, 1978.

Stewart, 1977
Stewart, Andrew F. *Skopas of Paros.* Park Ridge, New Jersey: Noyes Press, 1977.

Stewart, 1982
Stewart, Andrew F. *Skopas in Malibu.* Malibu: The J. Paul Getty Museum, 1982.

Stillwell, 1938
Stillwell, Richard, ed. *Antioch-on-the-Orontes II, The Excavations, 1933–1936.* Princeton: Princeton University Press, 1938.

Stillwell, 1941
Stillwell, Richard, ed. *Antioch-on-the-Orontes III, The Excavations, 1937–1939.* Princeton: Princeton University Press, 1941.

Strong, 1903
Strong, Eugenie. *Burlington Fine Arts Club Exhibition of Ancient Art.* London: 1903.

Strong, 1908
Strong, Eugenie S. "Antiques in the Collection of Sir Frederick Cook, Bart. at Doughty House, Richmond." *Journal of Hellenic Studies,* vol. XXVIII, pp. 1–45, pls. I-XXIV. 1908.

Strzygowski, 1904
Strzygowski, Josef. *Koptische Kunst, Catalogue général des antiquités égyptiennes du Musée du Caire,* vol. XII. Vienna: A. Holzhausen, 1904.

Svoronos, 1908
Svoronos, J.N. *Das Athener Nationalmuseum,* volume of plates I. Athens: 1908.

Terrace, 1962
Terrace, Edward L. B. *The Art of the Ancient Near East in Boston.* Boston: Museum of Fine Arts, 1962.

Thimme, Getz-Preziosi, 1977
Thimme, Jürgen, and Patricia Getz-Preziosi, et al. *Art and Culture of the Cyclades.* Karlsruhe and Chicago: Badisches Landesmuseum, University of Chicago Press, 1977.

Toynbee, 1934
Toynbee, Jocelyn M. C. *The Hadrianic School, A Chapter in the History of Greek Art.* Cambridge: The University Press, 1934.

Toynbee, 1973
Toynbee, Jocelyn M. C. *Animals in Roman Art and Life.* Ithaca, New York: Cornell University Press, 1973.

Travlos, 1971
Travlos, John. *Pictorial Dictionary of Ancient Athens.* London: Thames and Hudson, 1971.

Turr, 1984
Turr, Karina. *Falschungen antiker Plastic seit 1800.* Berlin: Mann, 1984.

Uhlmann, 1982
Uhlmann, V. *Hefte des archäologischen Seminars der Universität.* Bern: 1982.

Vermeule, C., 1953
Vermeule, Cornelius C. *Catalogue of Classical Antiquities in the Sir John Soane's Museum.* London: Sir John Soane's Museum, 1953.

Vermeule, C., 1959
Vermeule, Cornelius C. "Hellenistic and Roman Cuirassed Statues, the Evidence of Painting and Reliefs in the Chronological Development of Cuirass Types." *Berytus* XIII, fasc. 1, pp. 1–82, pls. I-XXVI. Copenhagen: Museum of Archaeology, American University of Beirut, 1959.

Vermeule, C., 1964
Vermeule, Cornelius C. "Greek, Etruscan and Roman Sculptures in the Museum of Fine Arts, Boston." *American Journal of Archaeology* 68, pp. 323–341, pls. 97–110. 1964.

Vermeule, C., 1964a
Vermeule, Cornelius C. "Greek and Roman Portraits in North American Collections." *Proceedings of the American Philosophical Society* 108, no. 2, pp. 99–134, figs. 1–45. 1964.

Vermeule, C., 1967
Vermeule, Cornelius C. *Museum of Fine Arts Bulletin 65.* Boston: Museum of Fine Arts, 1967.

Vermeule, C., 1968
Vermeule, Cornelius C. "Graeco-Roman Statues: Purpose and Setting." *The Burlington Magazine,* vol. CX, number 787, pp. 545–557. figs. 12–19. 1968.

Vermeule, C., 1969
Vermeule, Cornelius C. *Polykleitos.* Boston: Museum of Fine Arts, 1969.

Vermeule, C., 1971
Vermeule, Cornelius C. "Recent Museum Acquisitions, Greek and Roman Sculptures in Boston." *The Burlington Magazine,* vol. CXIII, no. 814, January 1971, pp. 37–45, figs. 43–55. 1971.

Vermeule, C., 1974
Vermeule, Cornelius C. "Ten Greek and Roman Portraits in Kansas City." *Apollo,* XCIX, no. 147, May, 1974, pp. 312–319, figs 1–10.

Vermeule, C., 1976
Vermeule, Cornelius C. *Greek and Roman Cyprus.* Boston: Museum of Fine Arts, 1976.

Vermeule, C., 1977
Vermeule, Cornelius C. *Greek Sculpture and Roman Taste.* Ann Arbor: University of Michigan Press, 1977.

Vermeule, C., 1978
Vermeule, Cornelius C. *Roman Art: Early Republic to Late Empire.* Boston: Department of Classical Art, Museum of Fine Arts, 1978.

Vermeule, C., 1980
Vermeule, Cornelius C. "The Weary Herakles of Lysippos." *American Journal of Archaeology,* 79, pp. 323–332, pls. 51–55. 1980.

Vermeule, C., 1980a
Vermeule, Cornelius C. *Greek Art: Socrates to Sulla.* Boston: Department of Classical Art, Museum of Fine Arts, 1980.

Vermeule, C., 1980b
Vermeule, Cornelius C. *Hellenistic and Roman Cuirassed Statues.* Boston: Department of Classical Art, Museum of Fine Arts, 1980.

Vermeule, C., 1981
Vermeule, Cornelius C. *Greek and Roman Sculpture in America.* Berkeley and Los Angeles: University of California Press, 1981.

Vermeule, C., 1982
Vermeule, Cornelius C. *The Art of the Greek World: Prehistoric through Perikles, Art of Antiquity,* volume 2, part 1. Boston: Department of Classical Art, Museum of Fine Arts, 1982.

Vermeule, C., 1983
Vermeule, Cornelius C. *Divinities and Mythological Scenes in Greek Imperial Art.* London: Spink and Son, 1983.

Vermeule, C., 1983a
Vermeule, Cornelius C. "Souvenirs of Alexander the Great's March through Persia to India." *Fenway Court,* pp. 43–45, fig. 4. Boston: Isabella Stewart Gardner Museum Annual Report, 1983.

Vermeule, C., Anderson, 1981
Vermeule, Cornelius C. and Kristin Anderson. "Greek and Roman Sculpture in the Holy Land." *The Burlington Magazine,* vol. CXXIII, no. 934, January 1981, pp. 7–19, figs. 9–38. 1981.

Vermeule, C., Cahn, Hadley, 1977
Vermeule, Cornelius C., Walter Cahn, and Rollin von N. Hadley. *Sculpture in the Isabella Stewart Gardner Museum.* Boston: Isabella Stewart Gardner Museum, 1977.

Vermeule, C., Neuerburg, 1973
Vermeule, Cornelius C. and N. Neuerburg. *Catalogue of the Ancient Art in the J. Paul Getty Museum.* Malibu: The J. Paul Getty Museum, 1973.

Vermeule, C., Vermeule, E., 1972
Vermeule, Cornelius C., and Emily T. Vermeule. "Antiquities at Wellesley." *Archaeology,* 25, no. 4, pp. 276–282, illus. 1972.

Vermeule, C., von Bothmer, 1956
Vermeule, Cornelius C., and Dietrich von Bothmer. "Notes on a New Edition of Michaelis: Ancient Marbles in Great Britain, part two." *American Journal of Archaeology,* 60, no. 4, pp. 321–350, pls. 104–116. 1956.

Vermeule, C., von Bothmer, 1959
Vermeule, Cornelius C., and Dietrich von Bothmer. "Notes on a New Edition of Michaelis: Ancient Marbles in Great Britain, part three: 1." *American Journal of Archaeology* 63, pp. 140–165, pls. 35–38. 1959.

Vermeule, E., 1964
Vermeule, Emily T. *Greece in the Bronze Age.* Chicago: Chicago University Press, 1964.

Vermeule, E., 1977
Vermeule, Emily T. "Herakles Brings a Tribute." *Festschrift für Frank Brommer,* pp. 295–301. Mainz: Philipp von Zabern, 1977.

Voshchinina, 1974
Voshchinina, Aleksandra. *Musée de l'Ermitage, Le portrait romain.* Leningrad: Editions d'Art Aurore, 1974.

Waagen, 1854
Waagen, Gustav Friedrich. *Treasures of Art in Great Britain.* London: J. Murray, 1854.

Walter, 1923
Walter, Otto. *Beschreibung der Reliefs im kleinen Akropolismuseum in Athen.* Vienna: Österreichisches Archäologisches Institut, 1923.

Walters Art Gallery, 1947
Walters Art Gallery. *Early Christian and Byzantine Art.* Baltimore: Walters Art Gallery, 1947.

Waywell, 1971
Waywell, Geoffrey B. "Athena Mattei." *Annual of the British School at Athens* 66, pp. 373–382, pls. 66–72. 1971.

Waywell, 1978
Waywell, Geoffrey B. *Classical Sculpture in English Country Houses*. London: XI International Congress of Classical Archaeology, 1978.

Webster, 1967
Webster, Thomas B. L. *Monuments Illustrating Tragedy and Satyr Play, Bulletin of the Institute of Classical Studies of the University of London*, Supplement 20. London: 1967.

Wegner, 1939
Wegner, Max. *Die Herrscherbildnisse in antoninischer Zeit*. Berlin: Mann, 1939.

Weitzmann, 1979
Weitzmann, Kurt ed. *Age of Spirituality, Late Antique and Early Christian Art, Third to Seventh Century*. New York: The Metropolitan Museum of Art, 1979.

Wenning, 1983
Wenning, Robert. "Hellenistische Skulpturen in Israel." *Boreas, Münstersche Beiträge zur Archäologie* 6, pp. 105–118, figs. 1–3. Munster: 1983.

Whatmough, 1942
Whatmough, Joshua. "Two Etruscan Inscriptions." *Classical Philology* 37, no. 4, p. 431. Chicago: University of Chicago Press, 1942.

Wiggers, Wegner, 1971
Wiggers, H., and Max Wegner. "Caracalla bis Balbinus." *Das römische Herrscherbild*, vol. II, part 1. Berlin: Mann, 1971.

Williams, 1984
Williams, Ellen Reeder. *The Archaeological Collection of the Johns Hopkins University*. Baltimore and London: Johns Hopkins University Press, 1984.

Williams, 1968
Williams, Eunice. *Gods and Heroes: Baroque Images of Antiquity*. New York: Wildenstein Gallery, 1968.

Winkes, 1989
Winkes, Rolf, *et al. Portraits and Propaganda, Faces of Rome*. Providence: David Winton Bell Gallery, List Art Center, Brown University, 1989.

Winter, 1898–1902
Winter, Franz. *Kunstgeschichte in Bildern, Neue Bearbeitung*, I. Altertum. Leipzig und Berlin: E. A. Seemann, 1898–1902.

Wood, 1983
Wood, Susan. "A Too-Successful Damnatio Memoriae: Problems in Third Century Roman Portraiture." *American Journal of Archaeology* 87, pp. 489–496, pls. 66–69. 1983.

Wood, 1986
Wood, Susan. *Roman Portrait Sculpture 217–260 A.D., The Transformation of an Artistic Tradition*. (Columbia Studies in the Classical Tradition 12). Leiden: E. J. Brill, 1986.

Wood, 1987
Wood, Susan. "Isis, Eggheads, and Roman Portraiture." *Journal of the American Research Center in Egypt*, volume XXIV, pp. 123–141, figs. 1–17. 1987.

Wrede, 1981
Wrede, Henning. *Consecratio in Formam Deorum, vergöttlichte Privatpersonen in der römischen Kaiserzeit*. Mainz: Philipp von Zabern, 1981.

Wrede, 1981a
Wrede, Henning. "Klinenprobleme." *Archäologischer Anzeiger*, Heft 1, pp. 86–131, figs. 1–45. Deutsches Archäologisches Institut. Berlin: Walter de Gruyter and Co., 1981.

Wroth, 1903
Wroth, Warwick. *British Museum Catalogue of the Coins of Parthia*. London: Trustees of the British Museum, 1903.

Zoega, 1808
Zoega, Georg. *Li bassirilievi antichi di Roma*. Rome: Pietro Piranesi, 1808.

Concordance of Acquisition Numbers

Acc. no.	Cat. no.	Acc. no.	Cat. no.	Acc. no.	Cat. no.	Acc. no.	Cat. no.
593.1941	151	1920.44.191	68	1942.211	82	1961.86	24
1899.9a., b., and c	121	1920.44.193	70	1943.1045	36	1962.70	8
1899.10	60	1920.44.201	1	1943.1046	57	1963.24	49
1900.4	156	1920.44.204	44	1943.1314	122	1963.54	135
1900.17	34	1920.44.206	78	1947.33	91	1966.134	21
1902.5	42	1920.44.208	71	1949.31	155	1966.135	134
1902.10	19	1920.44.209	110	1949.47.67	145	1968.106	37
1905.6	94	1920.44.221	87	1949.47.138	142	1969.175	11
1905.7	93	1920.44.222	137	1949.47.142	9	1969.177.1	117
1905.8	25	1922.72	27	1949.47.144	125	1969.177.2	118
1906.7	51	1922.171	20	1949.47.145	96	1969.177.3	116
1908.3	149	1924.33	88	1949.47.148	126	1969.188	154
1909.20	23	1926.31.2	111	1949.47.151	124	1970.25	95
1913.13	46	1926.48	30	1949.78	143	1970.145	127
1913.28	31	1927.38	26	1949.83	140	1971.92	123
1917.194	29	1927.203a., b.	112	1949.108	119	1972.50	22
1919.507	48	1928.176	80	1949.112	144	1972.306	136
1919.508	55	1932.49a., b.	121	1954.71	138	1975.41.112	146
1919.509	50	1932.56.115	84	1956.9	17	1975.41.115	130
1919.510	61	1932.56.115A	86	1956.21	92	1975.41.116	150
1919.511	66	1932.56.117a., b.	114	1960.446	43	1976.36	139
1919.512	89	1932.56.118	113	1960.447	3	1977.197	148
1920.44.32	73	1932.56.123	120	1960.448	14	1977.216.196	109
1920.44.133	77	1932.56.125	83	1960.449	41	1977.216.2185	103
1920.44.134	33	1932.56.127	132	1960.450	59	1977.216.2186	106
1920.44.135	63	1932.56.128	129	1960.451	12	1977.216.2507	52
1920.44.136	45	1932.56.129	104	1960.452	4	1978.495.235	97
1920.44.138	72	1933.157	54	1960.453	6	1978.512	47
1920.44.140	131	1933.158	39	1960.454	5	1979.401	107
1920.44.141	69	1934.19	58	1960.455	2	1979.402	15
1920.44.144	85	1934.196	128	1960.456	18	1979.414	141
1920.44.145	38	1935.6	81	1960.457	32	1981.47	90
1920.44.146	64	1935.22	153	1960.458	105	1981.119	101
1920.44.148	56	1939.139	147	1960.459	40	1983.69	133
1920.44.149	65	1940.126	102	1960.460	13	1983.83	152
1920.44.151	62	1940.130	75	1960.461	7	1984.195	10
1920.44.160	67	1940.131	100	1960.462	98	1988.459	35
1920.44.165	79	1941.2	28	1960.463	16	XKA 60	53
1920.44.167	74	1942.210a., b.	115	1960.465	99		
1920.44.180	76			1960.471	108		